California Design
1910

Library of Congress Cataloging in Publication Data

Main entry under title:

California design 1910.

Reprint of the 1974 ed. published by California
Design Publications, Pasadena, with index added.
1. Art industries and trade—California—History—
20th century. 2. Arts and crafts movement. I.
Andersen, Timothy J., II. Moore, Eudorah
M. III. Winter, Robert.
NK808.C34 745.4′49794 80-11097
ISBN 0-87905-055-1

California Design 1910

Editors:

Timothy J. Andersen
Eudorah M. Moore
Robert W. Winter

Photographer: Morley Baer

➜
Peregrine Smith, Inc.
SANTA BARBARA AND SALT LAKE CITY
1980

California Design 1910 Exhibition
October 15 - December 1, 1974
Pasadena Center

California Design, until 1974 a department of the Pasadena Art Museum, initiates an independent life with this exhibition. Established in 1967 as a tax exempt corporation, we have long been dedicated to the exposition of objects and ideas relating to the environment man chooses to make for himself. This activity will be continued and increased.

We plan to develop exhibitions in architecture, design and the crafts in Pasadena as well as in museums and exhibition facilities in other areas. This exhibition, *California Design—1910*, will serve to begin a pilot educational program using our exhibitions as a base for curriculum and project development in coordination with the schools.

We maintain a commitment of concern for the quality of the objects with which man surrounds himself, and a dedication to increase the individual's awareness and value judgment of his man-made environment.

Foreword

Anonymous
Pair of cedar gates
h. 30¾", 1915
Martha Mertz

The intent of the directors in assembling this exhibition was to make a broad survey of the creative expressions in California roughly between 1895 and World War I, a germinal period of cultural consolidation within the State. At this time the influence of the international Arts & Crafts movement had reached the Coast. The exhibition is, in a sense, a record of how the forms and values of the movement were influenced and changed by the nature and surroundings of the Californians. It has been our desire to establish an aura of the attitudes of the times, sociologically and stylistically, rather than attempt a rigid historical study of the painting, architecture or crafts per se. By our choice of paintings, which are primarily landscapes, we have sought to give a sense of place. By the emphasis on furnishings and fittings as well as architecture, on literature and presswork as well as painting, we have sought to demonstrate the integrated diversity of their creative vision and the prevalence of a unified attitude towards the arts as part of the whole fabric of life and living. In presenting this combination of materials it is our hope to give viewers not so much a glimpse of things past, as the opportunity to extrapolate from the objects a value judgment for the present in terms of design and life style.

Eudorah M. Moore

Acknowledgements

The editors wish to acknowledge with gratitude a grant from the California Arts Commission. Without the initial impetus of that funding this exhibition would not have been possible.

Our thanks to those generous scholars listed below who contributed monographs for this book. Their sharing of insights and information has been vital to the exhibition and the catalog:

Jane Apostol Randell L. Makinson
Paul Evans Bonnie Mattison
Janet Ferrari Esther McCoy
David Gebhard Ward Ritchie
Robert Haas Robert Winter
Harvey Jones

To those who aided in research on biographical information and sources of material we owe endless gratitude:

Kenneth Aaker Joan Clapham
John Beach Alson Clark
Kenneth Cardwell Robert J. Clark

Carl S. Dentzel Megs Meriwether
William W. Ellinger Ken Miedema
Dr. Elliot Evans Nancy Moure
Mary Gleason Tom Owen
Samuel W. Hammill Sally Plehn
Barbara Horton Sim Bruce Richards
Richard Longstreth Thomas G. Smith
Janeen Marrin Albert Sperisen
Keith Marston Janaan Strand
Valarie Mathews Lawrence Test
Kathy McManus

To Lois Boardman who arranged events peripheral to the exhibition as well as being cheerful errand runner, donor, and tower of strength, and to Marilyn Blanck who researched and wrote a syllabus for the secondary schools of the Pasadena system to be used in conjunction with the exhibition—no words could express our debt.

Our thanks to James and Janeen Marrin who assembled the material and designed the installation of the two Craftsman rooms in the exhibition. These spaces incorporated the work of Stickley and others outside of California and sought to give the ambience of the Arts and Crafts surroundings.

We are most appreciative of the many things Don Pollard, Assistant City Manager of Pasadena did to ease the transition into the city facilities.

We should also like to acknowledge the generosity of the Oakland Museum in lending such a substantial body of material as well as to commend the Oakland staff for their cooperation and help in providing information and coordinating the loan.

Lenders to the Exhibition

Mr. and Mrs. Richard Anderson
Stanley C. Anderson
The Atchison, Topeka and
 Santa Fe Railway Company
Dr. Francis Ballard
Alan Batchelder
Book Club of California
Bowers Museum
G. Breitweiser
Dr. and Mrs. Lyman Brewer
Philip Brown
Mr. and Mrs. Edward Bunting
California Historical Society
Mr. and Mrs. John A. Carrington
Ronald R. Chitwood
Ted Coleman
F. L. Compton
Patricia and Charles Crozier
Edie and Fidel Danieli
Terry De Lapp
Carl S. Dentzel
Mrs. Harry Dixon
Armand du Vannes Art Gallery
Eunice Mannheim Edwards
Dr. Elliott Evans
Fine Arts Gallery of San Diego
Dr. and Mrs. Roland Fisher
Clemens Friedell, Jr.

Gamble House—City of Pasadena,
 University of Southern California
Gardena High School Student Body
Dr. & Mrs. Robert Bartlett Haas
Mrs. Annette T. Handy
Barbara Curtis Horton
John Howell Books
Judson Studios (Walter Judson)
Mr. and Mrs. John Kulli
Laguna Beach Museum of Art
Mr. and Mrs. Terence Leichti
Los Angeles Athletic Club
Los Angeles County Museum of Art
Kenneth Maley
James and Janeen Marrin
Keith P. Marston
Mr. and Mrs. Robert Mattison
Al McKeown
T. S. McNeill
Eva Hanson Tower Meacham
Elva Meline
Martha Mertz
Mission Inn
Dr. Robert A. Nash
Michiko and Al Nobel
The Oakland Museum
Occidental College Library
Mr. and Mrs. Thomas H. Ott

City of Pasadena
Poulsen Galleries
Private Collectors
Jeanne Mannheim Reitzell
Sim Bruce Richards
Ward Ritchie
The Robertson family
San Diego Society of Natural History
San Francisco Church of the
 New Jerusalem
Rudolph Schaeffer
Irwin Schoen, M.D.
Jason Schoen
Dr. and Mrs. B. D. Sharma
Catherine P. Short
Albert Sperisen
Mr. and Mrs. Malcolm Stinson
Katherine B. Trower
University of California, Berkeley,
 College of Environmental Design
The Art Galleries, University
 of California, Santa Barbara
University of San Francisco
William van Erp
Stephen Glenn White
Mr. and Mrs. Alexander Whittle
Dr. Robert Winter
Mary Q. Zaffuto

Bertha Lum
Untitled woodblock print
16¾″ x 11½″

G. Breitweiser

Foreword to 1980 Edition

Originally published for the six week exhibition in 1974, this catalogue has had considerable influence in popularizing the attitudes and artifacts of the 1910 California craftsmen. Our hunch has proven to be accurate: this material does speak cogently to many of our own concerns as well as having timeless appeal. The book's impact has grown beyond the design professions despite limited national exposure. To achieve a wider distribution and make the book available to an international audience this second printing is being published by Peregrine Smith, Inc.

This second printing differs from the first only in minor changes and the substitution of an index for the catalogue listing.

Contents

California and the Arts and Crafts Ideal
Eudorah M. Moore

Stemming from ideas expressed by Thomas Carlyle (1795-1881) and further articulated by his cultivated follower John Ruskin (1819-1900) the Arts and Crafts idea began taking the shape of a movement with the pragmatic and energetic activities of William Morris (1834-1896).

Ruskin was concerned that the iron hand of the machine was enslaving, rather than freeing man, that specialization was fragmenting rather than making him whole. He pictured art as a necessity to life, and the hand and commitment of the artist as necessary to art. He viewed creative labor as a fulfillment rather than a curse. Medievalism and the Guild system recurred as ideals towards a utopian social order.

The pre-Raphaelite painters by their sympathy with medieval design were the first to turn attention to beauty of design, color and significance in the accessories of daily life, but it remained for the remarkable and articulate William Morris to generate the activity which brought about the Arts and Crafts Movement. Morris' capacities in the whole creative spectrum establish him as the Arts and Crafts ideal. He wrote throughout his life and was among the preeminent poets of his time. Yet his concern for beauty of object and surrounding caused him to form with a group of talented friends, a decorating company which undertook carving, metalwork, stained glass, wall paper, chintz and carpet design and production. The company flourished and the ideas articulated by Carlyle and Ruskin had found embodiment in design. His friend Swinburne said that he was more inspired by literature than life, his socialism was tinged with a passionate search for an artistic ideal and that he was not primarily interested in men at all but in objects. Nevertheless, it was he more than anyone, who first gave fact to the dream.

The widening message from Carlyle, Ruskin and Morris was further broadened by the formation of the Arts and Crafts Exhibition Society which held its first exhibition in 1888 at the New Gallery. This was an expression of discontent against the Royal Academy for including only painting and sculpture in their exhibitions rather than all the arts of design and it finally gave a name to the movement which had been yeasting for 20 years.

Inevitably the ideas and designs emerging from the English activities found their way to the United States.

The broad Arts and Crafts Movement in the U. S. has been so well covered by Robert Judson Clark in his Princeton catalog (1972) that repetition is redundant here. The names of Hubbard and Stickley, the fame and influence of *The Craftsman* Magazine, the craftsmen, manufacturers, and architects who expressed the thrust of the movement as it spread across the U. S. are meticulously recorded and pictured in that book.

However, a point which has not been generally made is that the real intent of the ideals formulated by Ruskin and Carlyle seems perhaps to have come closer to being broadly realized in the lives and works of California's turn of the century creative community than at any time since William Morris. The original ideas expressed by Ruskin concerned an attitude towards life and objects, a value statement not a design style. Within the attitude, styles could be as diverse as the visions which created them. In developing a business which produced a Craftsmen's style the real Craftsman's spirit was lost. The moment the idea became concreted in a design style it lost the very individuality which was its essence.

Let us picture the land on which the ideational seed of the Arts and Crafts Movement fell as it moved to the West. California at the turn of the century was, as Theodore Roosevelt put it, *West of the West* a land apart, but both the ideas and artifacts of the Movement had reached the coast. The period when the Arts and Crafts influence is most perceptible are the years between 1890 and 1920. This time represents in one sense the period of the beginning of California's cultural consolidation.

Prior to this, the life of the two sections of the State had been as diverse as if they had been different countries. The gold rush had brought an influx of American settlers overland and around the Horn to speed San Francisco's urban growth in the mid-nineteenth century. Its early 'sense of city' and the fortunes made and spent in the building and decoration of opulent palaces established a cultural life which drew heavily on Europe both for training and artifacts.

In the south the adobe village of Los Angeles snoozed away another 40 years with its earliest settlers drifting in from the greatest distances. (Anaheim settled by Germans, El Toro in Orange County an English colony and French merchants developing a prospering life in Los Angeles.) In the 70's Ludwig Louis Salvatore, writing a travel book, *Eine Blume aus dem Goldenen Lande oder Los Angeles* says, "on

<p style="text-align:right; font-size:2em;">Introduction</p>

7

the streets of Los Angeles are heard spoken English, French, Spanish and German," and he repeats that Americans, Europeans and Californians (Mexicans) were about equally divided. However, a wave of American immigrants in the 80's engulfed the cosmopolitan little town and settling into the indolent ranchos, planted orange groves and formed the villages which have merged into the conglomerate of Los Angeles.

As we view the populations of Los Angeles and San Francisco from the 90's to 1920, we find the two cities though very different in character, for the first time with essentially similar population patterns. For the first time the U. S. had really populated all of California. Whether these American immigrants came for health or for gold they almost universally felt they had found Eden. The overland trip by train made the State available without hardship, and the railroads, by their subsidies to artists and writers, rung paeans of praise for the benign beauties of landscape and climate of those places served by the Santa Fe.

As the nature of the soil determines the growth of the plant it was inevitable that the ideas of the Arts and Crafts Movement would take a different form in Eden than in England.

California was the land of immigration. Almost every one had come from someplace else, bearing with him his cultural past. Yet, obviously, leaving his root, subject to influence and open to search and ready to do it himself. George Wharton James who published the one issue of the Arroyo Craftsman magazine (October 1909), had been associate editor of Stickley's Craftsman magazine. Albert Valentien had decorated pottery at Rookwood before receiving the commission from Ellen Scripps which brought him to California to paint the States' wild flowers and incidentally to establish his own pottery there. Charles and Henry Greene had come from Cincinnati after an eastern education. Most of the State's artists had studied abroad and a surprising number were born in Europe.

The one thing which seemed to bind artist and author, architect and craftsman alike, which seemed to hover over the entire creative community in both north and south was a strangely palpable sense of place-of the land and of the individual's identity with it. There was something new and pervasive about the quality of the western light. The benign climate brought an almost romantic consciousness of nature. There was a sense of timelessness of being in a world apart—

a world which could be remade in one's own vision—in which one's desired life style could be realized and one's influence felt.

That the qualities of shimmering light, benevolent climate and room to grow, along with a profound awareness of the beauties of nature, affected the creative output of artist and architect alike there can be no doubt. The ideational climate of the State at this period was as permissive as the weather, though the appearance of exotic colonies in complacent middle class communities caused ripples. Mrs. Tingley's extraordinary Point Loma Theosophical Community, a Moorish-Egyptian wonder built near San Diego in 1900, brought the yogi influence into the State, and the followers of the *New Thought* movement were enlightened by George Wharton James lecture at the 1915 Fair entitled *California, the Natural Home of New Thought*. There was scarcely a religious attitude which was not represented in the State.

The sense of experimentation was not limited to religion. At Cawston's ostrich farm in Pasadena, was set up in 1903, a solar motor which could drive an engine with enough power to irrigate 300 acres of orange trees.

Anonymous
Window, leaded glass
h. 25½", ca 1910
Mr. and Mrs. Thomas H. Ott

The great air meet of 1910 produced a new altitude record of 4165 feet, and a new cross country record of 17 hours and 17 minutes was made in a White car between San Francisco and Los Angeles.

The wilderness, for the first time, began to be regarded as something to be protected rather than defeated. Camping, simple and elaborate, was a pleasure of the summers. Muir was walking the Sierra heights and bidding for the protection of Yosemite and mountain fastnesses.

This was the California which heard and embraced the Arts and Crafts ethos. As we have previously stated, the movement in the West seemed to be expressed more as a value judgment and a life style, and the embracing of the arts as an indispensible part of life, than the repetition of any single design vision. Certainly the furniture and architecture of the Greenes' and that of Easton seem poles apart. Yet in each case there exists a wholeness and completeness of idea, a statement of design in relation to materials and to the surroundings for which they were made which is similar. Again, the furniture of the Mathews, decorative, finished, detailed couldn't be further from the work in the *made by nature* style of George Harris. Yet a totality and commitment of the vision of each places them both within the concept. Arthur Mathews in many ways seems to suggest William Morris in the social aspects of his concerns and the diversity of his accomplishments. As he was architect, decorator, mural and easel painter, furniture designer, teacher and writer. His thoughts on the planning and rebuilding of San Francisco after the 1906 holocaust were expressed in his magazine *Philopolis*. His long directorship with the California School of Design had its influence on California painters. For him certainly art and life were one. Yet contrary to Morris, his design vision was on a classical rather than a medieval base.

The painting of this period is heavily weighted towards landscapes and can perhaps be said to have enough points in common so that it could almost be classed as a school. When the first artists found their way to California, Düsseldorf set the style in American painting with rigid reportive renderings of every detail. But the painting of the turn of the century freed itself from this yoke. Black is almost totally eliminated from the palette, the color tones are generally middle range. Influences can be seen of both Barbizon School and Impressionism but the genre slips beyond either. There is an almost romantic feeling in much of the painting and certainly there is an overriding sense of optimism. Yet solid painterly techniques give weight and quality to the paintings. But the biographies of the painters are possibly as revealing as their styles for they often indicate a total involvement in the arts so much a part of the Craftsman ideal.

In *Art in California* (1916), Bruce Porter writing on architecture says, "this decade accomplished a type of middle class dwelling that is distinguished by refinement and the use of native woods. These dwellings inaugurated what may be almost a *Californian* style in homes. The redwood interiors of the dwellings made agreeable backgrounds for the domestication of Japanese works of art that continue to work a strong influence upon California life and its struggle towards a conscious sense of beauty."

In architecture, Californians perhaps best and most successfully realized Morris' ideal of "works of genuine and beautiful character dedicated rather to the luxury of taste than the luxury of costliness." For certainly the plans and detail of the California *Craftsman* houses hold up today as a demonstration of that ideal. One might add in retrospect that the concept of courts, modest bungalows closely spaced on intimate grounds, providing privacy with communality, dignity with low cost, seem as much an extrapolation of the Craftsman ethic as the tenderly detailed and precious explorations of wood now grown to the class of luxurious and unattainable works of art.

It is my belief that the ideas of Carlyle and Ruskin, expressed and enlarged on by Morris, seeped into the optimistic consciousness of turn of the century California and found perhaps their broadest and most diverse expressions. As these ideas were manifested in the lives and works of Clyde Browne, Van Erp, the Mathews and others covered in this catalog they took their place to become California's craftsman's tradition.

It is a tradition of life style, aesthetic value judgments and involvement with materials. It is expressive, experimental, and as diverse as the visions of the artists. It in turn has spread its influence eastward across this country and finally culminated in the 1972 craftsman exhibition at the Victoria and Albert Museum in London. It is the modern crafts movement.

I should like to acknowledge Carey McWilliams' *Southern California* as the source of some of the Southern California information. E.M.M.

The little stream that ripples through
The canyon shaded from our view,
'Mid ferns still wet with heaven's dew,
Does ever press thee to its heart,
its gently-throbbing, tender heart—
Its surging heart when Winter's dart
Transforms the Arroyo Seco.

O Paradise to mortals given,
To make us think the more of Heaven,
To make us prize the blessings given,
Where hills and mountains e'en surround,
Lulled by the winds to calm profound,
Key of the valley thou art crowned,
Fair Vale of Pasadena!

Mrs. R. P. Waite
Los Angeles County Directory
1886

"The Arroyo would make one of the greatest parks in the world." This was Teddy Roosevelt's comment to his friend Charles Fletcher Lummis as they viewed the Arroyo Seco in 1911. The incursions of the Rose Bowl at the north and the Pasadena Freeway at the south have limited the great conservationist's dream. Nevertheless, except for these wens on nature, and the additional sacrilege of having the channel of the creek bed paved with concrete (a flood control device), the essential beauty of this California phenomenon has remained, in some cases been enhanced, in the years that have followed. The Arroyo is Pasadena's greatest visual treasure to be enjoyed by hikers, equestrians, lovers and coyotes.

Its greatest distinction derives, however, not from its relatively unspoiled virginity but from man's compromise with nature called civilization. It can be said with only a little exaggeration that the beautifully arched Colorado Street Bridge, designed by John Drake Mercereau and built of reinforced concrete in 1912-1913, gives the same focus to the narrow of the gorge that is attained by the aqueduct in Segovia. The effect has been somewhat marred by the building of a freeway bridge near it in the '50s, but even the freeway bridge echoes the arches of its older companion. Viewed from below the rhythms of these two marvels of engineering remind us that not all man's functional works need be ugly.

But the strongest human touches—ones that have the most to do with the exhibition which is the reason for this catalog—are the houses near the Arroyo. On the western side a cliff rises precipitously from the floor of the Arroyo. Along its crest are houses, mainly built in the '20s—literally palaces in the Spanish Colonial Revival and Tudor idioms—with marvelous views not only of the Arroyo but of the towers and domes of Pasadena in the foreground and, on a smog-free day, the magnificent San Gabriel mountains with snow-capped Mount Baldy completing the vista.

On the eastern side, the land dips in two terraces from the Orange Grove Boulevard ridge before it finally plunges into the gorge of the Arroyo. This area was the western fringe of the Indiana Colony which settled Pasadena in 1874. Although it has today Pasadena's oldest Yankee dwelling (the Clapp House) dating from the year of the founding, this area was apparently not at first thought to be a place to build and was until the turn of the century used as a picnic area, wildflower and bird sanctuary. It had, of course, known Indian settlement. The Gabrielinos, a branch of the Shoshone Tribe, had several semi-permanent villages along the stream, particularly where springs flowed from the

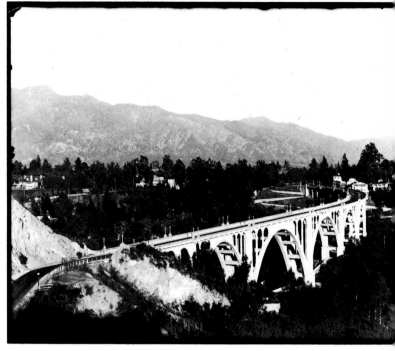

Colorado Street Bridge, Pasadena
1912-1913

Arroyo wall. During the Mexican period there had been attempts to raise cattle and cultivate the land. Indeed, up to the '80s a few ruined adobes gave evidence of the Mexicans' efforts to develop the Rancho San Pasqual, as the area was called. Then with the Yankee occupation, orange groves and olive orchards were planted here and there. The Gamble House by Charles and Henry Greene once looked out on a sea of orange blossoms, and the evidence of elderly olive trees is still to be seen in the 600 block of Arroyo Boulevard, not only in the huge trunks of the trees themselves but also in the black stain on sidewalks, streets and driveways. By the early twentieth century the eastern terraces were beginning to be landscaped for gardens, the one planted by Adolphus Busch, the beer tycoon, being by far the most famous, extending as it did from Orange Grove westward and into the Arroyo and ending at the rock formation known as Camel's Hump.

Despite the tendency to allow logging operations in the Arroyo, it was in 1900 the almost unique (for Los Angeles County) rural idyll that it is today. The preservation of the natural environment was not without its ups and downs. As early as 1885 the indefatigable preservationist Charles F. Lummis founded the Arroyo Seco Foundation and, as its first president, began the struggle to keep the Arroyo sacred long before the term "ecology" was used in its present context. The result was that it became a wonderful place to live—at least for some people!

The Arroyo Culture
Robert W. Winter

In her beautiful and rare *Wild Flowers of the Pacific Coast* (1887) Emma Homan Thayer tells of a visit to the Arroyo. She was entertained "by a lady whose home was on the ridge, and in the midst of a fine orange grove." Though she found this place to be fairy-land bathed in the perfume of orange blossoms and swathed in roses, she decided to walk down the Arroyo where she had been told there was an array of wild flowers that she would find interesting to paint. She was particularly enchanted by the wild peony and stayed so long in the Arroyo that the sun had set before she returned to the ridge. Her hostess was very anxious:

"You have remained out too late," she said. "The Arroyo is a dangerous place after the sun has disappeared from it."

"Tramps!" I asked in alarm. "Oh! no, no tramps, but those that tramp in it are in danger from the damp chilly air that takes the place of the sunshine. But come, a good cup of tea will make you all right."

The ridge may not have been Orange Grove but, assuming with poetic license, that it was, the scene, besides being amusing, emphasizes a fact clearly observable to the student of Pasadena's history, a demarcation between the "civilized" air of the orange grove highland with its mansions already rising in the '90s and the "wild" nature of the Arroyo. The comparison involves social distinctions as well, for the very wildness was a deep attraction to a special class of citizens. The Arroyo literally had at the turn of the century *no* mansions comparable in size and ostentation to Orange Grove's Wrigley, Merritt, and Cravens houses which still exist, or to the many earlier ones which have been pulled down to make way for garden apartments. In the early 1900s the Arroyo was dotted with houses of modest size indicating a more humble income than that of the millionaires on the hill. Moreover, these were houses with a style—a conscious style—very different from most of the buildings on Orange Grove. The great majority of the houses built in the flurry of construction in the Arroyo in the period just before World War I were in the "Craftsman" style, called that (not then but today) for the magazine edited by Gustav Stickley in New York, the American organ of William Morris' ideas and the Arts and Crafts movement, which developed a kind of romance with the architecture of the Arroyo. Actually Craftsman denotes not one but several styles—English Tudor and Cotswold, Swiss Chalet and Bavarian Hunting Lodge, the Shingle Style of the East Coast and the Mission and Oriental influences of the Pacific side. Sometimes these remain relatively pure. Usually they are mixed. The thing that holds them together is wood, usually on the exterior, always on the interior—wood whose nature was glorified, sometimes seeming to come rough-hewn from the forests, sometimes, most clearly in the work of the Greenes and the Heinemans, beautifully, lovingly carved and polished, but always wood.

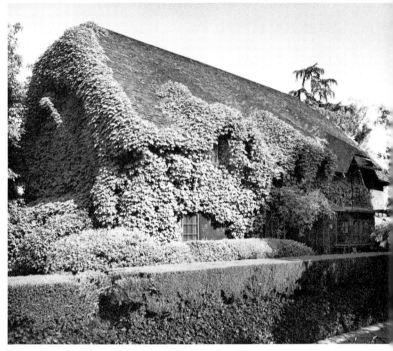

E. J. Cheesewright house, Pasadena
Louis du Puget Millar (Jeffery, Van Trees and Millar), 1909

Designed by an Irish architect, who had arrived only two years earlier, this completely shingled house recalls the hooded eaves and thatched roofs found throughout the English Cotswolds.

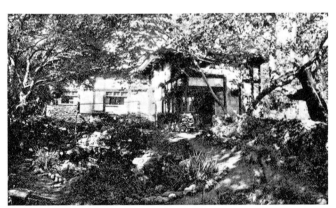

A. S. Bent house, Highland Park
Sumner P. Hunt (Hunt, Eager & Burns), ca 1909

This Craftsman house overlooking the Arroyo reveals an affinity for Tudor architecture through its *half-timbered* effect. Today the house is much less picturesque since the Pasadena Freeway runs through its garden.

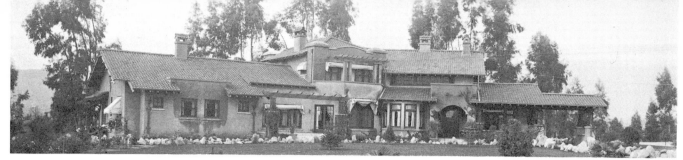

Hindree house, Pasadena
Alfred Heineman (Arthur S. Heineman), 1909

The house was designed in the Mission Revival style.
The boulders were brought up by cart from the
Arroyo to be incorporated in the landscaping and a
huge fireplace built in the double story entry space.

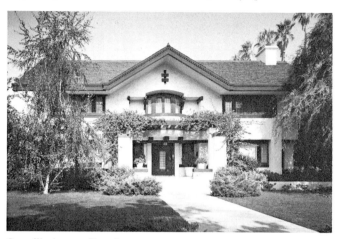

Scoville house, Pasadena
Frederick L. Roehrig, 1909

Although quite removed from the *Prairie*, this house
clearly shows the influence of the Prairie School,
a contemporary Mid-west phenomena, that would
have reached the coast through the architectural
journals of the time.

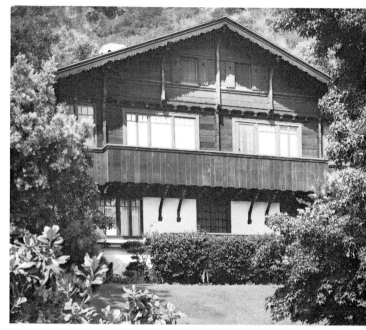

Pillsbury guesthouse, Pasadena
R.E. Williams (Train and Williams), ca 1910

Built against the San Rafael Hills overlooking the
Arroyo, this is one of several *Swiss chalets* that
were originally along this street.

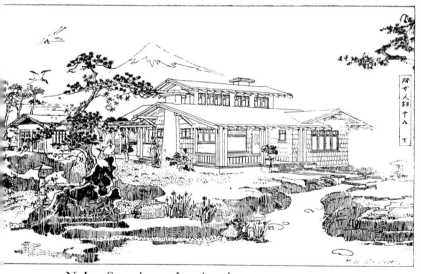

N. Lee Stary house, Los Angeles
Arthur L. Acker, 1910

This is a good example of the Japanese inspired
bungalows constructed at this time throughout
California. The rendering by Ross Montgomery
reveals the source of imagery perhaps more clearly
than the actual product.

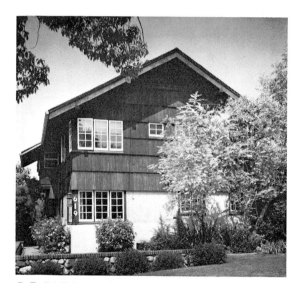

C. B. Hall house, Pasadena
Timothy Walsh, ca 1910

The architect of this Craftsman house was inspired by
Bavarian hunting lodges. Walsh was a visiting
Boston architect brought to Los Angeles to design
the Catholic cathedral, a project which never
materialized.

Now the use of this woodsy Craftsman style was no simple coincidence of time and fortune. It has an ideological, even moral significance. On one level the material and the fusion of styles indicate a feeling for the environment of the Arroyo, an attempt to associate well known picturesque human contrivances with the picturesque natural landscape. It is of more than slight consequence, for instance, that the row of Greene and Greene houses on Arroyo Terrace was called "Little Switzerland." Indeed, Elizabeth G. Graham in the July, 1916, issue of the *Craftsman* gave us an insight into the thinking. Featuring pictures of houses in the Arroyo, she found these houses, all of them with certain features of Swiss chalets, particularly well adapted for the picturesque site and with the style furnishing an "opportunity for outdoor living without a sense of manipulating the construction.... The long roof lines of the Swiss chalet, the projecting timbers, all give opportunities for deep porches, for open-air sleeping rooms, for outdoor dining spots, to be found in few other types of modern building, except some of the Japanese houses of the remote interior." (pp. 221-222)

This theme is developed more fully in Graham's closer analysis of the buildings she illustrates. The mountain cabin, the place of ease, was, its admirers claimed, particularly suited to the climate and rugged environment of the Arroyo. It is also suited to a particular style of life. The mansions on Orange Grove were beautifully adapted to the style of high society symbolized by the Valley Hunt Club. The Arroyo style was suitable for artists and literary people whose ambience included the Coleman Chamber Music concerts and the Pasadena Playhouse. As at Berkeley, the other great California center of Craftsman architecture, the simple shingled bungalow, enriched with the most discriminating taste in painting and hand-crafts, was built by intellectuals, not essentially people endowed with genius but the California variety of intellectual, productive, in tune with liberal ideas, cosmopolitan, and at the same time in touch with nature, even folksy in his attitudes toward family and the good life. The Orange Grove culture remembered Meridian Street in Indianapolis. The Arroyo culture, while certainly not leaving Indiana (the East) behind, cultivated the arts better than money.

The supreme, almost too perfect example of the Arroyo type was Charles Fletcher Lummis, a graduate of Harvard in the Class of 1881, just a little behind his friend Theodore Roosevelt. With literary pretensions and some talent, Lummis made a deal with Harrison Grey Otis, the publisher of the Los Angeles *Times* that he would walk from Cincinnati to Los Angeles,

writing up his experiences on the way and afterward, in return for the promise of a job on his arrival. After the journey, which widened his limited Harvard education by introducing him to the Indian culture of New Mexico and Arizona, Lummis was given the job of city editor of the *Times*. Thus began Lummis' enthusiastic invasion of the cultural life of California and his contribution to almost every facet of it.

No need to go into the details of this contribution, especially since every detail is in Dudley Gordon's *Charles F. Lummis: Crusader in Corduroy* (Cultural Assets Press, 1972). Suffice to say that in the period from 1885 to 1928 he was at various times City Librarian, founder of the California Landmarks Club (1895) which began the restoration of the Missions, founder of the Southwest Museum, one of the great repositories of American Indian art, editor of the *Land of Sunshine* (later *Out West*) magazine which he converted from the promotion of real estate to the promotion of Spanish, Mexican and Indian culture, author of numerous books on poetry and essays on the Southwest and builder of a unique house on the banks of the Arroyo which became a salon for local artistic talent as well as an oasis for notables who crossed the desert to visit Los Angeles—and Lummis!

But it is the meaning of this fantastic man that concerns us here. He was a man of culture who affected a corduroy suit. He was a champion of the civil rights of all Indians, but when it came to collecting elements of their culture, he usually chose the New Mexico variety, that is, the ones who made magnificent pottery (which he collected as Easterners collected Greek pots or Chinese bronzes), danced through gorgeous ceremonials (which he photographed), and sang songs which he could adapt to the chromatic scale of his civilization and record in his own voice on records still preserved at the Southwest Museum. In other words he chose a culture which, though exotic, was at the same time easily accessible to someone educated in the traditional values of Harvard.

Similarly, his house, begun in 1895, was ostentatiously primitive. Lummis, with the aid of Isleta Indians, dragged boulders from the nearby Arroyo and set them into the facade of his castle in order to give it an indigenous quality. Incidentally, it was simply stuccoed in the rear. Inside, we have the rustic mountain cabin, but contrived to overwhelm the viewer with its rusticity. Through all this primitivism, sophistication appears not only in the doors, sideboards, and metal-work reportedly designed by Maynard Dixon, one of Southern California's major painters, but also

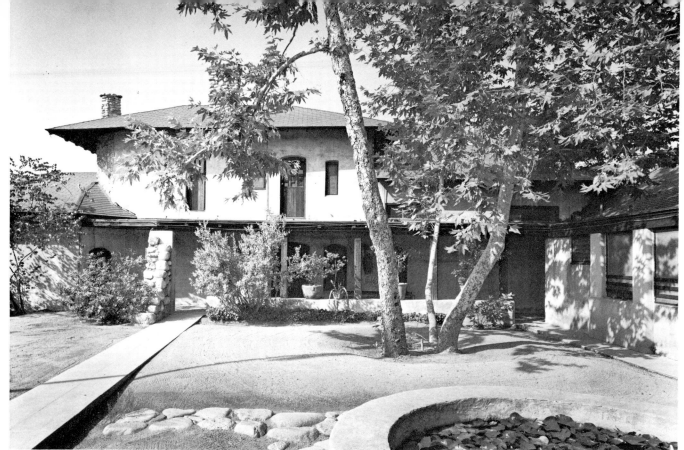

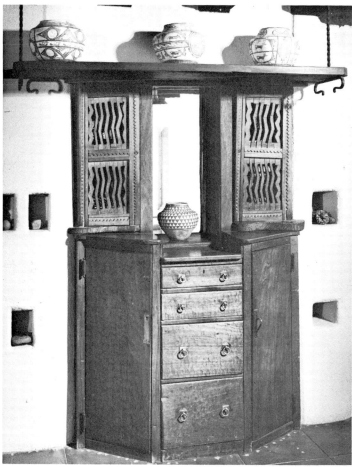

Charles F. Lummis house, Highland Park
begun 1895

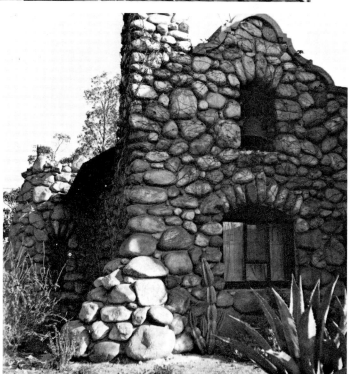

in the Art Nouveau decoration of a bedroom fireplace by Gutzon Borglum who later and in a different spirit went on to sculpture the great stone faces on Mount Rushmore. An autographed photograph of the King of Spain, who knighted Lummis ("Don Carlos") in 1915 for his services to the Spanish-American culture, is framed in rough wood as are the pictures of Mary Austin and John Muir. A picture of Lummis and Theodore Roosevelt walking down the steps of the Hall of Letters of Occidental College is also framed simply.

Civilization and nature, if not wedded, at least meet in Lummis and his house. It is a civilization whose gaudiness has been toned down by natural simplicity. At the same time, nature has been improved or complemented. An interesting feature of the house, one that is not always noted, is the cobblestone mission gable (with bell) that forms one wall of the kitchen wing. It is, of course, a reference to Lummis' deep interest in the Spanish-Mexican past. The question immediately arises why he was so interested in the past, indeed why so many Southern Californians were interested in the Hispanic past. They certainly had no intention of returning to Mexican rule or to the mission economy or even to the ranching days. By reading Lummis' *Land of Sunshine*, even sketchily, it is easy to see what the interest was all about. Lummis was a Romantic, no doubt of that, a Romantic seeking the resurrection of a past that never really existed. But the reader continually comes across attributes of ease, contentment, quiet, happiness, generosity, simplicity, harmony with nature. All these are connected to missions and the life supposedly around them. Like Helen Hunt Jackson's *Ramona* (1884) somewhat earlier and Frank Norris' *Octopus* (1901) exactly contemporary, Lummis and the other writers for the *Land of Sunshine* looked back to a better day before the Yankee tramelled up the golden hills. The mission symbolized a mood which many Americans, not all of them artists by any means, would like to have seen restored. The idea of the California past met a need in a culture which also celebrated aggression, drive and even greed. It continues to meet a need. Thus the popularity of the missions today, especially the simple, unostentatious ones. The mission represents, as much as the Swiss chalet, harmony with nature and a retreat from the reality of an economy of exploitation. The fact that the Spanish exploited the Indians, though not ignored, is rarely stressed, and if mentioned, it is, like slavery in Harriet Beecher Stowe's *Uncle Tom's Cabin*, a regrettable incident in an otherwise ideal situation.

Now, to attribute such high-flown motives to Lummis and his friends, and by extension to the Arroyo culture in general, may seem dangerous, even far-fetched. It would be, if there were not so much evidence besides the *Land of Sunshine* to support the hypothesis. Every mission gable and Swiss roof line does not, of course, testify to ideological purity or to clear commitment to simplicity as against aggressive materialism. Yet they may indicate more ideas than we presently ascribe to architecture. We are accustomed to thinking of style as simply a matter of taste for which there is no disputing and no accounting. Whim and simple imitation are probably the causes of most contemporary architecture. But, in the case of the Arroyo dwellers, there is evidence that they had relatively complex associations with Mission and Craftsman styles, knew perfectly well what they were doing, and even intended their houses to be examples of good principles to other men.

Intellectual natural-men were not the exclusive property of the Arroyo. After all, there were other vales that attracted the rustic muse. John Burroughs lived for a time in Pasadena Glen near Sierra Madre. George Harris built his weirdly natural furniture in the Tujunga highlands. Even the flat country near Pasadena's emerging civic center attracted the sophisticate searching for truth among the orange blossoms. Such a figure was Arthur Jerome Eddy, a Chicago lawyer turned esthete, who chose Pasadena as his winter and then his permanent home. In 1905 he asked Frederick L. Roehrig to design a house which would embody the virtues indigenous to the Southern California culture. Eddy had seen many adobes, both simple and elegant. He admired the *U*-shaped plan as particularly suited to California living. It offered privacy and also the quality of intimacy with nature so desired by the intellectual-artistic community.

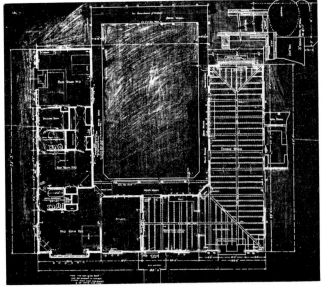

Floor plan—Eddy house

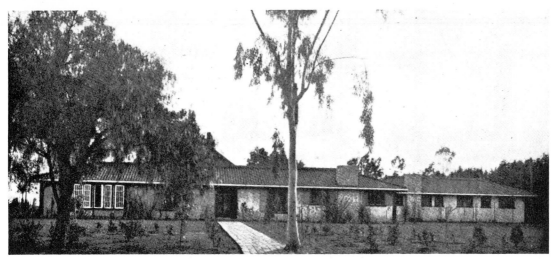

Roehrig gave Eddy a house in brick and concrete
which carried out the Mexican ideal in plan and exterior
impression, but was pure California Yankee Craftsman
inside. Eddy was to write a book Post-Impressionism
and Cubism just one year after the New York Armory
Show (1913) which introduced avant-garde art to
the common man in America. In this earlier house he
signaled his allegiance to the "new spirit" by adorning it
with Japanese prints and a collection of American
Indian artifacts excelled locally at that time only by
that of Charles F. Lummis, George Wharton James
and A. C. Vroman. Added to this was a living room
fireplace of boulders probably from the Arroyo and a
dining room set of redwood and mahogany whose
chairs were upholstered with leather, some of them
marked with the brands of the cattle farmers from
which it had been purchased. The paneling and ceiling
beams were all in redwood with marvelous iron fixtures.
All this was recognized by Gustav Stickley who
devoted much space in the November 1906 issue of
the *Craftsman* to Eddy's and Roehrig's ideas. All this
was *not* recognized by the citizens of Pasadena who
allowed the building to be demolished in 1972 in order
to make way for one of the ugliest apartment
houses ever conceived by man.

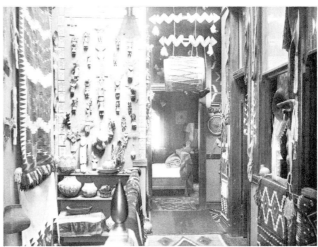

North American Indian artifacts
residence of A. C. Vroman, Pasadena

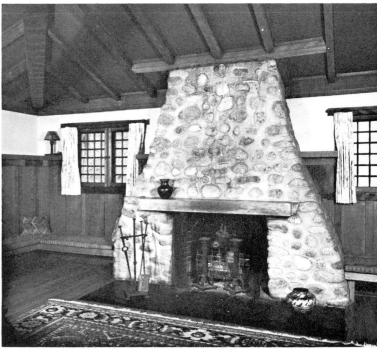

Exterior and interior details—Eddy house

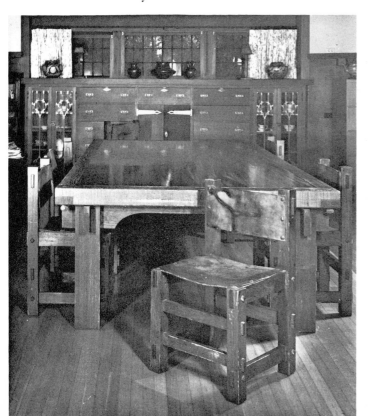

Eddy was an intellectual strongly acknowledging his debt to the Spanish and American Indian civilization . . . a sort of high culture Lummis. But to return to the Arroyo, we find, just a mile or so above Lummis' "El Alisal" a different sort of tribute to the Spanish-Mexican heritage, *The Abbey San Encino* which Clyde Browne, a printer by trade, began building in 1909. The south end is obviously based on the simple tile-roofed mission church, even though it is made of dressed boulders from the Arroyo. The English would call the interior of this wing "the great hall," at one end of which is a tile fireplace and at the other a pipe organ built by Browne himself. At the side of this building is a tiny mission cloister or patio entirely surrounded by the remaining rooms of the house. In other words, except for signs of the eccentricities of the builder, which include the names of his friends (many of them associated with Occidental College) on the columns and mementoes of famous buildings (e.g. a small stone from Westminster Abbey) in its walls, and its tiny scale, it reflects not only the mission plan but also the Mexican house plan. Beyond the main house but almost connected to it are small buildings (there once were more) used for shops and artist's studios.

Some of Browne's aspirations can be read in the walls of his house. He desired, and indeed was somewhat successful, in gathering interesting people around him, as Lummis had. For instance Ward Ritchie, the publisher whose essay on the literary aspects of the Arroyo culture appears in this catalog, and Lawrence Clark Powell, the Librarian Emeritus of UCLA, while students at Occidental College got their interest in the craft of book-making when they were rooming at the Abbey. Other worthies assembled in the great hall to hear Browne sing his old songs by his Batchelder tile fireplace.*

But first and foremost, Clyde Browne was a printer. The house signals the craft, with a stained glass window showing a Franciscan over-seeing an Indian boy who

*See Edwin H. Carpenter, "Clyde Browne—'Master Printer'," *Quarterly News-Letter of the Book Club of California.*

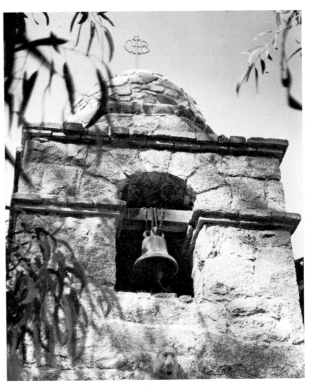

The Abbey San Encino

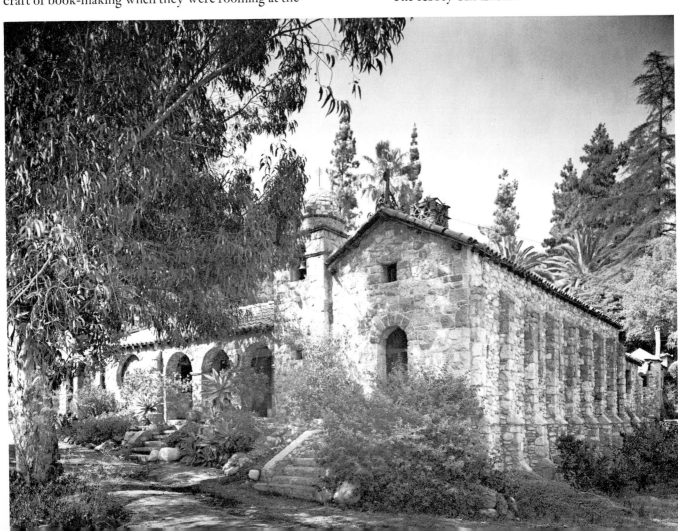

is printing with a hand-press. What he is printing is not known, but Browne's own work has been collected at the Huntington Library and at the library of Occidental College for whom Browne was semi-official printer until his death. It is very similar to the florid designs turned out by Dard Hunter for Elbert Hubbard's Roycroft Press, and through Hunter it owes its deepest debt to the English printer and social reformer William Morris.

William Morris, along with his teacher (by books) John Ruskin, was undoubtedly one of the most important people in the nineteenth century—a man whose reputation has suddenly increased in the last ten years and whose stature will grow as long as we remain critical of the concept of material progress, the growth ethic which has dominated our economy and dealt cruelly with our morality. In the mid-nineteenth century Morris, the son of a rich London stockbroker, went to Exeter College at Oxford University ostensibly to study for the Anglican priesthood. Instead he read John Ruskin's chapter in the *Stones of Venice* on "The Nature of Gothic" and decided that the way to save souls was through art. What he found convincing in Ruskin's work was an idea, constructed out of fact and fantasy about the Middle Ages, of a better world before hierarchies of art were established, before the artist was separated from the general process of which his contribution was a part. Ruskin conceived of the Middle Ages as an organic society where everything, every labor, every idea, was related to every other thing and to the whole working, dynamic mechanism of society, the worship of God and the veneration of the Holy Mother. By Ruskin's day the centrality of religious belief to the society was, even to Ruskin,

impossible, but the assumed structure of medieval society was highly desirable. Ruskin perceived his modern English society as fractured by the machine, by specialization, by impersonality, by repression of individual dignity. He looked forward to a culture where, under some other aegis than the Virgin, organic unity would be restored. In "The Nature of Gothic" the ideal is a wish; in later works (e.g. *Fors Clavigera*) it is spelled out—a restoration of the medieval guild system and a monarchical society where (Ruskin's mind was always on the brink of failure) Ruskin himself would apparently be king.

Morris never went so far into absurdity. But he was challenged by Ruskin's concept of an organic society, so different from what he saw as the chaos of nineteenth century England, devoted to greed, exploitation and the repression of humanity through mechanization. Morris' alternative, beautifully encapsulated in his utopian romance *News from Nowhere* (inspired by Morris' reading of the American Edward Bellamy's *Looking Backward* which Morris found too mechanistic) was a society where men would be free to find their own natural capacities because the onerous labor had been taken over by the machine. Notice, Morris did not reject the machine from his utopia as so many of his critics have suggested he did—probably because they never read the book. In the better day "all work which would be irksome to do by hand is done by immensely improved machinery; and in all work which it is a pleasure to do by hand, machinery is done without."

As this passage suggests, Morris wished to return to the hand-crafts and at the same time reinforce the Protestant work ethic—without Protestantism. Steeped in the heady brew of these ideas, Morris set out in 1859 to build a house for himself and his new wife, Jane. He chose as its architect his friend Philip Webb who designed a country house more than vaguely medieval. Naturally when the Morrises came to furnish it they could find nothing in their society which showed the love of work and the caress of fine craftsmanship which they had learned to demand, so they and some friends designed and fabricated many of the furnishings of the house. This was the beginning of an association of men and women, led by Morris, which eventually became Morris and Company. It was an organization which was successful in getting important commissions from people who desired fine craftsmanship. Usually, this meant the rich. But it was also the spiritual god-father of a movement among a host of individuals and groups dedicated to a renaissance in the utilitarian as well as the fine arts. It was the beginning of the Arts

and Crafts movement in England. In the 1880s William Morris societies and Arts and Crafts societies sprang up in every city and in virtually every village. The same can be said for the United States—the oldest being the Minneapolis Society of Arts and Crafts (1895—at first the Chalk and Chisel Club), closely followed by Boston and Chicago (both 1897). By 1907 when the National League of Handicraft Societies was organized in Boston, its affiliated societies throughout the United States numbered 33. There were many more that were not affiliated.

Many of these societies were, of course, simply discussion groups, but since they organized showings of hand-crafted products and promoted interest in the useful arts, they were very important in encouraging, like Morris and Company, work in ceramics, wallpaper design and production, metalwork, stained glass, furniture, architecture, rug-making, book design and binding, and many other areas of design. The chief organ of the movement in England was *The Studio* magazine (reprinted and enlarged in the United States as the *International Studio*). The most aggressive apostle of Morris' ideas in America was Gustav Stickley's *Craftsman* magazine which gave its name to the American movement, but between 1901 and 1916 (the years the *Craftsman* was printed) many other professional and popular journals, such as the *Architectural Record, House Beautiful, The Ladies Home Journal, The Chautauquan, Arena,* were propagating the Craftsman faith, sometimes as only one of the many faiths. But for at least a short period in the early twentieth century some magazines—the *Ladies Home Journal* is only one case in point—were almost completely devoted to the Craftsman esthetic.

It was through the popular magazines, and not the *Craftsman,* that most Southern Californians learned to despise the inferior products of the machine and appreciate the handicrafts. Indeed, to many people who vividly remember the period before World War I the word "Craftsman" is foreign. Alfred Heineman, a Craftsman architect if there ever was one, once shocked me by asking, after a long conversation about his work in which I mentioned Stickley, the *Craftsman* magazine, and craftsman principles many times, "What do you mean by *Craftsman?*" The much more understandable word was *Mission,* the significance of which will not be lost on the reader of the foregoing pages.

Nevertheless, the Arroyo had its connection with Stickley and the *Craftsman* in its nuncio George Wharton James, for a time an associate editor of the *Craftsman* magazine. Choosing Pasadena as his home

(he lived at 1098 North Raymond), he, like his arch-rival Charles Fletcher Lummis, plunged into Indian lore and pushed "modern" mission architecture in his many books and articles in the *Craftsman* magazine and also in *Handicraft,* the journal of the Boston Society of Arts and Crafts. It is through a journal which he tried to found that we have evidence of an organized Arroyo Guild of Craftsmen. The *Arroyo Craftsman* which James edited exists in only one issue, October, 1909, but it is a fascinating, if tantalizing, issue with the crest of the guild, an arm and hammer in the middle of a sunburst underneath which is the motto, "We Can." The motto itself is important, for, of course, it is a typically Californian paraphrase of Gustav Stickley's "Als Ik Kan" ("If We Can") which traces directly to William Morris' even more tentative "Si je puis." The *Arroyo Craftsman* gives the address of the Guild as 201 Avenue 66 in Garvanza, across the street from the building in which the painter William Lees Judson had founded his School of Fine Arts (the fore-runner of the College of Fine Arts at the University of Southern California) and over whose door the crest of the Arroyo Guild is still blazoned in terra cotta.

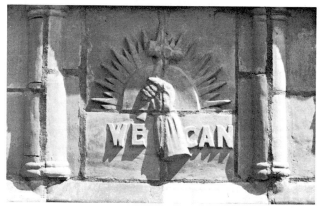

On page 52 the lineage becomes explicit: "We freely and cordially express our acknowledgements to the original Craftsman, Gustav Stickley, not only the founder, proprietor and editor of that great exponent of the Simple Life and of Democratic Art—*The Craftsman* magazine—but the originator of the Craftsman (so-called Mission) furniture, which has helped so materially to elevate the taste of the American people from the enamel-polished, machine-carved, slop-jointed, dishonestly-made furnishings of a home, to those of truly artistic standards. In an early number we propose to give an article on the Life and Work of Mr. Stickley, the American William Morris, whose devotion to pure art is calculated to work as great a revolution in this country, as did the work of Morris in England. More than a year's daily and intimate association with Mr. Stickley in the freedom of his home more than justifies the promise that this will be

the most full and authoritative article on the Great Craftsman that has yet appeared. We are assured our readers will look forward to it with interest."

Apparently they did not, and more's the pity, for James was in a position to write about Stickley's ideas and works in a way that still has not been done. Also, we would know much more about the Guild, who was in it, and what was accomplished. What the single issue offers us is, however, of great interest. The members were apparently ready to do anything including architecture, stained glass, carpets, metal-work, vases, pictures, books, "sculptured leather by the medieval manner," tiles, even landscape architecture. "Every member of the hive is busy, each one in his or her own way—for here women are on an equality with men."

The writing for the *Arroyo Craftsman* is uniformly bad. Yet the associations are absolutely marvelous. Hanson Puthuff, an artist in the "Eucalyptus School," was featured. An article advocating irregular as against formal gardens, suggested that even the smallest

This illustration shows how a city lot may be laid out to conform with all the rules of landscape gardening

bungalow might have its landscape garden. Naturally James wrote on Indian baskets. The Arroyo Craftsmen were also *against* billboards and *for* the reading of *The Arena, The Chautauquan,* Elbert Hubbard's *The Fra, House Beautiful* and, of course, *The Craftsman.* An article on a Tudor-Craftsman house, designed by Robert F. Train and Robert Edmund Williams linked those architects with the Arroyo Guild. In fact, it argued for the use of Arroyo boulders in the foundation of the house, even though it was to be erected in Santa Barbara!

TWO-SUITE COTTAGE FOR MRS. J. F. FERGUSON, SANTA BARBARA, CAL. TRAIN AND WILLIAMS, ARCHITECTS.

It would be folly to project too much from what we know about the Arroyo Guild except that it was somewhat more successful than its journal. Tempting themes appear. For instance, just behind the Guild Hall, overlooking the Arroyo and dramatically visible from the Pasadena Freeway, is the Fargo House. Its elevation is so clearly affected by the great Pasadena architects, Charles and Henry Greene, that it is almost certain that they had a hand in the design. Were the Greenes involved with the Guild? If the Guild was in existence by 1900, was it at all responsible for the dramatic change in the Greenes' taste and assurance? We know that they used workmen from the Judson Studios to craft their magnificent stained glass designs, though the glass usually came from Tiffany. Were the Greenes otherwise connected to James and Judson? No doubt someone still alive knows the answers to these questions. Probably somewhere documentation exists. But we must at present leave these matters to surmise.

A less questionable tack leads from an article in the *Arroyo Craftsman* by James A. B. Scherer, the President of the Throop (pronounced "troop") Polytechnic Institute, the forerunner of Cal Tech. Obviously James asked for the article as an endorsement of the Arroyo Guild and its journal. It was also an opportunity for Throop to get some publicity. In "The Throop Idea," Scherer tells us something about the intentions of what was to become one of the greatest scientific institutions in the country, intentions which may be surprising, even incredible, to those presently engaged in disparaging "amoral" science. The key to the concept by which Throop worked is Pasadena, which, he observed, "is not only one of the most beautiful and healthful of cities, but also it is noted for its very high standards of morality. Saloons are prohibited by charter." Moving forward, he found that "Pasadena combines the conservatism of the East with the big and broad horizons that you get only in Southern California."

The Throop idea also combined conservatism with broad horizons. Throop would offer both engineering

and the humanities in order that its students would get their "rightful heritage of culture" for "an engineer should be more than a machine: he has a right to all the broadening enrichment of the mind that he can get." Throop required four years of English and of a foreign language and insisted on history and *the broader sciences.* "Our theory of education is that it ought to fit men and women to do their actual work in the world, while providing them also with those refined tastes that turn much of the bitter of life into zestful enjoyment. . . . Character, culture, and good craftsmanship might well spell our creed; and Pasadena helps us to live up towards it."

Throop was not in the Arroyo, but its genteel high-mindedness was very much a part of the Arroyo culture. Thus, the appropriateness of Scherer's article in the *Arroyo Craftsman.* Also, although Scherer barely hinted at the fact, Throop was similarly concerned with craftsmanship. Throop was more than sympathetic to the principles of the Arroyo Guild, and its New York mentor, Gustav Stickley. One of the obsessions of the *Craftsman* magazine was getting manual training into the high schools. In fact, it can be said that in the last six years of that journal, as it saw taste moving away from Stickley's "honest" furniture and as it mirrored in its pages this change in taste, the *Craftsman* took one of its few pleasures from the fact that schools in the manual arts were multiplying throughout the country. Although strangely never mentioned in the *Craftsman,* Throop had been one of these, and its students turned out excellent examples of the straightforward Craftsman esthetic demanded by Stickley.

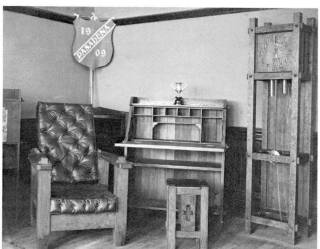

Throop's relationship to the Arroyo was further defined by the man who was called in 1902 to join the Department of Arts and Crafts, Ernest A. Batchelder. A native of Nashua, New Hampshire, Batchelder had studied at the Massachusetts Normal School in Boston and then at the Birmingham (England) School of Arts and Crafts, one of the bastions of Morris' ideas. Batchelder in 1901 came under the influence at the Harvard Summer School of Design of Denman W. Ross, for a time the President of the Boston Society of Arts and Crafts and occasional contributor to its journal, *Handicraft.* In the preface to his first book, *The Principles of Design* (1904), a gathering together of materials he had published in the *Inland Printer,* Batchelder explicitly referred to his reworking of Ross' ideas. The *Principles,* especially in its illustrations, also showed Batchelder's great interest in Japanese and

American Indian art and his acquaintance with the work of the Boston firm called the Grueby Faience Company, a maker of ornamental tiles. The reputation of the *Principles* seems to have called Batchelder to the attention of Throop, and he was hired as an instructor. For the next several years he spent his winters teaching at Throop and his summers at the Minneapolis Guild of Handicrafts, where incidentally one of his students was Grant Wood who acknowledged Batchelder as a principal influence on his art education. His work at Throop was no less effective and in the years he was there he supervised the workshop and gave courses in design to hundreds of students. One of them, Alfred Heineman, a younger contemporary of the Greenes, told me that Batchelder was the beginning of his career in architecture. In fact, "Batchelder's course in design was the only formal education I ever

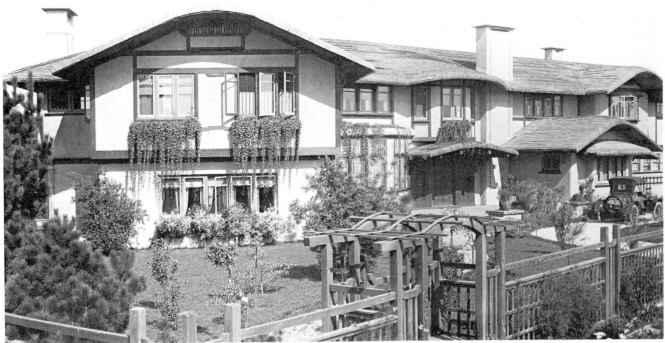

had in art," he said as he pointed to Plate XXII in Batchelder's *Principles of Design*. "It's all there—all Batchelder's theory."

By 1909 Batchelder had moved away from Throop, for reasons unknown—perhaps because Throop was changing (it became Cal Tech in 1910) and perhaps because his own interests were specializing. In 1909 he set up his own school of arts and crafts in a board-and-batten shed on property he had bought near the Arroyo and began the production of decorative tiles for which he is famous. He also began building, closer to the Arroyo, his fine Craftsman house in the

Freeman house, Pasadena Alfred Heineman, 1913

An example of Alfred's imaginative synthesis of influences—both local and distant. Note the use of Batchelder tile in the chimneys. It was this photograph, originally published in 1914, that architect Bruce Goff would recall fifty years later as having had an impact on his own development.

Swiss Chalet style. His courtship of a young pianist, Alice Coleman, the daughter of an English teacher at Throop, culminated in marriage in 1913; a marriage symbolized in the living-room fireplace with two tile lions holding shields, one with Ernest's crest, a rabbit sketching, and the other with Alice's, a harp.

Ernest's success in making and selling tiles is manifest in this exhibition. It can be seen in his own house which is a veritable museum of his tiles from 1910 to 1928, a period in which he moved from sober Craftsman browns touched with blues, to lighter colors and imaginative scenes and into the Spanish Colonial and Pre-Columbian revivals, ending with a little Art Deco in his guest house (1928) next to the garage. But his extraordinary talent is widely distributed throughout Pasadena and Southern California where almost every

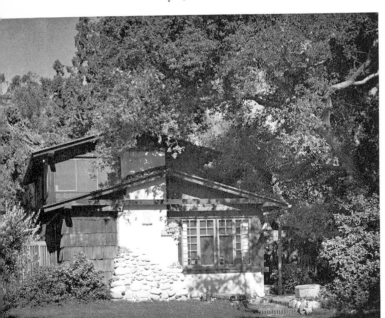

Ernest A. Batchelder house, Pasadena
1913

house in the period 1910 to 1932 had a little Batchelder tile, especially in the fireplace. The two most elaborate local demonstrations of his art, the interiors of Finney's

Cafeteria (once "The Chocolate Shop"—1914) and of the Global Marine Building (originally the "Fine Arts Building"—1926) are still easily visited at 217 West Sixth and 811 West Seventh in central Los Angeles. The biggest commission, however, was for St. Catherine's Church in St. Paul, Minnesota.

The reader will find the technical aspects of Batchelder's work covered under his biography in this catalog and, of course, in elaboration through this exhibition. But the point of this essay is to give background and social history. Here Batchelder's credentials are very strong. We have already mentioned his education in Boston and in England. Another trip to England in 1905-6 while he was on leave of absence from Throop gave him a chance to deepen his studies, both in esthetics and in the practice of European art. When he returned to Pasadena in 1906 he wrote a series of articles printed first in the *Craftsman* in 1908 and then published by Macmillan in 1910 as *Design in Theory and Practice*. This book and other articles that he published in the *Craftsman* show him to have developed a deep interest in medieval building, carving and fabrics that was not so apparent in the *Principles*. It is this Gothicism that effected his tile-making as was pointed out by Mabel Urmy Seares in the *International Studio* in 1916, and which is apparent in his personal collection of tiles, some of which he included with dozens of his own into his fireplace. Though made at the Moravian Pottery and Tileworks at Doylestown, Pennsylvania, these tiles were clearly inspired by medieval designs, one of them "The Knight of Margam" based on a tile at Margam Abbey.

Gothicism, the return to the Middle Ages, has been a theme throughout this essay. It is at the center of the turn-of-the-century Tudor, Swiss Chalet and Cotswold revivals. Even the Mission style, though based on 18th century models is, as with Clyde Browne, associated with monasticism. With a little stretching, indeed, it is quite obvious that the revival of Oriental decoration in wood was seen "in the soft religious light" of medievalism. Lummis' "castle" on the Arroyo melds Gothic and Mission. James' Arroyo Guild with its association of workers in the various crafts, simply rings variations on the theme. Behind it all is, of course, William Morris and the Arts and Crafts movement.

Curiously, Batchelder, while exemplifying medievalism, is at the end a critic of it—especially as it asserted itself in the revival of the guild system. One of Morris' quirks, it will be recalled, was his celebration of the craft guild as a sort of pre-Socialism, an anticipation of a Marxian classless society. Not many of Morris' followers accepted their hero's Marxism, but in varying degrees, they most certainly accepted his guild idea, modernized as *cooperation*. Arthur Heygate Mackmurdo's Century Guild, organized in East London in 1882 was a cooperative, strongly modified by Christian Socialism, in which the workers were also the owners and managers of the corporation. But there are certainly impracticalities involved in such high-minded enterprises, the chief of which is that they have a tendency to raise idealism above materialism and thus to disaffect the very people whom they were intended to benefit. Such an enterprise was the experiment in an Arts and Crafts guild by Charles Robert Ashbee, a Cambridge graduate who went off to East London to do good at Toynbee Hall in the 1880s and who soon found himself reading Ruskin's "The Nature of Gothic" to workingmen and founding a Guild of Handicraft (1888) based on the cooperative ideal. The workmen, apprentices at first, would gradually work themselves into a share in the company, become involved in its management, and begin to reap its rewards.

At first all went fairly well. The Guild of Handicraft was especially productive in silver-work, jewelry, book-making (in 1898 it bought William Morris' presses) and furniture. But then in the flush of success, Ashbee and the workers decided on the supreme rejection of materialism—an exodus from London to Chipping Campden, one of the loveliest Cotswold towns, then as now, fifteen miles from the nearest railroad, so that the products had to be drawn by ox-carts to the station. Vive le Moyen Age! Ashbee, like Morris, did not reject the machine outright, but he hoped that the chief power for the necessary mechanical apparatus would

come from a mill-race running through the eighteenth century silk factory in which he set up shop. Water-power was not enough, however, and a gas engine had to be (no doubt decorously) installed.

Batchelder visited Ashbee in 1905 and quickly sized up the situation: "The environment was the best, sunshine and flowers—and will one ever forget the charm of the old leaded glass windows with the mottled spots of sunshine across the floor of the shops!—the gardens at the rear, the quaint, rambling village street with its

aggressive capitalism. The competition of such firms as Liberty and Company in London was too much for Ashbee's cottage industry. But the chief problem, Batchelder noted, was within the community. Each member of the Guild had made a substantial personal investment, and there were few dividends. They had been promised a voice in the management, but that voice was kept silent. And then Batchelder delivered himself of a deathless sentence: *Cooperation that does not cooperate breeds discontent among those who are cooperated upon.*

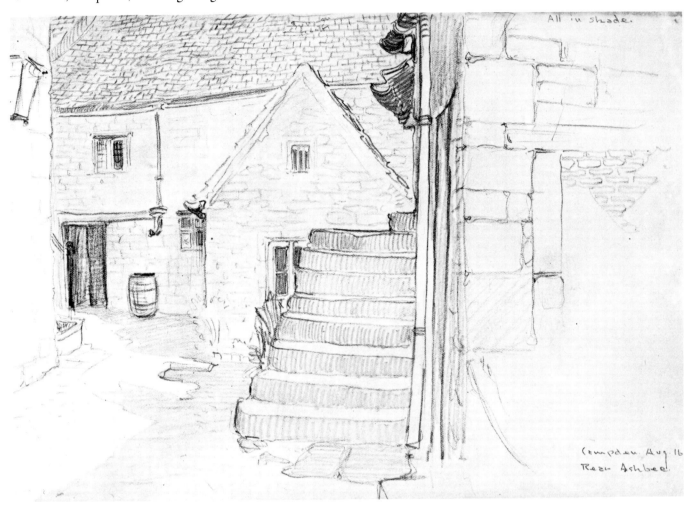

All in shade.

Campden Aug 16
Resn Ashbee

Pencil sketch—The Woolstaplers Hall at Chipping Campden Ernest A. Batchelder, 1905

little market hall and stone roofed houses. Under the circumstances one would expect to find a spirit of harmony and contentment with men interested in their work and in the welfare of the shop itself. But the time I was there I found, on the contrary, a spirit of discontent, what we in America would call *knocking*."

Part of the problem was, as Batchelder saw it, that the spirit of Morris had passed with his death in 1896. Also, Ashbee's idealism had not faced the problem of

Batchelder's own economic ventures were hardly better, though he functioned on purely capitalistic methods. As one of his workmen said, "Ernest never had any money; it was always his partners who had the business sense." It was almost inevitable that his tile empire would shatter, as it did, in the Great Depression. But here along the Arroyo, (his ghost hangs over my shoulder as I write in the room where he died), he continued to function in the genteel tradition of the Arroyo culture. Alice went back to piano teaching, and Ernest devoted himself to worthy causes. He had been a member of the Pasadena Planning Commission in the

twenties. Also, for sixteen years he was a member of the Library Board. Now he joined the Pasadena Playhouse Association, in whose halls by Elmer Grey, Alice's Coleman Chamber Music Concerts played for years, and in 1931 became its president *for twenty years.* In 1936 the "Rabbit" and the "Harp" jointly received the Arthur Noble Award as outstanding citizens of Pasadena. Indeed, it was Alice who phrased the Arroyo culture's formula for life most characteristically: "The house, the home, music, art, self-expression, love, understanding, and work blended in a manner to create a complete, well-rounded pattern of living."

Much before 1932 the Arroyo culture was changing. In 1974 it is still the best culture to be found below Santa Barbara. But by World War I a style was becoming history. Pasadena had outgrown the Mission Revival and the woodsy Craftsman style and was settling into the Spanish Colonial Revival and Warren Gamaliel Harding. The Arroyo Guild of Craftsman had by 1915 disappeared without a trace. Lummis, with a few competitors, was still presiding over the culture, but with Sumner Hunt's great Southwest Museum (1912) on the hill, Lummis' empire was consolidated. Clyde Browne finished his Abbey San Encino in this period, significantly in the picturesque quaintness of the Spanish Colonial Revival rather than the monumentality of the Mission with which he had started. Batchelder, after learning how to make tiles in lighter and more vivid colors, had almost forsaken the Craftsman browns. Robinson Jeffers had graduated from Occidental and was moving toward *Tor House.* The world was different, more sophisticated, but somehow less cosmopolitan.

Such figurative allusions exaggerate and to some extent distort the picture of what was going on in the Arroyo, but only slightly. A case in point is that of Charles and Henry Greene. They are, thanks to their genius and the good publicity of their advocates, saints in this community. Their achievement is beautifully covered in this show and excellently commented upon by Randell Makinson in the accompanying essay. But their work before 1900 is almost beyond belief, wretched, though, since they, like their contemporary Frank Lloyd Wright, were greatly gifted, even their early worst is important. Suddenly and significantly, around 1901, just as Gustav Stickley began publishing the *Craftsman* and just as Will Bradley began his series of interiors and furniture for the *Ladies Home Journal* (several of these interiors and the individual pieces of furniture were cut out and pasted by Charles Greene into his scrapbook), their style changed and they became architects. In fact, they were not alone.

Many men, some with no preparation whatsoever for careers in architecture, became competent, even good, architects as a result of the ministrations of the *Craftsman,* the *Ladies Home Journal, House Beautiful,* and the many other organs of William Morris' ideas, especially the rash of bungalow books which carried plans as well as elevations of houses that could be adapted to the site. The simple lines of the Craftsman style could easily be followed.

The Greenes were products of a manual arts high school in St. Louis. They also received certificates from the Massachusetts Institute of Technology which, if it did not so loudly as Throop proclaim its allegiance to the humanities, was considerably stronger on architectural history than Throop could hope to be. The MIT faculty in architecture was either educated at the Ecole de Beaux Arts in Paris or was strongly influenced by that foremost architectural school. It promoted the notion that architecture was to be discovered in a study of the history of styles, Greek and Gothic being basic. Beaux Arts training did not preclude the idea of originality. It, in fact, encouraged it. But originality, it assumed, occurred within tried and true forms, and the student must have a sound knowledge of history before he tried his artistic wings. In other words, the nineteenth century students of MIT were not the ignoramuses in architectural history that young architects, taught to despise the "meaningless" styles, are too often today.

As Mr. Makinson notes in his accompanying article on the Greenes, they were literally "saved" by the Craftsman esthetic, just as many other architects were saved. Yet the Beaux Arts training lingered on, particularly in the mind of Charles who was also the more talented of the two. They could work authoritatively within Craftsman simplicity, but their love of styles and their worship of immaculate craftsmanship were always pulling them toward greater enrichment. Thus the best known of their houses—the Gamble, the Blacker, the Pratt and the Thorsen— mark at once the apotheosis of William Morris' conception of bringing love to work through handicrafts, and at the same time a veering away from Craftsman simplicity; indeed, an anticipation of the diverse eclecticism of the twenties. The Gamble House chairs (1909), for instance, utterly deny the original simplicity of Stickley's furniture, except very importantly in their magnificent craftsmanship. They are Japanese Chippendale. The next step would be antiques and a Segovian balcony at the Cordelia Culbertson House (1911).

None of this discussion is intended to denigrate the Greenes and uphold early Stickley. To do so would be as absurd as to deplore the difference in style between the two towers of the cathedral at Chartres. Such a view is not just absurd, it is unhistorical. Change occurs. Taste fluctuates. When craftsmanship is excellent, as it was consistently in the Greenes' work, there is only cause to celebrate. Nevertheless, it may be significant that none of the Greenes' most ostentatious houses are in the Arroyo though they sometimes overlook it. Someone once asked Charles how he accounted for the excellence of his architecture. He is supposed to have answered, "Why, I think it was because we had rich clients." It is difficult to keep to Craftsman simplicity when given an open purse.

There was a strain in the Craftsman movement which was always close to becoming quaint. William Morris, for all his manly vigor, did not escape it. Hovering over all the arts and crafts, not just architecture, was a tendency to stretch sentiment into sentimentality. I believe that the key to this tendency lies in the medievalism which touched even the most straightforward work. Yet what beautiful things it produced. As you look about this exhibition, consider the way of life that the objects represent. They are idealizations of what Leo Marx in his *Machine in the Garden* calls "the middle landscape," that is, like the Arroyo with its human improvements, they stand half-way between the savage and the over-civilized. They are not primitive. They acknowledge the use of the machine, but the machine used in the cause of greater humanity. They are, most of them sophisticated, but not over-sophisticated, intellectual but not effete.

The balance between elegance and simplicity is evoked, I think, by an incident which I uncovered a few years ago when I was reading through the memoirs of Charles Robert Ashbee, whose experiment in the arts and crafts at Chipping Campden I have mentioned. Ashbee loved the United States and visited here many times, usually managing to see his friend Frank Lloyd Wright somewhere along the line. When the Campden experiment completely collapsed in 1909, C.R.A. and his wife, Janet made one of their visits, this time getting into the West. I was enjoying Ashbee's jaundiced view of Los Angeles and delighted to see his spirits raised by meeting "a Mr. C. Sumner Greene." But I was electrified by the next entry in which Ashbee described the day that he and Janet spent touring Pasadena in Charles' new motor car. The trio visited a number of Greene's houses and also his workshop. But the part that really catches the mood of the Arroyo culture

and "the middle landscape" came at the end of the day when Charles took the Ashbees to his home on the Arroyo. "We looked out on the mountains and discussed single tax in the intervals of tea and fingering the surfaces of Greene's scholarly panelling. As the afternoon wore on, a glorious sunset lit the snow of the mountains to rose red."

A Note on Sources: I have tried to indicate in the text the source of my material. However, I also must acknowledge my debt to Tim Andersen, Randell Makinson, F. L. Compton, William Current, Esther McCoy, Elva Meline, the archivists at the Pasadena Public Library, Tom Owen, Janaan Strand. All these people helped not only with factual references but also with those rarest of all things, ideas. Above all, I thank that elegant Pasadena architect, Lawrence Test, who, being trained in the Beaux Arts tradition by Paul Cret, knows the value of history, knows what it is, and loves it.
R.W.W.

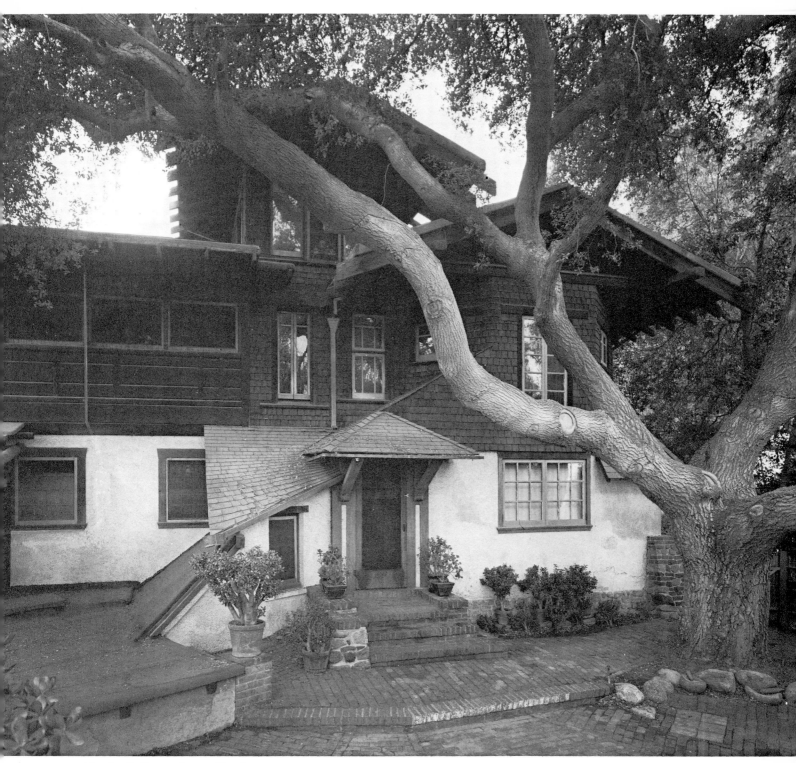

Charles S. Greene house, Pasadena
begun 1901

Jean Mannheim Studio, Pasadena

In selecting the paintings and painters for this exhibition we sought to maintain certain broad parameters. First, of course, was the time period, 1890-1920.

From several hundred painters working in this period, we made selections to the approximately fifty shown in the exhibition. Our final decision as to whom we would include was a highly subjective weighing out of painterly attributes, cross involvement with and influence on others in California's creative life of the time.

Generally speaking, our choices were weighted towards a style which seemed finally to us almost a California genre.

Naturally, because more than purely painterly or stylistic considerations were brought to bear in our decisions, there are exceptions. The main exception in terms of time is the Edwin Deakin painting which is dated 1876. We were unable to borrow the mission paintings he was doing during our period. But we felt that the woodland camping scene chosen was so related to the point we were making of the influence of nature and the appreciation of the out of doors, that we could legitimately include it. It also serves as a demonstration of the tighter painting style of the preceding period. We were influenced to include the paintings of Valentien because of his involvement with

art pottery both here and in Ohio and because of their merit as botanical paintings.

Hernando Villa reflected the Mexican tradition of Los Angeles, and his railroad posters and illustrations were indicative of the tone of commercial and post card art of the time.

Although James Swinnerton's painting was not within the genre of our main consideration, it seemed important to include him as the initiator of a school of desert painting, and as an extraordinary character.

Grace Hudson's interest in Indians was typical of the intellectuals in California at this time, and her illustrations for George Wharton James' book on basketry place her squarely within the area of our concern.

Finally, Borein and Dixon are also outside the style of the majority of our selections but both, because of the interaction and deep involvement with the personalities whom we touch on throughout the catalog, and on the basis of their own strong merits, seemed important to include.

The review of the paintings necessary to the selections for the exhibition left us with a very real and renewed respect for the merits of California's 1890-1920 painters.

Painting

The Painters & Sculptors:
biographies by Jane Apostol

Franz A. Bischoff 1
1864-1929

Born in Austria in the little town of Bomen, Franz Bischoff came to the United States in 1885 and founded the Bischoff School of Ceramic Art in New York. He was recognized as one of the greatest china painters in the country. In 1906 he came to Southern California for a visit and stayed on, building a studio in South Pasadena near the Cawston Ostrich Farm. He rapidly developed an interest in landscape and began making oil paintings of such California scenes as the poppyfields of the Arroyo Seco. His own garden was the inspiration for many of his flower paintings.

Edward Borein 2
1873-1945

Ed Borein, whose work documents the changing West, was born in ranching country, in San Leandro, California. He went to school in Oakland with Jack London and in his teens began working as a cowboy. He drifted from ranch to ranch in the West and Southwest and through Mexico to Guatemala, a vaquero who painted and sketched the life around him. He sold his first picture in 1896 to *Land of Sunshine*, the magazine edited by Charles Lummis.

The two men later became close friends, and Borein and his wife were married in Lummis' home on the Arroyo Seco in Los Angeles. By 1902 Borein had a studio in Oakland, and he had become a successful illustrator of Western themes. In 1907 he went to New York to study etching at the Art Students' League. His only other formal art training was a month's drawing instruction in San Francisco. In 1921 Borein settled in Santa Barbara and built a Hopi-style house near his friend Carl Oscar Borg. For a time Borein taught at the Santa Barbara School of the Arts. It was largely at Borein's suggestion that the Rancheros Visitadores were formed.

Dimensions in inches, height precedes width.

3 *The Range Rider*
tempera, 9¾ x 13½

Dr. Irwin Schoen

Untitled, Tiburcio Vasquez 4
oil on canvas, 28 x 36

Carl S. Dentzel

Carl Oscar Borg 3
1879-1947

Born in Grinstad, Sweden, Carl Oscar Borg was apprenticed at fifteen to a painting contractor. At twenty, he traveled to England and was hired to paint portraits and seascapes and also to paint stage scenery. In 1901 he sailed for the United States, earning his passage by painting pictures for the captain's cabin. In 1904 Borg arrived in Los Angeles and found work as a decorator and scene painter. Idah Meacham Strobridge was one of the first to exhibit his paintings. Borg spent most of 1907 and 1908 in Santa Barbara, often camping and sketching on the Channel Islands. The artifacts he found there stimulated his interest in the American Indian and archaeology. Mrs. Phoebe Apperson Hearst saw a sketch by Borg, was impressed by it, and arranged for him to study and exhibit in Europe. On his return in 1914, he was commissioned by Mrs. Hearst to paint the Indians of the Southwest and to make photographs and motion pictures for the University of California at Berkeley. Borg made many friends among the Hopis and was initiated into their ceremonies. From 1918 to 1924 he lived in Santa Barbara, moving there again in 1935. He spent the interval in Los Angeles, where he opened his own art school and worked as art director for the silent movies. Borg considered the Grand Canyon his country, and at his death his ashes were scattered there.

John Gutzon de la Mothe Borglum 4
1867-1941

Gutzon Borglum, sculptor of the presidential portraits on Mt. Rushmore, began his art career in Los Angeles. Born in a log cabin near Bear Lake, Idaho, he grew up in the Midwest and at seventeen came to Los Angeles. He opened a studio two years later and began painting California scenes and giving art lessons. In the late 1880s he studied with William Keith and Virgil Williams at the School of Design in San Francisco. John C. Frémont and his wife Jessie were among Borglum's early patrons. After returning to Los Angeles, Borglum painted Gen. Frémont's portrait. He also did some paintings for Lucky Baldwin, and had an illustration published in the first issue of *Pacific Monthly*. In 1890 Borglum went to Paris, winning membership in the National Society of Beaux Arts with one of his Western sculptures. On his return to California in 1893 Borglum bought a house in Sierra Madre. He made a portrait bust of Mrs. Frémont and one of "Father Throop." He wrote on California art for Lummis' *Land of Sunshine* and designed a new cover for the magazine. After a second visit to Europe, Borglum set up a studio in New York and turned more and more to sculpture. He began talking of the need for a colossal art to match America's greatness. In 1924 his first mountain carving was unveiled: a gigantic head of Robert E. Lee on Stone Mountain, Georgia. In 1927 Borglum began carving the massive granite heads on Mt. Rushmore National Memorial and worked on them until his death.

Maurice Braun 5

1877-1941

Maurice Braun was brought to New York at the age of three from his birthplace in Nagy Bittse, near Budapest. He studied five years at the National Academy of Design in New York and won every prize offered by the school. He also spent a year studying with William Merritt Chase. After an interval of traveling and painting in Europe, Braun came to California in 1910 and built a studio at Point Loma, near San Diego. Braun was active in the beginnings of the San Diego Fine Arts Society and the Art Guild, and he became Director of the San Diego Academy of Art. Braun painted on the East Coast as well as in California, and in the twenties he maintained a studio at Old Lyme, Connecticut.

6 *The Forest Screen*
oil on canvas, 20 x 16

Poulsen Galleries

5 *Springtime*
oil on canvas, 34 x 36

Dr. Irwin Schoen

Benjamin Chambers Brown 6

1865-1942

Benjamin Brown was born in Marion, Arkansas, and studied at the St. Louis School of Fine Art and the Julian Academy in Paris. He and his family first came to California in 1886 and returned ten years later, drawn to Pasadena by its climate and by the reputation of Throop Polytechnic Institute. Brown opened one of the first art schools in Pasadena, and for years he held Sunday salons in his studio on North El Molino Avenue. He had his first exhibition of landscape paintings at the Hotel Green, then Pasadena's social center. With his brother Howell he founded the Print Makers Society of California, which held annual international exhibitions. Acclaimed here and abroad for his California landscapes, Brown first won fame with his paintings of Altadena poppyfields.

7 *California Oaks*
oil on canvas, 16 x 19

Atchison, Topeka, and Sante Fe Railway

Charles Mathew Crocker 7

1877-1950/51

Charles M. Crocker was born in a log cabin near Chicago and spent his early years in Decatur, Illinois, and St. Louis, Missouri. He had only a third grade education and did almost no reading until he was twenty-one. He began drawing at nineteen and took lessons with Jean Mannheim in Decatur. Crocker continued his studies at the Art Institute of Chicago. He came to California around 1910 and worked as a reporter on the Berkeley *Gazette*. A poet himself, he was a friend of Jack London, John Burroughs, and other writers. In about 1919 Crocker moved to Southern California, and his studio became a meeting place for artists and authors. Crocker was interested in philosophy and in the idea of light and color as a result of molecular motion. He moved to Chicago in 1938 and continued to paint there until his death.

Edwin Deakin 8

1838-1923

Edwin Deakin, who painted the California missions for 30 years, was born in Sheffield, England. As a young man he was apprenticed to a decorative artist in Wolverhampton. Deakin came to Chicago in 1856 "with half a trunkful of sketches." He earned his living tinting photographs and studied art in his spare time. In 1870 he moved to San Francisco and two years later exhibited with the new San Francisco Art Association. One of his first California subjects was Mission Dolores, and over the years he continued to paint the California missions. Between 1870 and 1899 he traveled by horse and buggy to the sites of all 21 Franciscan missions and painted three views of each. For the three missions which had been destroyed he referred to an old painting, a photograph, and a daguerrotype. From 1877 to 1880 Deakin traveled and sketched in Europe. Two of his European landscapes were exhibited in the Paris Salon of 1879. Deakin did many picturesque landscapes of Yosemite, Mt. Shasta, and the Sierra. He also did a series of paintings inspired by San Francisco's Chinatown and another series inspired by the San Francisco earthquake and fire. Deakin moved to Berkeley in 1890 and built himself a mission-style studio. His sketches of that community are among the earliest known. Later a street in Berkeley was named in his honor.

8 Untitled, Sierra camp, 1876
oil on canvas, 29 x 23

Carl S. Dentzel

9
Untitled
watercolor, 17 x 21

Dr. Irwin Schoen

Paul de Longpré 9

1855-1911

Paul de Longpré was the first artist in the United States to have an exhibition composed exclusively of flower paintings. He began drawing flowers as a child in his native France and at twelve was earning a living painting them on fans. The Paris Salon of 1876 hung a floral painting by de Longpré in its Salon of Honor. De Longpré came to New York in 1890 and six years later held an exhibit of flower paintings. Around 1899 he moved to Hollywood and built a large home, a Mission-Moorish extravaganza whose design was popularly attributed to de Longpré himself. The three-acre garden with its 4000 rose bushes became a popular tourist attraction. First a tallyho, then two or three **Pacific Electric red cars a day** ran to his studio. Reproductions of de Longpré's flower prints were given away with Sunday supplements, and also decorated the covers of sheet music which he wrote. Among his compositions were *Salute to Beautiful California* and *Souvenir de Los Angeles*. A street in Hollywood was named in de Longpré's honor.

11 *From the Canyon Rim*
etching, 22½ x 18½

Mrs. Annette T. Handy

Lafayette Maynard Dixon 10
1875-1946

By the time he was seven, Maynard Dixon was
sketching the ranch life around him in the frontier
town of Fresno, California, where he was born. He
continued with his drawing and at sixteen sent two
of his sketchbooks to Frederic Remington, who wrote
back with advice and encouragement. In 1893 Dixon
enrolled at the School of Design in San Francisco
but left after three months. That same year his first
illustration appeared in *Overland Monthly,* and soon
he had a job as staff artist for the San Francisco *Call.*
The first review of his work was written by Charles
Lummis, whom he came to regard as his foster
father. Dixon loved the outdoors and made frequent
sketching trips throughout the West. In 1900 he
went for the first time to Arizona, whose powerful
landscape had a lasting influence on his work. Dixon
lived all his life in the West except for the years 1907
to 1912 when he worked in New York, illustrating
magazines and Western novels. After his return to
California, Dixon painted murals for Anita Baldwin's
mansion in Rancho Santa Anita. He painted many
other murals, including those in the State Library at
Sacramento, the postoffices in Martinez and Canoga
Park, and the Bureau of Indian Affairs in Washington.
His last commission was a mural for the Sante Fe
city ticket office in Los Angeles. The largest
collection of Maynard Dixon paintings is at Brigham
Young University in Provo, Utah.

10 Poster, cover for *Sunset,* 1906
23 X 13

T. S. McNeill

Harold L. Doolittle 11
1883-1974

Harold Doolittle, who mastered most of the graphic
arts, was a descendant of Amos Doolittle, an engraver
with Paul Revere. Born in Pasadena, Harold Doolittle
studied at Throop Polytechnic Institute and
graduated in civil engineering from Cornell. With
this training he became chief design engineer for
the Southern California Edison Company.
Doolittle was largely self-taught as an artist. He was
known primarily for his aquatints but worked with
all the graphic processes, including collotype,
photography, and photogravure. He made his own
etching press and printing press, a mezzotint rocker,
and a mold and deckle for handmade paper. To make
his paper he used linen pulp from old napkins.
Doolittle built furniture, designed and made
monograms, and did bookbinding. He built his own
cello and taught himself to play. Doolittle was a
vice-president of the Printmakers of California, three
times president of the Pasadena Society of Artists,
and an honorary member of **Zamorano** Club.

John Bond Francisco 12
1863-1930

J. Bond Francisco was a landscape and figure
painter and the first concertmaster of the Los Angeles
Symphony Orchestra, which he helped form in
1897. Born in Cincinnati, Ohio, he studied violin in
Columbus and studied painting and violin in Paris,
Munich, and Berlin. He came to Los Angeles in the
early 1890s and built a house at Albany and 14th
Streets in an area then devoted to truck farming. The
house had an enormous redwood studio in which
Francisco entertained such celebrities as Victor
Herbert, Sarah Bernhardt, and Lillian Russell. He
also entertained young artists like Gutzon Borglum,
then a little-known painter in Los Angeles. Francisco
held his first Los Angeles exhibition in 1892. He often
went on sketching trips with Elmer Wachtel, and
for a time the two artists shared a houseboat at
Terminal Island. Francisco painted many desert and
mountain scenes. One of his favorite landscapes was
the Rim of the World area in the San Bernardino
mountains.

12
Rider at the Gate
oil on canvas,
18¼ x 24¼

Poulsen Galleries

14 *Poppies and Bush Lupines—Monterey County*
oil on canvas, 20½ x 30½

Dr. Irwin Schoen

John Marshall Gamble 14
1863-1957

John Marshall Gamble was born in Morristown, New Jersey. He studied at the School of Design in San Francisco and at the Julian Academy in Paris. For many years he lived in Santa Barbara. At one time he was president of an art school there, and he served for twenty-five years as color consultant for Santa Barbara's Architectural Board of Review. Gamble is known especially for his paintings of the mountains, hills, and wildflowers of California. He often sketched in the San Joaquin and Antelope Valleys. His favorite season for painting was just after the winter rains when the lupines and poppies were in bloom.

13

Hillside, 1912
oil on canvas, 28 x 34

Dr. and Mrs. Roland Fisher

Sam Hyde Harris 13
b. 1889

Sam Hyde Harris was born in Brentford, England, on the river Thames, and he has lived in California for over 70 years. Harris settled in Los Angeles and studied at the Art Students' League and the Cannon Art School. He also studied with Hanson Puthuff, Tolles Chamberlain, and Stanton MacDonald-Wright. Harris has won recognition for his paintings of desert and mountain scenes and for his advertising posters. In one of his posters he introduced the windmill which became the symbol of Van de Kamp's Bakery. His railroad posters advertising the Santa Fe and Southern Pacific summer trips to Chicago and the East are now collector's items. Harris taught at the Chouinard School of Art and has given numerous outdoor landscape classes. He has been active in many Southern California art groups. He served as director of the California Art Club, the Laguna Beach Art Guild, and the Whittier Art Association and as president of the San Gabriel Artists Guild. For many years Harris has owned Jack Wilkinson Smith's old studio in Alhambra, where he continues to paint.

Thomas Hill 15

1829-1908

Thomas Hill, the first artist to open a studio in Yosemite, was born in Birmingham, England. He came to Taunton, Massachusetts, with his family in 1841 and in 1844 moved to Boston where he was apprenticed to a coach painter. Hill moved to Philadelphia in 1853 and attended classes at the Pennsylvania Academy of Fine Arts. On 1861 he came West for his health and opened a studio in San Francisco. He painted some landscapes but specialized in portraiture. From 1866 to 1867 Hill studied in Paris and then returned to New England. He came to California again around 1872, settling first in San Francisco, then in Oakland. He was one of the earliest officers of the San Francisco Art Association and helped plan its School of Design. His painting *The Last Spike*, which commemorates the finish of the transcontinental railroad, now hangs in the California State Capitol. Hill painted at Yosemite for more than 40 years. It has been estimated that he did over 5000 oil paintings of the Park. An engraving made from one of his panoramic views of Yosemite was used as a frontispiece for the book, *Scenes of Wonder and Curiosity in California*.

15 *Yosemite*, 1894
oil on canvas, 65 x 48

Los Angeles Athletic Club

16 Untitled, landscape with eucalyptus trees, 1921
watercolor, 19½ x 27½

Collection of the Oakland Museum
Bequest of Ida D. Graham

Henry Percy Gray 16

1869-1952

Percy Gray came from an English family in which there had been twelve artists. Gray was born in San Francisco and began sketching as a young boy. At seventeen he entered the California School of Design and studied with Emil Carlsen. Later he studied at the Art Students' League in New York with William Merritt Chase. Gray worked as a newspaper illustrator on the San Francisco *Call* and the New York *Journal* and in 1898 headed the *Journal*'s art department. He returned from New York in 1906 and covered the San Francisco earthquake and fire. He settled in California, for a time in the Portola Valley, and began painting landscapes of the hills and coastal areas. He worked chiefly in watercolor. In 1923 Gray moved to Monterey. He saved an historic 1835 adobe from destruction and rebuilt it in a new location for his home. In 1938 Gray moved back to the San Francisco Bay area and painted the landscape around Marin and Sonoma counties.

Armin Hansen 17

1886-1957

Armin Hansen was born in San Francisco. He studied art with his father, a noted painter of Indian and frontier life, and also studied under Arthur Mathews at the Mark Hopkins Institute of Art. In 1906 Hansen entered the Royal Academy at Stuttgart. He returned to San Francisco in 1912 after working four years as a crew member on a Belgian ship. He held his first exhibition in San Francisco shortly after his return and taught briefly at the University of California, Berkeley. In 1913 he moved to Monterey where he painted and taught. There he helped organize the Carmel Art Association and served as its first president. Hansen was known for his paintings of fishermen and the sea. He often painted the San Francisco and Monterey harbors and the Oakland Estuary.

17 *Fishing Boat*
oil on board, 9½ x 13⅝

Bowers Museum

18 *Ka–Mo–Ki–Yu*, 1904
oil on canvas, 26 x 27½

Los Angeles Athletic Club

Grace Carpenter Hudson 18

1865-1937

Grace Carpenter was born in Potter Valley, California, near Ukiah. After studying at the California School of Design, she taught painting in Ukiah and did illustrations for *Sunset* and other periodicals. In 1890 she married Dr. John Hudson, who was interested in ethnology and gave up a medical career to study the art and language of the Pomo Indians. Grace Hudson exhibited in the Women's Department of the California State Building at the 1893 Columbian Exposition. In 1901 she visited Hawaii and did paintings of the children there, and in 1904 she was sent by the Field Museum of Chicago to paint the Pawnees in Oklahoma. After a trip to Europe in 1905 she and her husband settled in Ukiah. Their house had a totem pole out front. Grace Carpenter Hudson had been acquainted with California Indians from her earliest years. Many of her paintings are of the Pomo Indians in Mendocino County. Her interest in Indian subjects attracted the attention of George Wharton James, who commissioned her to illustrate his book on basketry.

Anna A. Hills 19

1882-1930

Anna Hills was born in Ravenna, Ohio. She studied at the Art Institute of Chicago, at Cooper Union in New York, and with Arthur Wesley Dow. After painting for several years in Europe, she came to California in 1912 and made her home in Laguna Beach. She was an adventurous woman who traveled and painted in remote areas of the West. A dynamic member of the Laguna Beach art community, she served as president of the Laguna Beach Art Association and helped establish the Laguna Beach Art Gallery. She lectured frequently and organized exhibits for schools and hospitals. The local garden club planted an avenue of eucalyptus trees in memory of Anna Hills, who loved painting trees and fought to preserve the natural beauty of Laguna.

19 *Golden Hillsides*, 1920
oil on masonite, 20 x 24

Laguna Beach Museum of Art

20 *The Pinnacles, Yosemite Valley*, 1901
watercolor, 26½ x 15¼

Collection of the Oakland Museum
Gift of Mr. & Mrs. Kenneth Kojima

21 *San Juan Capistrano*
oil on canvas, 13 x 18

Atchison, Topeka, and Santa Fe Railway

Christian Jorgensen 20
1860-1935

Chris Jorgensen came to San Francisco from his
native Oslo at the age of ten and at fourteen enrolled
in the newly opened San Francisco Art Association's
School of Design. He studied under Virgil Williams
and worked at odd jobs in exchange for lessons.
Jorgensen later taught at the school and from 1881
to 1883 was its assistant director. One of the first
things Jorgensen had sketched in California was a
Franciscan mission. Eventually he painted every
mission in California, traveling by horse and buggy
from San Diego to Sonoma. He painted several
canvases for the Ghirardelli Chocolate Factory, which
was owned by his wife's family. In 1899 Jorgensen
designed and built a house close to Yosemite Falls.
He spent nineteen years in Yosemite, painting scenes
of the Valley. Jorgensen was one of the pioneers of
the Carmel art colony. He built a boulder house in
Carmel in 1905 and also a log bungalow at Pebble
Beach. Later he built in the Piedmont Hills and also in
San Francisco. In addition to his Yosemite landscapes,
Jorgensen painted scenes of the Grand Canyon
(where he had spent a winter), the Sierras, and the
Pacific Coast from Oregon to Mexico. Many of his
paintings of Yosemite were bequeathed to the
United States Government for exhibit at the
Yosemite Museum.

William Lees Judson 21
1842-1928

William Lees Judson was born in Manchester,
England, and came to Brooklyn with his family in
1852. He studied art with his father and at the age of
ten was painting frescoes. After succeeding as a
portrait painter and teacher in Ontario, Canada,
Judson continued with his art studies in New York,
London, and Paris. He was drawn to Chicago by
prospects of the Columbian Exposition, but work and
study shattered his health. He came to California
in 1893 to recover. Stirred by California's landscape
and history, Judson turned from portraiture and
began painting scenes of the old mission days. He
loved the Arroyo Seco and painted it in all its seasons.
Judson taught art at the University of Southern
California, organized its College of Fine Arts, and
became its first dean. In 1901 a new Fine Arts building,
studio, and gallery were built next to his home on
the Arroyo at Garvanza, which is now Highland
Park. The college remained there about twenty
years, and members of the Arroyo Guild
built their studio-homes nearby.

Fernand Harvey Lungren 22
1857-1932

Fernand Lungren grew up in Toledo, Ohio. (His birthplace is given as either Toledo or Hagerstown, Maryland.) He began drawing as a child, illustrating scenes from dime novels. At 19 he left college to study with Thomas Eakins at the Pennsylvania Academy of Fine Arts. Lungren sold his first illustration in 1879 to *Scribner's Monthly*. After several years as an illustrator, he went to Europe to study but was soon disillusioned by the attitudes of the Academy and Salon. In 1892 he opened a studio in Cincinnati for commercial design. A turning point in his career came when he accepted a job with the Santa Fe Railroad to make drawings of the Southwest. He traveled widely in Arizona and New Mexico and was adopted by a Hopi clan. From his knowledge of the Hopis he wrote and illustrated a children's story and an article on mesa life. In 1903 he came to Los Angeles, settling near Charles Lummis. In 1906 Lungren moved to Santa Barbara and built an adobe in Mission Canyon. He was a founder of the Santa Barbara School of the Arts and taught landscape painting there. Lungren was fascinated by Death Valley and painted it many times, wanting to show its beauty in every mood and season.

22 *Sunrise Sierra*
 oil on canvas, 32 x 60

 The Art Galleries, University of California, Santa Barbara
 Fernand Lungren estate

William Keith 23
1838-1911

William Keith may have known more of California's landscape than any other artist. He explored a great deal of the state, often in the company of his friend, John Muir. Born in Scotland, Keith came to New York in 1851 and at the age of eighteen was apprenticed to a wood engraver. After his apprenticeship he worked for Harper & Brothers, and in 1858 he spent two months in California making illustrations for *Harper's Weekly*. He soon settled in San Francisco and from 1865 to 1868 had his own engraving firm. Meanwhile he had begun to paint, encouraged by his wife who was an artist and a teacher. His first commission was painting scenic views of the Northwest for the Oregon Navigation and Railroad Company. Keith spent most of 1870 in Düsseldorf, the center for Germany's new school of realistic landscape painting. He was in Boston during 1871 and returned to California in 1872. For the next ten years Keith painted the high mountain country of the West. In 1885 he built a home in Berkeley, whose wooded landscape inspired many of his later, more subjective paintings. Keith lost approximately 2000 of his works in the San Francisco earthquake and fire. Undaunted, he recreated from memory many of his pastoral landscapes.

23 *Springtime Showers in Berkeley*
 oil on canvas, 24 x 30

 Dr. Irwin Schoen

Jean Mannheim 24
1861-1945

Jean Mannheim was born in Kreuznach, Germany. He learned drawing from his father and worked as a bookbinder before beginning his formal art training in Paris and London. He came to the United States in 1881 and returned periodically to Europe for further study. He taught for two years at the Brangwyn School in London. Following a successful career as teacher and portrait painter in Decatur, Illinois, and Denver, Colorado, Mannheim came to Pasadena in 1908. He and his wife designed one of the first houses built on the Arroyo and moved there in 1909. In 1913 he founded the Stickney Memorial School of Fine Arts. Mannheim was acclaimed for his bold expressive style and his handling of color. He painted many aspects of the California landscape and was one of the few Western artists who never completely abandoned figure painting.

The Road
oil on canvas, 30 x 36

Collection of the Oakland Museum
Lent by the M. H. De Young Museum
Gift of the Skae Fund Legacy

Xavier Martinez 25
1869-1943

Martinez was born in Guadalajara, Mexico, as Javier Timoteo Martinez y Orozco. He was proud of his Indian heritage, and for the name Timoteo he later substituted Tizoc. He began painting with watercolor when he was ten, and he learned the techniques of fresco painting from a relative who was a decorative artist. In 1893 Martinez enrolled at the California School of Design in San Francisco, and in 1895 went to Paris to study at the École des Beaux Arts and the Academy of Carrière. He returned to San Francisco in 1901, and his studio became a lively center for the city's Bohemian life. In 1902 Martinez helped found the insurgent California Society of Artists. After the San Francisco earthquake and fire, he moved across the Bay to the Piedmont Hills. He painted many landscapes of the area. He also painted in Guadalajara with Maynard Dixon and in Monterey with Charles Rollo Peters. In 1913 he spent two months on a Hopi reservation. Arthur B. Davies commissioned Martinez to do a series of portraits of Westerners. Among his subjects were Jack London, Gelett Burgess, and Francis McComas. From 1908 until 1942 Martinez was on the faculty of the California College of Arts and Crafts. When he died, the California State Legislature adjourned in his honor.

24
Wind on the Heath
oil on canvas, 28 x 36

Jeanne Mannheim Reitzell and Eunice Mannheim Edwards

27 *Monterey Oaks*
oil on canvas, 23 x 26
Frame by The Furniture Shop
Collection of the Oakland Museum

26 *Seated Girl on Sand Dunes*, 1897
pastel on sandpaper, 11¼ x 11⅜
Frame by The Furniture Shop

Collection of the Oakland Museum
Gift of Mr. Harold Wagner

Lucia Kleinhans Mathews 26

1870-1955

Lucia Kleinhans was born in San Francisco. She
attended Mills College for a year, then enrolled in the
Mark Hopkins Institute of Art. She studied with
Arthur F. Mathews, whom she married in 1894, and
also studied one summer in Whistler's Académie
Carmen In Paris. Lucia Mathews was active in the
Sketch Club, which she helped reestablish in San
Francisco after the earthquake and fire of 1906.
Beginning in 1910 she and her husband made yearly
trips to the Monterey Peninsula. One of her
Monterey landscapes won a medal in the Panama-
Pacific International Exposition. Lucia and Arthur
Mathews worked together on *Philopolis* Magazine and
the Philopolis Press, with Lucia designing many
vignettes, decorative borders and initials. The
couple also collaborated on projects of the
Furniture Shop, which for almost 20 years produced
custom-designed furniture, accessories, and
decorative objects. Lucia supervised the color
selections and decorative carving, also carving and
painting many of the objects herself, such as relief
panels, picture frames, and boxes. Her floral motifs
emphasized native plants, especially the California
poppy. An enthusiastic gardener, she advised on the
placement of *Portals of the Past* in Golden Gate Park.

Arthur Frank Mathews 27

1860-1945

Born in Markesan, Wisconsin, Arthur F. Mathews
grew up in Oakland where his family settled in 1867.
He worked in the Bay area as architectural draftsman,
designer and illustrator, then studied and exhibited
in Paris. Soon after his return to San Francisco in
1889 he became chief assistant to the director of the
California School of Design. From 1890 until 1906
he was director of the school and an influential
teacher. The California landscape was an important
element of Mathews' painting, and he was one of the
few California artists of his generation to paint
figure groups successfully. An outstanding muralist, he
was awarded a gold medal by the American
Institute of Architects for distinguished achievement
in this endeavor. Twelve of his California history
mural panels adorn the state capitol rotunda in
Sacramento. In 1906 Arthur and Lucia Mathews
helped start the monthly magazine, *Philopolis*, "to
consider ethical and artistic aspects of the rebuilding
of San Francisco." An allied venture, the Philopolis
Press, specialized in handsome limited editions for
which the Mathews designed layouts and decoration.
Also in 1906, Arthur Mathews and a friend opened
The Furniture Shop, which produced furnishings and
decorative objects, all especially designed to
harmonize in every detail. Arthur F. Mathews was a
master of the California Decorative Style. As painter,
teacher, writer, and designer he influenced the taste
of turn-of-the-century San Francisco.

29 *The Mountain*, 1908
watercolor, 21 x 27¾

Los Angeles County Museum of Art
Bequest of Dr. Dorothea Moore

28 *Landscape with Eucalyptus Trees*
oil on canvas, 15⅝ x 19¾

Collection of the Oakland Museum
Gift of Mr. & Mrs. Helmut Hungerland

30 Untitled, desert borax mine
oil on canvas, 20¾ x 29½

Carl S. Dentzel

Eugen Neuhaus 28
1879-1963

Eugen Neuhaus achieved recognition as landscape
artist, author, and teacher. Born in Wuppertal,
Germany, he studied at the Royal Art School
in Kassel and the Royal Institute for Applied Arts
in Berlin. He also studied in France and Holland.
Neuhaus came to California in 1904 and settled in the
San Francisco area. In 1908 he joined the faculty
of the University of California at Berkeley as a
teacher of graphics and decorative art. He became
the first head of Berkeley's art department in 1923,
and he continued teaching at the university until
1949. He also taught at Mills College in Oakland from
1918 to 1928. Neuhaus painted in a version of the
California Decorative style. He wrote numerous
books, including a study of the history and ideals of
American art and a biography of William Keith.

Francis John McComas 29
1874-1938

Born in Fingal, Tasmania, Francis McComas moved
to Australia about 1890. He studied at Sydney
Technical College, worked as an illuminator in
Sydney, and then took a job as seaman. He arrived in
San Francisco in 1898. McComas studied briefly
with Arthur Mathews in 1899 and that same year
entered the Julian Academy in Paris. He returned to
San Francisco in 1901 but made frequent trips
to Europe, where he painted and exhibited. In 1909
he went to Arizona for his health and began painting
the desert landscape. McComas had three paintings in
the Armory Show. He moved to Carmel in 1912
and became famous for his paintings of the cypress
groves around Carmel and Monterey. His ashes are
buried in Monterey under a boulder at Cypress Point.

Thomas Moran 30
1837-1926

Born in Bolton, Lancashire, England, Thomas Moran
came to the United States in 1844 and grew up in
Philadelphia. At sixteen he was apprenticed to a firm
of wood engravers, but left in 1856 and turned to
painting. In 1861 he went to England to study
Turner's work. Soon after his return to Philadelphia
he began illustrating books and magazines. In 1871
he illustrated an article on the Yellowstone wilderness
area using his own imagination to create some rough
sketches. Later that year he joined F. V. Hayden's
survey expedition so he could actually see Yellowstone
and prepare more drawings. His vivid sketches
helped convince Congress to declare Yellowstone
our first national park. Congress bought Moran's
panoramic oil painting, *The Grand Canyon of the
Yellowstone*, and a second panorama, *The Chasm of
the Colorado*, which he painted after traveling through
the Grand Canyon with Major John Wesley Powell
in 1873. Thereafter, Moran made frequent trips West
and returned to the Grand Canyon in 1892 at the
invitation of the Santa Fe Railroad. He visited the
Grand Canyon many times, often continuing on to
California, which he had first visited in 1872.
In 1916, Moran spent the winter in Pasadena and
exhibited at the Green Hotel. The next year he
wintered in Santa Barbara, and from 1922 until his
death he lived there year round. Moran has been
called "the father of the national parks." Mount
Moran in the Tetons and Moran Point in Yosemite
are named for him.

33 *Nocturnal*, home of Joaquin Murrieta
oil on canvas, 14½ x 18½

Dr. Irwin Schoen

Edgar Alwin Payne 31
1882-1947

Edgar Payne was born in Washburn, Missouri. He
left home at the age of fourteen and found work
painting houses, signs, and stage sets. He later painted
murals for many Midwestern theaters and
courthouses. Payne was largely self-taught but
studied a short time at the Art Institute of Chicago.
He made his first sketching trip to California in 1911
and spent several months in Laguna Beach painting
with Hanson Puthuff and Norman St. Clair. He
later settled in Laguna, organized the Laguna
Beach Art Association, and became its first president.
Payne wrote a book on the composition of outdoor
painting. He frequently visited the High Sierras,
and a lake there was named for him.

32 Untitled, San Francisco Chinatown
oil on canvas, 21½ x 15¼

Carl S. Dentzel

Jules Francois Pages, Jr. 32
1867-1946

Jules Pages was born in San Francisco, the son of
a French artist who had come to California during the
gold rush days and opened an advertising and
engraving business. Pages worked as an apprentice
in his father's business and also as a newspaper artist.
He studied in Paris under Constant, Lefebvre, and
Robert-Fleury. After returning to California in the
1880s, he headed the art department of a San Francisco
newspaper for several years. In 1902 Pages began
teaching at the Julian Academy in Paris. He
occasionally visited the United States and in 1915
served on the art commission of the Panama-Pacific
International Exposition in San Francisco. Pages lived
in France until 1941 and then moved back to
California.

Charles Rollo Peters 33
1862-1928

Charles Rollo Peters won fame with his paintings
of moonlit landscapes, especially those of old
Monterey. Peters was born in San Francisco. He
showed an early aptitude for sketching and after a
brief interlude in business began studying with Jules
Tavernier. He later studied with Virgil Williams
at the California School of Design and in 1887 entered
the École des Beaux Arts in Paris. Peters remained
in Europe until 1890 and exhibited in Munich and at
the Paris Salon. Upon his return to San Francisco
he opened a studio on Sacramento Street in the
Bohemian quarter of the city. His nocturnes were a
success in this country and abroad. In 1900 Peters
moved to a 30-acre estate in Monterey. There
he entertained lavishly, often at moonlight parties.

31 Untitled
watercolor, 17½ x 21½

Dr. Irwin Schoen

34
Silence
oil on panel, 26⅛ x 32¼

Collection of the Oakland Museum
Lent by the M. H. DeYoung Museum
Gift of the Skae Fund Legacy

Gottardo Piazzoni 34
1872-1945

At the age of fifteen Gottardo Piazzoni came to California from his birthplace of Intragna, Switzerland. He joined his father who had come to California earlier and started a dairy business on an old Spanish land grant in Carmel Valley. In 1891 Piazzoni entered the California School of Design in San Francisco and studied under Arthur Mathews and Raymond Yelland. Piazzoni went to Paris in 1895 and studied at the Julian Academy and the École des Beaux Arts. He returned to California in 1898 and three years later opened the Piazzoni Atelier d'Art in San Francisco. He shared a studio with Arthur Putnam and later traveled with Putnam in Europe. Piazzoni was active in the First Secessional Art Exhibition of 1902 which led to the formation of the San Francisco Society of Artists. He also helped organize the California Society of Etchers. From 1919 to 1935 he taught at the California School of Fine Arts. In addition to landscape painting, Piazzoni did many murals. The best-known are those along the staircase of the main library in San Francisco.

Hanson Duvall Puthuff 35
1875-1972

Hanson Puthuff was born in Waverly, Missouri, and was an honor student at the University Art School in Denver. He worked briefly as a mural painter in Illinois, designed posters in Denver, then moved to Los Angeles in 1903. There he painted landscapes, designed billboard posters, and for a while painted stage scenery. He had his first major landscape exhibit in 1905. Puthuff helped organize the Art Students' League of Los Angeles in his Highland Park studio. The California Art Club was also formed in his studio. In 1913 Puthuff painted murals of the California landscape for the Irving Gill-designed Laughlin Theatre in Long Beach. He also painted backgrounds for habitat groups in the Natural History Museums of Los Angeles and New York. Hanson Puthuff completed work on his autobiography at the age of ninety-three.

35 *Languorous Summer*
oil on canvas, 30 x 40

Dr. and Mrs. Roland Fisher

Guy Rose 36
1867-1925

Guy Rose was born in San Gabriel, California. His father developed the old Sunnyslope Ranch, which became famous for its wine and oranges. From Los Angeles High School and the San Francisco Art Academy, Rose went to Paris in 1888 to study at the Julian Academy. He was probably the first Californian to be recognized by the Salon, winning an honorable mention in 1894. In 1895 he taught at the Pratt Institute in New York and did magazine covers and illustrations. Soon after, while traveling in Greece, he contracted lead poisoning from his paints, severely affecting his hands and eyes. He suffered at certain times thereafter from results of the poisoning. In 1899 Rose settled in France, living there until 1912 when he returned to the United States. He came to Pasadena in 1914. Rose served for several years as director and instructor at the Stickney Memorial School. He also served on the board of governors for the Los Angeles County Museum.

36 *Lifting Fog*
oil on canvas, 23½ x 28½

Dr. Irwin Schoen

37 Untitled
oil on canvas, 20 x 35

Dr. Irwin Schoen

James Guilford Swinnerton 37
1875-1974

James G. Swinnerton was the initiator of a school of desert painting and was one of the first comic strip artists. He was born in Eureka, California, and at fourteen ran away to San Francisco. After being an apprentice harness-racing driver for the Lucky Baldwin stables, he entered the California School of Design. At seventeen he was hired by the San Francisco *Examiner* and began drawing weather cartoons which featured a little California grizzly. The bear and its daily antics evolved into one of the early comic strips, *The Little Bears and Tigers*. Swinnerton's *Little Jimmy*, which ran for nearly forty years, began in 1905 in the Hearst papers' first color supplement. While working in New York, Swinnerton was stricken with tuberculosis and given a month to live. He returned to California in the early 1900s, settled in Palm Springs, and lived near there for over 60 years. After his return, Swinnerton began exploring the Southwest and painting desert landscapes. A visit to the Hopi pueblos inspired the comic strip *Canyon Kiddies*, which gently preached the value of the desert and the Indian's relationship with nature. The Hopis also inspired Swinnerton's book for children, *Hosteen Crotchetty, or How a Good Heart Was Born*. Swinnerton made frequent trips to the Navajo country, and Swinnerton Arch in Monument Valley is named for him.

38 Untitled, old adobe
oil on canvas, 32¾ x 49¾
California Historical Society

Jack Wilkenson Smith 38

1873-1948

Born in Paterson, New Jersey, Smith studied at the
Art Institute of Chicago and the Cincinnati Art
Academy. He held his first exhibition in Lexington,
Kentucky, where he worked as a commercial artist.
Smith's paintings won him a job as artist for the
Cincinnati *Enquirer,* and his front-line sketches of the
Spanish-American War brought him national
attention. Smith came to Los Angeles around 1906. He
helped found the Sketch Club and was active in the
California Art Club. He was largely responsible for the
founding of the Biltmore Salon, which was established
to exhibit and sell the work of local artists.

39 Untitled
oil on canvas, 24 x 36
Dr. Irwin Schoen

Will Sparks 39

1862-1937

Will Sparks was born and educated in St. Louis,
Missouri. He attended Washington University, the
St. Louis School of Fine Arts, and St. Louis Medical
College, where he majored in anatomy. He also
studied at the Julian and Colorossi Academies in
Paris and worked as medical illustrator for Louis
Pasteur. When he returned to the United States,
Sparks became an artist for the Cincinnati *Enquirer.*
After hearing stories of the West from Mark Twain,
he headed for California and arrived about 1888.
He worked for newspapers in Fresno and Stockton
and in 1891 settled in San Francisco. Sparks was an
editor and feature writer for the San Francisco
Evening Call, and for about four years he taught
anatomical drawing at the University of California,
Berkeley. Between 1887 and 1919 Sparks made thirty-
six paintings of missions in California and the Southwest.
He relied on old Spanish sketches for his paintings
of missions that were no longer standing. In 1933
Sparks began a second series of mission paintings. He
also painted a series inspired by old California mining
towns. Sparks claimed to have painted at least
3000 pictures.

40 Untitled
oil on canvas, 28 x 44
Armand du Vannes Art Gallery

Granville Redmond 40

1871-1935

Granville Redmond, a deaf mute, often painted
pictures of solitude and silence. Redmond was born in
Philadelphia and came to San Jose, California, when
he was three. As a young student he won several
prizes for his art work. Redmond studied with Arthur
Mathews and Amedée Joullin in San Francisco and
at the Julian Academy in Paris. During World War I
he acted in motion pictures and painted in a studio
on the Charlie Chaplin lot. Redmond once lived in
a converted trolley-car house at Terminal Island.

47

42 *Mt. Tamalpais from San Anselmo*
oil on canvas, 20 x 30

Poulsen Galleries

41 *Storax*
watercolor, 20 x 12½

San Diego Society of Natural History

Albert R. Valentien 41

(1862-1925)

A. R. Valentien made over 1000 paintings of
California native plants. Born in Cincinnati, Ohio,
he studied at the Cincinnati Academy of Art and
continued his studies with Frank Duveneck. At 19 he
went to work for Rookwood Potteries and almost at
once was made head of design and decoration. He
received a special gold medal at the Paris Exposition of
1900. Valentien began painting wildflowers while in
Europe for the Exposition. On a visit to San Diego
in 1903 he made 135 wildflower studies. Ellen Scripps
saw his work and commissioned him to make
paintings of all the California wildflowers. In 1908,
after 24 years at Rookwood, Valentien came to San
Diego to live. He traveled over the state making
watercolor paintings not only of wildflowers but of
native grasses, trees, and cacti. The paintings
commissioned by Ellen Scripps fill 22 portfolios which
now are at the San Diego Museum of Natural
History. Fifty of Valentien's wildflower studies are in
the State Capitol Building in Sacramento.

Manuel W. Valencia, Jr. 42

1856-1935

Manuel W. Valencia may have been the first native
Californian to become a professional artist. He was
born on the family hacienda at Rancho San Jose
in Marin County near San Rafael. After attending
Santa Clara College, Valencia studied art in Mexico
City. He later maintained studios in San Francisco,
San Jose, and Sacramento. Valencia painted
landscapes very much in the style of William Keith.

43 Untitled, stream
oil on canvas, 16 x 20

Jason Schoen

Elmer Wachtel 43

1864-1929

Elmer Wachtel was born in Baltimore, Maryland,
and came to California at the age of eighteen, joining
his brother, who managed the Sunnyslope Ranch in
San Gabriel for his father-in-law. During the day
Elmer worked in a furniture store; at night he played
violin and viola with local orchestras. In his spare
time he began to paint and sketch. He enrolled in the
Art Students' League in New York, left after two
months, and continued his studies at the Lambeth Art
School in London. Evenings he would join friends
painting in Gutzon Borglum's studio. In 1904 Wachtel
married the sculptor Marion Kavanagh. They lived
in the studio he built on Sichel Street in Los Angeles.
Later they moved to Mount Washington and finally
settled on the banks of the Arroyo Seco. Wachtel
was among the first artists to break away from
painting European landscapes and to show the beauty
of California's deserts, mountains, and arroyos. He
knew the countryside well, having explored it by
horseback and by car. Wachtel designed a car
himself and had it built locally. In addition to
painting, he was adept at sculpture, metalwork, and
furniture carving. Wachtel died on a sketching
trip to Guadalajara.

Marion Kavanagh Wachtel 44

1875-1954

Born in Milwaukee, Wisconsin, Marion Kavanagh studied at the Art Institute of Chicago and with William Merritt Chase. She came to San Francisco in 1903, taking advantage of a free ticket promised her by a Santa Fe executive if she ever decided to paint in California. After studying briefly with William Keith, she left for Los Angeles. There she met the painter Elmer Wachtel, whom she married in 1904. At the time of her marriage she was painting children's portraits, but as she and her husband traveled through California, she became more and more interested in landscapes. She became so familiar with the countryside that she could paint any native tree or shrub from memory. For 25 years she and Elmer Wachtel traveled and painted together, he working in oils, and she in water colors.

44 Untitled
watercolor, 24 x 36
Poulsen Galleries

Hernando G. Villa 45

1881-1952

Hernando G. Villa is perhaps best-known for his painting of *The Chief*, which became the emblem of the Santa Fe Railroad. Villa was born in a Los Angeles adobe at Sixth and Spring Streets. His parents had come to Los Angeles from Baja California in 1846, when all of California was still part of Mexico. His father was an artist with a studio on the Plaza, and his mother was an amateur singer. Villa studied at the Los Angeles School of Art and Design, the oldest art school in the Southwest, and later taught there. He also studied in Germany and England. Villa specialized in paintings of early California and the Indians of the Southwest. For more than forty years he was an illustrator for the Santa Fe Railroad, and he also did paintings for the Southern Pacific. Villa painted several murals, and he did a watercolor 120 feet long called *Tourists at the Mission* for a Los Angeles department store. He did illustrations for *Town Talk*, *West Coast Magazine* and a few books; including *Saunterings in Summerland* and a cookbook, *Early California Hospitality*. He reportedly used Charles Lummis as a model for the Indian fire-maker shown on a bookplate designed for the Southwest Museum. Villa was consulting artist for the restoration of the Santa Barbara Mission.

45 *Old Mission Plaza Church, Los Angeles*
oil on canvas, 40 x 29½

Carl S. Dentzel

47 *Vandalism*, 1916
oil on canvas, 50 x 60
Armand du Vannes Art Gallery

Thaddeus Welch 46

1844-1919

At the age of three, Thad Welch was brought by prairie schooner to Oregon from his birthplace in LaPorte, Indiana. He grew up near McMinnville and at nineteen went to work in Portland as a printer. He became interested in painting after seeing some watercolors by Peter Petersen Toft. Welch came to California in 1866. He eventually reached San Francisco, worked for *The Call* and *The Bulletin*, and became a member of the San Francisco Art Club. In 1874, with the help of a wealthy patron, he left to study at the Royal Academy of Bavaria in Munich. Welch remained in Europe until 1881, working for a time on the Paris *Herald* and living in a houseboat on the Seine. Before returning to California, Welch spent a good many years on the East Coast and worked for almost two years in Australia, where he painted cycloramas. He came to Pasadena in 1893 at the invitation of Prof. Thaddeus Lowe and after a short stay in Los Angeles went north and settled in Marin County. He began to paint the Marin Hills and from that time on he was greatly sought after as an artist. In 1905 Welch moved to Santa Barbara. In his workshop he made his own tools, built violins, and worked on several inventions. He painted the mountains and canyons around Santa Barbara, but continued to paint the landscape of Marin as well.

William Wendt 47

1865-1946

A landscape painter with a reverent attitude toward nature, William Wendt was California's first Associate of the National Academy. Wendt was born in Bentzen, North Germany, and apprenticed as a boy to a cabinet maker. At the age of fifteen he came to the United States and got a job in a Chicago art shop. He won his earliest recognition at the Columbian Exposition. He first visited California in 1894, settling here permanently in 1906 with his wife, the sculptor Julia Bracken. They bought the Wachtel studio on Sichel Street in Los Angeles. Wendt also maintained a studio in Laguna and retired there in 1928. It was largely due to Wendt that the Painters Club became the California Art Club, which had its headquarters in Barnsdall Park.

46 *Golden Hills*
oil on canvas, 14 x 24

Terry De Lapp

Arthur Putnam 48

1873-1930

Arthur Putnam is best known for his animal
sculptures, especially of the puma. Putnam was born
in Waveland, Mississippi, and grew up in Omaha. In
1892 he moved to La Mesa, outside of San Diego,
where his mother had a lemon orchard. Two years
later he went to San Francisco and studied with the
sculptor Rupert Schmidt. Returning to San Diego,
Putnam studied independently and supported
himself with a variety of jobs—even trapping pumas
for the San Francisco Zoo. He worked a year in
Chicago under Edward Kemeys, the animal sculptor,
then returned to California and married the artist
Grace Storey. From 1901 to 1905 Putnam lived in
the San Francisco Bay area. Bruce Porter (for whom
Putnam named a daughter) introduced him to the
architect Willis Polk, and Putnam began to do
architectural modeling. His first commission in
bronze was a series of figures for the San Diego
estate of E. W. Scripps. Putnam spent a year and a
half working and exhibiting in Europe and had
several animal bronzes accepted by the Paris Salon.
On his return to San Francisco, after the earthquake
and fire, Putnam camped in a tent while he built a
house and studio on Ocean Beach, just beyond
Golden Gate Park. He also built a small foundry.
When he considered making a cement block house,
friends in Pasadena sent him a machine for making the
blocks. Putnam did ornamental work for many of
the new buildings in San Francisco and modeled the
bases for the light standards along Market Street.
In 1911 Putnam had an operation for a brain tumor.
Partially paralyzed, he never recovered sufficiently
to continue work.

Alexander Stirling Calder 49

1870-1945

A. Stirling Calder was the son of a sculptor and the
father of another: Alexander Calder, who originated
mobiles. The work of Stirling Calder ranged from
the study of a child's head to the monumental
archway for Throop Polytechnic Institute in
Pasadena. Born in Philadelphia, Calder attended
the Pennsylvania Academy of Fine Arts and studied
two years in Paris. In 1905 he came West for his
health and in 1906 moved to Pasadena, where he
stayed until the fall of 1910. The archway for Throop
was unveiled February 5, 1910. The Calders first lived
in a house on Euclid Avenue near California
Boulevard, then moved to a converted barn in
Linda Vista above the Arroyo Seco. In 1913 Calder
was made Acting Chief of Sculpture for the
Panama-Pacific International Exposition in San
Francisco. He had two enormous sculpture groups
in the Exposition and also a *Fountain of Energy*.
From 1913 to 1915 Calder maintained studios in San
Francisco and Berkeley. He then moved to New
York City. One of his best-known works is the statue
of Leif Ericsson presented to Iceland on the 1000th
anniversary of its Parliament. Calder also did the
sculptured pedestal of the Washington Arch in New
York City. His last completed work was a
monumental head of Winston Churchill.

Southern California
Ward Ritchie

Ralph Fullerton Mocine, illustrations
Cuentos de California
1904
Ward Ritchie

The literary history of Southern California dates from 1854 with the publication of a wretched little booklet written by William Money—so-called Bishop, Deacon and Defender of the Faith of Jesus Christ—entitled *Reform of the New Testament Church*. It was the first book to be printed in Los Angeles. But it wasn't until almost a half century had passed that there was a serious literary movement in the southland communities. Northern California, on the other hand, teemed with writers who exploited the colorful west of those days—Mark Twain, Brete Harte and Joaquin Miller, among the earlier ones, and Frank Norris, Gelett Burgess and Edwin Markham later on in the nineties. Meanwhile in Southern California during that fifty years there was only one book of consequence printed locally, Major Horace Bell's *Reminiscences of a Ranger*. There were others, of course, written about the salubrious climate and the best selling *Ramona* by Helen Hunt Jackson.

The creative stirrings began in the 1890's and centered along the banks of the Arroyo Seco, an almost dry river bed during most of the year but often a raging torrent during the winter months. It originated in the San Gabriel mountains above Pasadena and flowed down through the western part of Pasadena, the old San Rafael Rancho, passing by South Pasadena on one side and the old town of Garvanza on the other. Eventually it flowed into the Los Angeles River.

Possibly the first significant writer to inhabit this area of rugged hills and sycamore trees was Charles Fletcher Lummis. In 1884-85 he had tramped some 3,500 miles across the continent from Cincinnati to Los Angeles. He had sent weekly letters describing his hike to Harrison Gray Otis, the publisher of the Los Angeles Times, and upon his arrival was greeted and given the job of city editor of this paper. Several years later in June of 1894, Charles Willard started a magazine called *The Land of Sunshine*. A year later he persuaded Lummis to assume the editorship, and with his aggressive energy Lummis made it into the leading literary journal of the Pacific Coast until its demise in 1910. In 1902 its name was changed to *Out West*, as Lummis was worried that its former title was "too much Chamber of Commerce."

In 1898, realizing that he must insure his magazine quality material, he enlisted as stockholders and contributors a number of qualified writers and historians of the west. He wrote at that time, "Every American magazine worth counting is structurally Eastern. Not one has really continental horizons. A magazine adequate to represent the West must be not only cultural as its field is, but Western in knowledge, in theme and in feeling. It can only be produced by Westerners."

It was on the banks of the Arroyo Seco that Lummis chose to build his home. It was a physical labor which he did with the help of several Indian laborers. It is a house of granite boulders which he garnered from the Arroyo, hauled up the banks and cemented into the walls of the home he called *El Alisal* after the big Sycamore tree in his patio. Here he wrote, entertained notables and founded the Southwest Museum, built on the slopes of Mt. Washington within eyesight of his home.

Mary Austin joined Lummis' "Arroyo Seco group" in 1899 and its stimulus sparked her latent talent, resulting in her masterpiece, *The Land of Little Rain* published in 1903. She wrote for *The Land of Sunshine* and enjoyed and benefited from the stimulation of evenings with Lummis' guests in "the

Literature and Presswork

long, dark, barbaric hall"; as she described this home where Lummis entertained with Spanish food and Indian songs.

Among the many contributors to *The Land of Sunshine* was a widow from Humboldt, Nevada. Lummis wrote a sketch of her in the New Year's issue of 1901 saying, "Up on that remote and beautiful mountain ranch, a long way out of the world—as the world wobbles now—this ranchwoman of the sage-brush is turning her own competent hands to several good uses. Aside from the big ranch on the Humboldt, she has a gold mine up in the cañon. And as housekeeping and mining and ranching are not enough for a really active spirit, and as writing is only half enough recreation, Mrs. Strobridge has plunged as heartily into bookbinding."

Lummis' encomiums were just enough to lure Idah Meacham Strobridge from her ranch and gold mine to the sycamore-studded banks of the Arroyo Seco. She built a home and her *Artemisia Bindery* a few blocks from Lummis' *El Alisal* and competed, to his great distress, in luring and entertaining visiting celebrities. Most of the leather bindings which she did have disintegrated because of inferior leather but she wrote and published three books about the western deserts of enduring value and typographical interest. They are now collectors' items: *In Miner's Mirage Land* (1904), *The Loom of the Desert* (1907) and *The Land of Purple Shadows* (1909).

Probably the most competitive with Lummis was George Wharton James. He was almost exactly the same age and they both arrived in California within a few years of one another. James became interested, as was Lummis, in the fate and well-being of the Southwest Indians. Their rivalry became quite vindictive. Lummis maintained that James was a "literary racketeer" and in an article he wrote entitled

Untruthful James he said, "It is rather well understood by Indians and whites, along some five hundred miles of the Southwest that Mr. James may tell the truth when he cannot well help it."

James edited the *Mt. Lowe Echo*, a publicity journal for Thaddeus Lowe's Mt. Lowe Railroad and Tavern, and while he could have been thought of as a "literary salesman" he wrote more than forty books of some value concerning "romance, history, botany, birds, science and scenic wonders of California and the Southwest." He was also interested in publishing and under the imprint of The Arroyo Guild Press commenced a program that would have encompassed works of almost every writer in the west. It died, however, soon after the first publication, a piece by Charles Warren Stoddard.

Olive Percival
Bookplate
ca. 1901

Ward Ritchie

Also living on the banks of the Arroyo were other authors who contributed to this minor literary renaissance. There was Amanda Chase Mathews with her *Hieroglyphics of Love* about Los Angeles Sonora Town; Olive Percival, poet and book collector; and Carolyn Foster. There appeared a few books by the Arroyo Press and the Los Angeles College Settlement written by writers of this area.

On the other side of the Arroyo, the east side in South Pasadena, lived Margaret Collier Graham, perhaps one of the finest and most polished writers of this period. Her short stories appeared not only in *The Land of Sunshine*, but also in *Harpers* and *The Atlantic Monthly*. She was an early champion of women's liberation and also of California. She once wrote, "I have lived in California since 1876 and have in consequence no desire to go to heaven."

Idah Meacham Strobridge
Maynard Dixon, illustrations
The Land of Purple Shadows
1909

Ward Ritchie

53

In those beginning years of the twentieth century, situated on Figueroa Street (then called Pasadena Avenue) and backed by the tracks of a noisy railroad continuously bringing more settlers to Southern California, was the campus, at that time, of Occidental College. It was but a few blocks from the Arroyo and while it may not have actively participated in the literary activities of the area, it had among its student body several students, writing at that time, whose talents were destined to greatness. Perhaps the most gifted was Nora May French whose talent and beauty was later absorbed into that seacoast of Bohemia— Carmel. She was the toast and love of Jack London, Jimmy Hopper and George Sterling. She committed suicide in desperation at the age of twenty-six in George Sterling's cabin. A posthumous volume of her poems was published in 1910.

Robert Glass Cleland, of this group, became a scholarly historian. He taught history for many years at Occidental, was Dean and Vice-President. Eventually he became a senior research scholar at the Huntington Library and wrote many books of historical interest on California and the west.

Most intriguing was another Occidental student, perhaps a little early for the Highland Park campus but most involved in historical events of the first decade of the twentieth century. Homer Lea was a frail hunchback who wanted to be a hero. He studied in detail the battle plans of Napoleon and all other military strategists. Knowing he would never be accepted in the U.S. Army, he went to China and became the chief military advisor of Sun Yat Sen with the rank of general. Some years later he wrote *The Valor of Ignorance*, published in 1909. In this book he warned the United States of the potential danger of a Japanese invasion and outlined in intimate detail how it could be accomplished, through the Philippines, Hawaii to the West Coast. Thirty years later the Japanese used this as a textbook in their prepared attack on the United States.

The best known of the Occidental College group of this era, however, is the poet Robinson Jeffers. His earliest poems appeared as early as 1906 in the Occidental student publication, *Aurora*, and in the *Youth's Companion*. His first book, *Flagons and Apples*, was published in 1912 though his reputation wasn't firmly established until his *Tamar* in 1925. While he is primarily considered to be the poet of the Big Sur and the Carmel coast, his origins were on the Arroyo Seco of Southern California.

Clyde Browne
The Abbey Fantasy
1929

Dr. Robert Nash

Although later in date, this piece is typical of work produced by Browne in the earlier period.

The few miles of the Arroyo Seco, from the old Colorado Street bridge down to the Los Angeles river, was probably the cultural center of Southern California in the early years of this century. One gem remains —the *Abbey of San Encino*. It is almost completely hidden, down the hill from Figueroa near York Boulevard. In 1909 Clyde Browne began building himself a home and printing shop in this gully. He built a combination of California Mission, medieval castle and monastery. There was a cloister, a dungeon, a chapel with an elaborate pipe organ he built himself and a printing shop with a stained glass oval window showing a Padre and an Indian operating an old wooden hand press. Up the hillside he built a series of studios which he rented to artists, authors and craftsmen. Clyde Browne worked for a half century in this anachronistic atmosphere, trying to revive—in his printing and in the songs he sang before his warm stone fireplace accompanied by his guitar—the mood of bygone centuries.

Across the Arroyo, in a modest dull apartment in South Pasadena lived a man almost unnoticed who was one of the great typographic designers of the 1890s and early 1900s. This was Will Bradley who was rediscovered a few years before his death and given the acclaim rightfully due him.

No really *great* literature was produced in Southern California in these years around 1910 but there was a yearning and stirring of creative activity which is of nostalgic interest.

SOFT gray walls half hid beneath the hill, behind the frosted olive eucalypti, mark the Abbey manse. There it lies, drowsy in the summer trades, stolid in the wintry storms, swept by seasons and years, mossy and lichened from the passing dews, hoar with sepulchral dusts of time, San Encino's olden Abbey, hardby the arroyo ford upon the King's Highway.

Time was the builder sat upon the hilltop and saw the slope and plain all littered with sage and cacti, with rubble and the waste of passersby, with demon chilicote and ghostly weeds of yesteryear, and in his fancy grew the high-domed tower, cloister and hall, flags of the court, the broad-tiled roofs, and hand-forged grills, and o'er it hung the cloying, vibrant lull of brazen throats in the massy campanile, and as he dreamed his dreams the ways of workers burgeoned and burst into bloom within his fantasy and he wotted again of the craftsmen he had marked in other lands,

{5}

Northern California

Robert Haas

San Francisco's rich literary history began with the diaries and memoirs of the goldrush pioneers and prospered with the professionally trained, academically oriented newspapermen who chronicled and editorialized their way through the first twenty-five years of the city's development.

When, in 1875, William Chauncey Bartlett, already a veteran *Bulletin* writer, delivered his lecture on "Literature and Art in California" before the faculty, students and visitors of the University of California, he remarked upon California's steady literary growth to that date and listed as evidence about one hundred and sixty books which had been written by California authors and reached publication. Most of these were written by San Franciscans and were first printed in San Francisco.

For San Francisco had early managed to attract a substantial group of writers of brilliance, wit and stature. There were short-story writers, essayists, novelists, nature writers, historians, educators, lawyers, religious writers, specialists in satire and regional humor. Names to conjure with, both then and later, were John Cremony, Frank Marryatt, Eliza Farnham, John Hittell, Mark Twain, Frank Soulé, Henry Halleck, Clarence King, Joseph Hutchings, Charles Stoddard, Edward Rowland Sill, Bret Harte, Joaquin Miller, Hubert Howe Bancroft, Ina Coolbrith and Ambrose Bierce.

These authors found a place for their shorter works in San Francisco's newspapers and journals. The most important of these, from the literary point of view, was *The Overland Monthly* (1868 ff.) which created the first serious audience for western writing in the east.

Full length books, in those days, were usually printed locally and at the author's expense. Although commercially motivated and aesthetically cautious, several early San Francisco printers produced handsome volumes of solemn pictorial charm. *Poems*, by Charles Warren Stoddard, printed by Bosqui in 1867, is an example.

Locally printed books were locally distributed by one or more of the willing booksellers with whom San Francisco, at the time, was liberally supplied. If the books prospered, even though regionally oriented, they were promptly taken up by eastern trade publishers, and the authors found their way to a more than local fame.

In San Francisco making literature was a serious business, but, as Bartlett had pointed out in 1875, "No one has sought to live here exclusively by authorship." By day writers were newspapermen, school teachers, housewives, librarians, lawyers, or were otherwise gainfully employed. The rest of the time they were authors.

Yet, in the last quarter of the nineteenth century, many San Francisco authors seem to have come into their own through such journals as *The Overland Monthly*, *The Argonaut*, *The Wasp* and *The Californian*: Edward Rowland Sill, Dan de Quille, Edwin Markham, Frank Millard, William Bartlett, Sam Davis, Joaquin Miller, John Muir, Josephine McCrackin, Kate Douglas Wiggin, Ambrose Bierce, Dan O'Connell, Emma Frances Dawson, Ella Sterling Cummins, Mary Austin, Gertrude Atherton, Ina Coolbrith, Arthur McEwen, W. C. Morrow, Charles Warren Stoddard. Many were now looking forward to publication in eastern journals as well as in those at home.

Bret Harte and Mark Twain had long since reached sufficient fame to leave California for good; Ambrose Bierce was about to go. They were the "Old Bohemians." Fortunately there were towering figures coming on—Gertrude Atherton, Frank Norris and Jack London, whose drive to make literature out of the social issues of the day ushered in the new California realist school. The great publishing houses of the east, recognizing the relevance of this hard-headed new content, sought these new authors out. Their books were mass produced in the 1890's and distributed on a national scale. For this generation of authors, the new protective copyright law of 1891 had made writing a more possible full-time profession.

Not so for San Francisco's old-time newspaper staff writers, who now found their jobs threatened by new policies which favored sensationalism in the press, spectacular headlines, increased illustrations, and the use of syndicated news rather than the conservative word-bound staff writing they were used to provide. Many a fine newspaperman of the old school failed to make the adjustment and found himself displaced by the new generation of bright young men—the "New Bohemians"—who, at the turn of the century, proceeded to reshape northern California's literary life by responding to some of the more *avant-garde* impulses reaching them from the taste makers of Europe and the American east.

Gelett Burgess
The Lark
No. 1, No. 4, No. 7
1895

Albert Sperisen

The new Bohemians had first gathered in San Francisco around the advent (in 1895) of the way out, precious, but short-lived little magazine, *The Lark*, edited by Gelett Burgess (a whimsical young writer on the *Examiner* staff) and published for a brief two years by the good-natured bookseller and friend of deserving young authors, William Doxey. *The Lark* was a sport and a typographical wonder, whose verve and style followed upon England's *avant-garde Yellow Book*. A whole circle of writers and artists identified with the enterprise and the fresh air each issue brought into being for the two years of its existence. Besides Gelett Burgess there were Bruce Porter, Ernest Peixotto, Porter Garnett, George Sterling, Nora May French; Gertrude Atherton, Frank Norris and Jack London were the solid figures of success in the group. After the fire and earthquake of 1906, the group shifted its epicenter to Carmel and gathered in, among other writers and painters, Mary Austin, Arnold Genthe, Charles Warren Stoddard, Rollo Peters, Upton Sinclair, Xavier Martinez and the young Robinson Jeffers. The camaraderie of the group, their openness to the new tempo of things, and their artistic productivity supported a new California style in the arts, much of which emerged through their collaborative work for the Worlds' Fair of 1915 under the artistic direction of its guiding spirit, Edgar Walter.

All through the two decades which followed the publication of *The Lark*, one can find evidences of a new spirit in the arts in California on the part of both artists and patrons. California had already sent evidences of unique craftsmanship to be exhibited at the World's Columbian Exhibition in Chicago in 1893 showing the world that the west coast was now in contact with the international arts and crafts movement inspired in England by the thinking of Thomas Carlyle, John Ruskin and William Morris. The San Francisco Midwinter Exposition of 1894 demonstrated the same thing at home. Notions were current that the handicraftsman could produce major art if he could only guide his product "from conception to completion" without the intervention of industrial machinery or the commercial motivation of mass production. A return to personally designed and personally produced pottery, furniture, textiles, metalwork, glass, and even bookmaking energized a whole Arts and Crafts Movement in America, 1876-1916.

San Francisco had always been an author's city and a printer's city. In the 20th century it became a mecca for those now attracted by the ideals of the Arts and Crafts Movement, who looked for *more* than the good commercial production of their works.

The tradition of the artist-craftsman printer had undergone a revival in England under William Morris at his Kelmscott Press, established in 1890. Morris saw his books through the press personally—choosing the work, the paper, the type face, the decorations, the composition of the page, the illustrations. He then personally set and printed a limited edition of the work and added a colophon, before binding, giving information about the book's materials and maker. Stylistically, Morris' work was heavy and romantically medieval in appearance, affecting florid borders, block

Florence Lundborg
The Lark, poster
November, 1895

University of San Francisco

arrangements of type and caps, and decorated initials, often in red. By 1891 a William Morris book had appeared in America in a photographic facsimile and had considerable influence upon such American book designers as D. B. Updike of the University Press in Cambridge, who in turn championed the style for many years. Updike's superb example, *The Altar Book*, issued from his own press in 1896, was called "the perfect book."

Another more classical manifestation of the Arts and Crafts style in English bookmaking was to be found in the work of Cobden-Sanderson, who chose, in the works issued from his Doves Press, to go back to the 16th century Venetian printer, Aldus, for his inspiration, or to the printers of the French Renaissance. His books were consequently small, more delicately decorated, and, as a result, more legible. He has been called an exponent of the Aesthetic Style. In America, this style was taken up by Thomas Bird Mosher and T. L. De Vinne.

These contrasting antiquarian styles in book-design often lost some of their purity in practice by incorporating art nouveau ornament and illustration (in the Mackmurdo, Aubrey Beardsley, Walter Crane manner) as well.

The Arts and Crafts movement in bookmaking reached San Francisco with the turn of the century and became a part of the wider movement, soon to include the architecture of Maybeck and Julia Morgan, the designers Lucia and Arthur Matthews, the metalcraftsman Dirk van Erp, and the other designer-craftsmen of the area now working with the same commitment to integrity of design, quality in production, and personalized relationship with a like-minded client.

Henry H. Taylor and Edward DeWitt Taylor were the earliest established of San Francisco's artist-printers. They have been called the first exponents of fine printing in San Francisco. Edward had been a printer since 1882 and Henry had gone to Harvard to study with D. B. Updike. Their first non-commercial publications were either for private patrons or for San Francisco bookseller-publishers, such as A. M. Robertson or Paul Elder. Their credo was naturally that mechanical excellence was not enough in printing; that the printer must have control of his work "from the ground up"—choice of paper, cuts, binding and printing. They usually chose the classical approach to design—the sparing use of oranament, beauty of type and arrangement, and quality of printing.

Henry H. Taylor and Edward DeWitt Taylor
Thirty-Five Sonnets
1917

Book Club of California

One may well compare the press' 1903 volume by Charles W. Stoddard, *For the Pleasures of His Company* with its rather heavy illustrations by Marshall Douglass, its red and black title page and floriate chapter headings, with the 1920 *Lilith* by George Sterling, its more restrained, more classical title page, more delicate almost art-deco, cameo-like chapter decorations. Their press design moved away from the "Kelmscott style" to the Aesthetic Style, and past in later years. Their personalized approach to fine book press commissions led to the output of over one hundred and fifty publications by 1920. These represented such San Francisco authors as Charles Keeler, Gelett Burgess, Wallace Irwin, David Starr Jordan, Morgan Shepard, George Bromley, George Sterling, Joaquin Miller, **Nora May French**, Porter Garnett, Edward Rowland Sill and Frank Pixley, and were of such quality that the firm of Taylor and Taylor was awarded two silver medals for their work at the Exhibition of American Printing in New York.

Ricardo Orozco was the second artist-printer and designer to make his work in the arts and crafts manner felt in San Francisco. He was behind the planning of many volumes published by other firms, particularly items for Paul Elder and Company under their Tomoye Press imprint. His typography and graphic design have their own flavor. The books he issued both under his own hand and name are few, only seven to 1920, some with machine-set text. Notable was his use of strong red and black block designing and decorative devices which were derived from Aztec sources.

John Henry Nash came to San Francisco in 1898 as a printer from Canada. He was first employed by Stanley-Taylor, then in 1901 established the Tomoye Press for Paul Elder. From 1906-1909 he moved with the press to New York where he met and absorbed the influence of Theodore de Vinne, whose Aesthetic Style preferences stemmed from Cobden-Sanderson's Doves Press work as had the Taylor's. Upon his return to San Francisco in 1909, he became designer of the Paul Elder and Company's publications there. He later became a partner of the Taylors, but in 1916 he established his own firm.

Although Nash acknowledged a lingering debt to William Morris, his designing followed the antiquarian line of the *Aesthetic Movement* and thus showed a debt to the great classical printers of the sixteenth and seventeeth centuries. He used classic types, worked towards a spacious, flamboyant style of his own. Nash developed a great patronage for his fine printing, and by 1920, although just at the beginning of his long career, had some fifty superb publications to his credit, including books by Edwin Markham, Witter Bynner, Emma Frances Dawson, Robert Louis Stevenson, Charles Erksine, Scott Wood and Ambrose Bierce.

A fine example of his early work is the 1916 *The Ideal Book; or Book Beautiful* written by his British

Porter Garnett
Young Girl
1920

Book Club of California

John Henry Nash
A Son of the Gods and A Horseman in the Sky
1907

Book Club of California

fore-runner, Thomas Cobden-Sanderson. Little more than a pamphlet in length of text, it was nevertheless of imposing size, printed on fine paper in sparkling black ink, and with a title page in the Cobden-Sanderson, De Vinne tradition—blue ruled enframements containing Renaissance ornament printed in tan ink. The 1920 edition of Bierce's *A Horseman in the Sky* is in strong stylistic contrast; a red and black title page, with florid decorations by Roy Coyle, looking back to the William Morris style. Often called San Francisco's "super salesman of fine printing," Nash was nevertheless uncompromising in his belief that, whether hand printed or commercially printed, books can be "great typographical pictures" as were the classical books of printing history.

Thomas Russell had produced a modest three volumes by 1920, out of a modest seven by 1930. These books were printed by him personally at home after a lifetime of trade printing. He exemplified the Arts and Crafts ideal of total production in the hands of one man. With this, he combined impeccable editorial scholarship to produce handsome recreations of key documents in California printing history. His 1917 *The Narrative of Edward McGowan*, with its red and black title page, just resetting of the original text, and reproductions of the original illustrations, well represents the spirit of his work.

Taylor and Taylor, Orozco, Nash, and Thomas Russell were, therefore, the four printers of fine press books in San Francisco during the years 1900-1920. They were heirs to the international Arts and Crafts Movement, although all four moved away from the heavy early influence of the English "Kelmscott Style" to favor the wider scope of the Aesthetic Style. Whatever differences and individualities they brought to their work, they clearly shared the ideals of the Arts and Crafts Movement, and there shaped their careers until the end. Their contributions to graphic design on the west coast, and to attitudes about printing as a major art form, are part of the precious legacy we enjoy today.

Unfortunately the Grabhorns fall mostly outside the scope of this essay. Their *Announcement of a New Press* dates from 1920. But we know that Edwin and Robert Grabhorn carried on the tradition started by the Arts and Crafts pioneers of the book in California, enriching it for the new generation of authors, designers, book-sellers and art patrons which arose between the two wars.

San Francisco is today one of the great printing centers of America. Its typographical fame rests in large part on the work of the artist-printers of the first quarter of the twentieth century. Their work was clearly seen as a renaissance of the book in their time. Today it is being rediscovered by a new generation of expressive Californians nostalgic for a past they have never personally known. It is there for the searching, and its lessons of commitment to the eye and the hand, to integrity in the production and distribution of what is created, and to the need for *uncompromising quality* in doing one's thing, could trigger another renaissance on the west coast even as meaningful as the last.

John Henry Nash
The Man with the Hoe
1916

Book Club of California

Throop University

Janet Ferrari

The California Institute of Technology traces its lineage to an experiment which was, as an educational expression, the epitome of the Craftsman Movement. Throop University, Caltech's parent institute, was the creation of Amos G. Throop at the age of eighty, and the fulfillment of his aspiration to provide a form of education beyond simply the training of the intellect. Manifesting the growth of technology, Throop University focused its attention on the development of the total person. The goal was a synthesis of mind, body, and spirit, inherently containing a respect for all levels of human achievement. The quality of every act, whether in a court of law or a blacksmith's shop, was considered important as a product of the intellect, judgment, and conscious will of man. From this philosophy emerged a far reaching appreciation for intelligent manual labor that permeated the attitudes and values of the Throop community.

Throop University opened on November 2, 1891, next to the Green Hotel in Pasadena. It consisted of five schools: a College, a Normal School, a four year College Preparatory Academy, a two year Commercial School, and an eight year Elementary school. All five schools provided a standard education, but into each was integrated an equal emphasis on art and manual training. The textbook was considered a means of achieving a knowledge of nature, man, and the universe with practical application. The body was considered the mind's mechanism to carry out its will. In this pursuit, manual arts training was to take a leading role. A wide spectrum of skills was taught. Some of them were: freehand, architectural, and mechanical drawing; carpentry, wood turning, brazing, forging, soldering, bench and machine work in metals. The potter's wheel and clay modeling were also used as a drill for the eyes, hands, and senses. Along with the skills, the traditions of the various trades were imparted. Students were to *learn by doing*.

Manual training was not exclusively reserved for men at Polytechnic. A girl of eight could be found in the shop wielding a chisel as wide as her hand, while a boy of eleven labored over a miniature doll house constructed of well-mortised timbers with doors that opened and shut. Women too, were taught pottery, carving, woodworking, and a wide range of domestic skills.

Through its publications we know that Throop sought to reach out into the community, provide a viable means of living for its students, and solve a lack of sympathy between the classes by bestowing dignity upon each man's labors and talents. Throop functioned under these auspices for sixteen years. It began changing under the influence of George Ellery Hale in 1907, and began its evolution from a pioneer school in manual arts to the Caltech of today. Hale, the first director of the Mount Wilson Observatory, foresaw the potential scientific and industrial growth of California, and wanted Throop to meet the challenge. By 1908 the Elementary School had separated, the Commercial School was closed to further registration, the Normal School which contained the department of manual arts was discontinued. The College and Academy classes were strengthened in engineering. In 1911 the Academy faculty, students and building were turned over to Pasadena High School. By 1921, much of Hale's goal to establish a world center of scientific research was fulfilled emphasizing engineering and the pure sciences.

Perhaps many of the factors that signaled the birth of Throop University, also caused its demise. The advent of technology may have earlier moved man to seek out and preserve his total identity—encompassing himself, his creativity, and his creations. Then, this same technology, growing in momentum and demanding specialization and concentration of effort, seems to have dissipated the Throop idea of the complete person.

Education in the Arts & Crafts

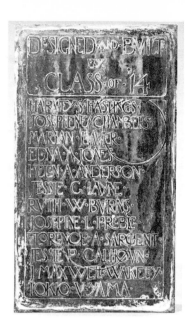

Los Angeles College of Fine Arts
Dedication plaque, copper with raised letters
h. 19″, 1914

Walter Judson (Judson Studios)

The plaque was originally attached to a garden structure on the campus of William Lees Judson's school overlooking the Arroyo, now the site of Judson Studios. In the 1920s, the school was absorbed into the University of Southern California becoming its Department of Fine Arts and Architecture.

F. L. Compton
Clock, cast ceramic with copper face
10½″, 1916

F. L. Compton

The clock was crafted by a former Throop student, then working for Batchelder. It has a brown, rubbed glaze that blends with the copper face, and suggestions of color in the landscape scene. Not to be behind the times, Compton changed the original keywind mechanism to electric a few years later.

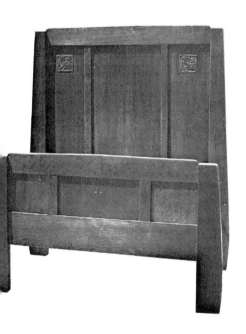

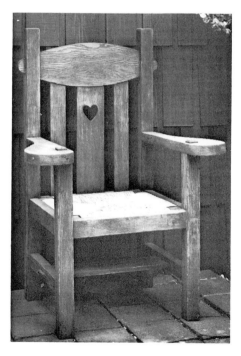

Polytechnic Elementary School
furniture, oak
bed h. 49¼″, stool h. 36″, trunk h. 17″, tray l. 15 w. 9¾, ca 1911

Eva Hanson Tower Meacham

These pieces were made by a thirteen year old student, Beryl Allen Tower. The carved details reflect Ernest Batchelder's influence.

Anonymous
Armchair, fir
h. 44″, ca 1910

Robert Winter

This is the kind of project a student in manual training at Throop might take on. The piece is not marked in any way, but it has the kind of detailing and materials often used in their classes.

Polytechnic Elementary School, sewing room

Following the thesis of manual training as a worthwhile adjunct to academic training. Throop conducted sewing classes as well as workshops in pottery, metalwork and leather.

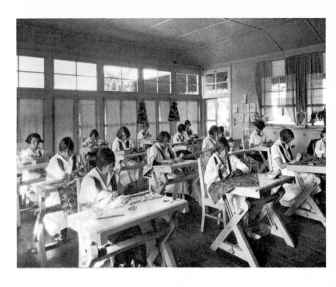

Polytechnic Elementary School, woodshop

Within this light and spacious environment, young people were taught the skills of woodworking in projects ranging from a small carved tray to large wardrobes, using oak and fir primarily.

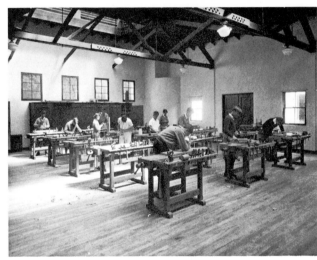

Myron Hunt and Elmer Grey, Architects Polytechnic Elementary School, Pasadena 1909

In contrast to the classic monumentality of school design in 1908, architects Myron Hunt and Elmer Grey designed the Polytechnic Elementary School as a single story, residential scale, redwood-clad building with all rooms opening onto a covered arcade. This was the original scheme for much of the school construction in California continuing to the present.

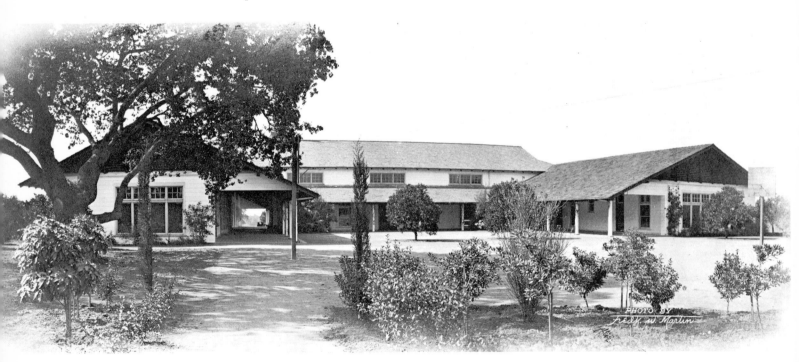

Frederick H. Meyer and the California College of Arts and Crafts

Born in Hamelin, Germany, in 1872, Frederick Meyer was brought up in the craftsman's tradition. With one uncle a designer and maker of fine furniture and another an art blacksmith, Meyer was often in their respective shops and could do competent work in both crafts before he was fifteen. In 1888 he came to California to visit an uncle who lived in Fresno. During this period he decided to devote his life to work in the crafts. He graduated from Cincinnati Technical School in 1892, attended Pennsylvania Museum School of Industrial Art in Philadelphia, and graduated from the Royal Art School in Berlin, 1896.

Returning to California, Meyer became Director of Art in the Stockton Schools. At this time he produced individual furniture designs and worked on furniture commissions. In 1902 he married Laetitia Summerville and moved to San Francisco where he established his own furniture design shop.

The 1906 earthquake and fire "razed the workshop and our home there and changed everything," Meyer writes. "After the fire, I attended a dinner of the Arts and Crafts Society of which I was president. We were asked to speak five minutes on what we would like to be doing instead of what we were doing. I spoke about my idea of a practical art school, one whose graduates would earn a comfortable living, and instead of teaching only subjects like figure and landscape painting, sculpture, etc., to teach design, mechanical drawing, commercial art and the crafts, as well as teacher training."

"Unknown to me, a newspaper feature writer from the *Call* was present and wrote up these ideas in the paper, 'This is the idea of an Art School, by F. H. Meyer.'"

Former students seeing the story contacted Meyer, and promised to enroll. He writes, "We had forty-three students that first summer of 1907 and all the money was $45.00 and my credit. The school started in the old Studio Building, Shattuck and Addison Streets in Berkeley, with three rooms and three teachers: Isabelle Percy West, Perham W. Nahl, and myself, with Mrs. Meyer as secretary. Soon Xavier Martinez came and took charge of the fine arts work."

Meyer assisted in the design of the education building display for the Panama Pacific International Exposition, and an alumni group under his guidance developed a "Model Artist's Studio" which won a gold medal.

He continued in active relationship with the School until his retirement in 1944. On January 6, 1961, at the age of 88 he died.

Although the whereabouts of the furniture he built on commission for the Spreckels and Hearst families is unknown, the school remains his memorial, continuing with the college level training of artists and craftsmen by which it has enriched the creative life of California since 1907.

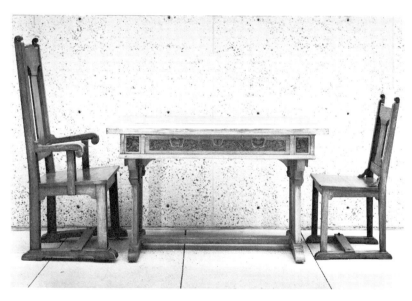

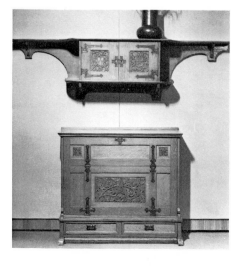

Margery Wheelock
Model's chairs, table, carved drawer
1915

Oakland Museum

Designed by Margery Wheelock under the direction of Frederick Meyer, this single-splat back grey toned oak chair was similar in design to a larger arm chair.

Margery Wheelock
Wall hung cabinet
Chest
1915

Oakland Museum

Pieces were executed by the California College of Arts & Crafts Alumna group with metal-work by Herman Steinbrun.

Stockton Art Pottery

1 By the mid-1890s both principal decorative techniques of art pottery in the east were being produced in California. At Stockton, the underglaze slip-decoration commonly called "Cincinnati faience"—an adaptation of Haviland's faience ware—was being made in 1895, designated as *Rekston* ware and markedly similar in treatment to Rookwood's *Standard* ware and the *Lonhuda* ware of Steubenville and Zanesville, Ohio.

Stockton Art Pottery: h. 7⅞"

Private collection

2 The Stockton ware without underglaze painted subjects resembles Bennington's flint-enamel glazed work popular in the east half a century earlier. This was definitely a product of the west, however, using a plastic yellow California clay from the Valley Springs region.

Michiko and Al Nobel

Stockton Art Pottery: h. 4"

3 Organized in 1891, the Stockton firm introduced the *Rekston* art pottery line four years later. By the fall of 1897 ten women were regularly employed as artists, and output of the art pottery was about a hundred pieces a day. Three years later economic conditions forced the firm's closure; while successor firms were organized, none resumed production of Stockton's artware.

Private collection

Stockton Art Pottery: h. 4½"

Pottery

Paul Evans

Roblin Art Pottery

4 The second decorative approach was that of translations (sometimes eclectically expressed) of Greek and Oriental objects, especially of classical shapes left in the biscuit state or highlighted with monochrome glazes. Foremost exponents of this technique were the Robertsons of Chelsea, Massachusetts.

Private collection

Roblin Art Pottery: h. 3½", executed by A. W. Robertson, dated February 1906

5 The Roblin pottery of San Francisco was established by Alexander Robertson before the end of the 1890s. Robertson was responsible for the potting and firing, Linna Irelan, his associate, often doing the decorating. L. Irelan's forte was modeling, and pieces with applied mushrooms or lizards were sometimes carried to an extreme. Robertson's own tastes were more severe and classical. Frequently the only embellishment he would employ was finely executed feet or handles, beading or a high-gloss glaze of a quality equal to the finest produced anywhere.

Private collection

Roblin Art Pottery: h. 3", executed by A. W. Robertson, dated April 1905

6 Robertson's chief interest was in the establishment of a pottery which would use California materials exclusively. Extensive experiments had convinced him that California was "the only state in the Union that has all the clays necessary for the production of the finest grades of pottery." Until the 1906 earthquake and fire forced the closure of this pottery, whatever material was used at Roblin—clay, glaze or slip—was native to California.

Private collection

Roblin Art Pottery: h. 3¾", decorated by Linna Irelan, dated 1898

Halcyon Art Pottery

7 In 1904 a Theosophist group opened a sanitorium at Halcyon for the physical regeneration of man, but the community itself was concerned with social, political and economic regeneration as well. To this end the Temple Home Association was formed, which in 1909 evolved a plan for a school and an art pottery. In 1910 the pottery opened with Alexander Robertson as instructor and pottery director.

Private collection

Halcyon Art Pottery: h. 3¼", dated 17 August 1911

8 Students were often responsible for the decoration of the ware, all of which was produced from the local red-burning clays of San Luis Obispo. This particular clay, most often left unglazed, lent itself to modeling and carving, again sometimes carried to an extreme. The early success of the pottery gave rise to

plans which called for it to serve as the basis of an Industrial School of Arts and Crafts at Halcyon.

Private collection

Halcyon Art Pottery: h. 3¼", dated 23 August 1912

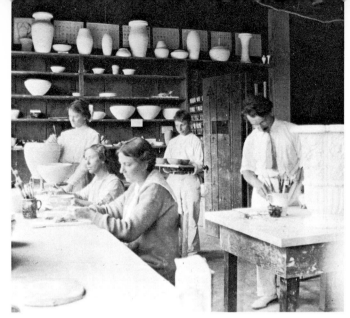

Arequipa Pottery

Frederick H. Rhead
Arequipa, 1911

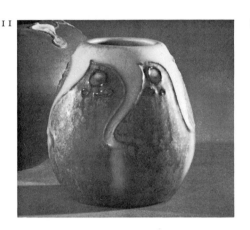

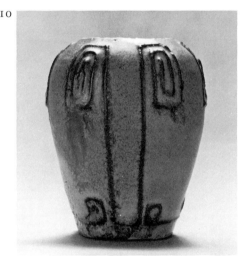

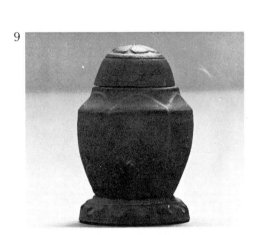

9 Most pieces produced at Halcyon bear some modeled decoration, the lizard being one of the most popular. Robertson himself made a number of significant pieces including this incense burner, clay whistles, paperweights, vases, bowls and pitchers. By 1913, with a revision of the Association's charter, the pottery was closed.

Private collection

Halcyon Art Pottery: h. 2¾",
dated 6 May 1912

10 In 1911 Frederick H. Rhead was employed as ceramist and instructor by Dr. Philip King Brown, organizer of the Arequipa Sanitorium at Fairfax. Like Robertson, Rhead made use of native California clays, Arequipa's coming from Placer County.

Michiko and Al Nobel

Arequipa Pottery: h. 4¾", Rhead period

11 Rhead made use of many of the decorative techniques he had perfected at Ohio art potteries, one of the foremost of which was the use of a squeeze-bag to apply a design motif.

Private collection

Arequipa Pottery: h. 3½", Rhead period

12 Sometimes a squeeze-bag decoration provided the outline into which various colored glazes or slips were inserted. This technique was used extensively in Weller Pottery's *Jap Birdimal* line, introduced by Rhead about 1903 when he was associated with the Zanesville, Ohio, firm.

Private collection

Arequipa Pottery: h. 5", Rhead period

13 The decorative techniques developed by Rhead were pursued by him at the many potteries—no less than seven—with which he was affiliated between 1902, when he came to the United States, and 1917, when he left the art pottery scene. This piece illustrates this point well when it is compared with the very similar example of Rhead's work executed at the Rhead Pottery, Santa Barbara, about 1915.

James and Janeen Marrin

Arequipa Pottery: h. 3″, dated 1912

13

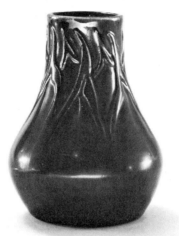

14

16 15

14 Rhead, captivated by the Chinese black glazes, achieved the successful production of these at Santa Barbara. This early example from the Arequipa kilns gives a glimpse of some of the outstanding pieces to come from his Santa Barbara pottery.

Michiko and Al Nobel

Arequipa Pottery: h. 4¾″, Rhead period

15 Rhead left Arequipa in 1913 and was followed by Albert Solon. It was Solon who greatly expanded the output of the pottery and exhibited it at the San Francisco Exposition. Several examples from the Solon period are in the collection of the National Museum of History and Technology (Smithsonian Institution), including one with Solon's prized Persian faience glaze. Work of the type shown here could be either of the Solon or Wilde period, but it is definitely post-Rhead.

G. Breitweiser

Arequipa Pottery: h. 3⅞″

16 F. H. Wilde followed Solon in 1916. In artware he continued much the same type of decoration as pursued during the Solon period with the introduction of some new glaze formulas. Trained in the production of art tiles, Wilde attempted to shift production from artware to handmade tiles, particularly of the Spanish type; but just as these were becoming the mainstay of the pottery, the war in Europe raised havoc with prices and the operation was closed in 1918. The Sanitorium remained open until 1957.

G. Breitweiser

Arequipa Pottery: h. 5½″

Valentien Pottery

17 About the same time Rhead arrived in northern California, Albert and Anna Valentien were beginning their pottery in San Diego. Both had achieved considerable fame through their work at the Rookwood Pottery of Cincinnati, where Albert was head of the decorating department.

Michiko and Al Nobel

Valentien Pottery: h. 6½″, fuchsia design

18 The known examples of Valentien work done at San Diego have art nouveau decoration in low relief. Each bears a shape number in the 20s, prefixed by a Z, perhaps connoting shapes designed for matt glaze decoration (as at Rookwood, where the Z followed the shape designation).

Private collection

Valentien Pottery: h. 8″, freesia design

17

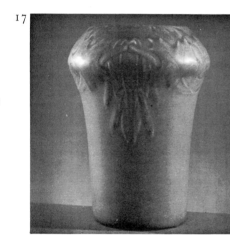

18

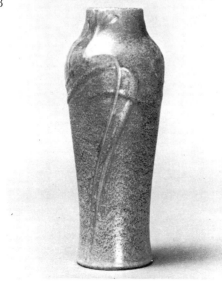

Grand Feu Art Pottery

19 Little is known of Cornelius Brauckman, owner and director of the Grand Feu pottery, or of the actual operation other than that its production roughly spanned the 1912-16 period. What is evident from even a cursory viewing of the output of the firm is the remarkable quality of body and glaze.

James and Janeen Marrin

Grand Feu Art Pottery: h. 7½″

20 *Grand feu*, by definition, is a ceramic ware fired at a high temperature which can mature body and glaze simultaneously. Both porcelain and gres are *grand feu* wares, the Grand Feu Art Pottery concentrating on the latter. *Gres-Cerame*, as the pottery called its ware, is a vitrified body like porcelain but is neither pure nor translucent.

Michiko and Al Nobel

Grand Feu Art Pottery: h. 2½″

19

20

21

22

21 No applied or painted designs were used, Brauckman relying on the natural effects created by the interplay of glaze and heat (the ware was fired at 2500°F.).

Edie and Fidel Danieli

Grand Feu: Art Pottery: h. 5½″

22 Glazes advertised by the Grand Feu pottery were Turquoise, Mission, Tiger Eye, Blue, Yellow, Green, Red and Moss Crystals, Green and Blue Ramose, Moss Agate (sponged appearance of green over light tan), Multoradii, Venetian Green and Sun Ray (shadings of brown, buff and pale green produced by melting glaze). This piece is an example of Mission, a mottled chocolate brown. Examples of Moss Agate and Sun Ray are in the collection of the National Museum of History and Technology (Smithsonian Institution).

Private collection

Grand Feu Art Pottery: h. 7½″

24 The high quality of craftsmanship evident in each piece attests to the caliber of Brauckman's work and places it among the finest art pottery produced in the United States.

Private collection

Grand Feu Art Pottery: h. 3¾″

25 One can speculate that Brauckman was influenced by Doat's book, *Grand Feu Ceramics*, the text which served as the inspiration for Adelaide Robineau's work. To date, however, it has been impossible to establish any direct relationship between Brauckman and Doat while Doat was in the United States.

Michiko and Al Nobel

Grand Feu Art Pottery: h. 5″

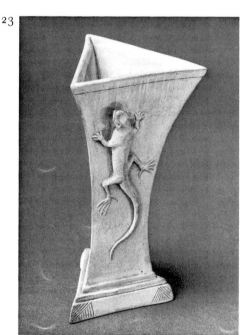

Alberhill Pottery

26 The Alberhill-Corona district in western Riverside County was one of the three most important clay producing areas in California in the early twentieth century. After leaving Halcyon in 1912, Alexander Robertson was engaged by James H. Hill, president of the Alberhill Coal and Clay Company, to experiment with the available Alberhill clays.

Private collection

Alberhill Pottery: h. 5¼″, dated 4 October 1914

27 28

23 During 1914, Robertson's last year at Alberhill, vases displaying the potential of an art line using Alberhill clays were exhibited as part of a lawsuit involving the company and the State of California. At that time Riverside County wanted to take a portion of the land containing the clay deposits for a public highway. Artware production was never undertaken at Alberhill on a large-scale basis, and the work of Robertson remains the sole output of Alberhill art pottery.

Private collection

Alberhill Pottery: h. 6¼″, dated 18 July 1913

27 In his work spanning a two-year period, Robertson produced many finely crafted examples of the potter's art, some receiving a Gold Medal at the 1915 San Diego exposition.

Private collection

Alberhill Pottery: h. 2½″, dated 1914

28 Glazed ware was undertaken on a limited basis, but the bulk of the work was left unglazed to show the qualities of the clay. The bisque vases range from red terra cotta to the softest pink and white, most pieces being of the lighter colors.

Edie and Fidel Danieli

Alberhill Pottery: h. 5⅛″, dated 1914

Markham Pottery

29 Herman C. Markham began his work on a commercial basis in 1905 at Ann Arbor, Michigan, assisted by his son Kenneth. All the ware has the same general appearance: as if recently excavated from some long-buried chamber. Prototypes were built or thrown, and from these molds were made. Shapes were modifications of classical forms, with no decoration other than that occurring in the surface patterns or veinings in the glaze. Each piece bears Markham's signature and an individual number. It appears that numbers below 6000 were produced at Ann Arbor; those above 6000 were apparently executed after the firm's move to National City, California, in 1913.

Michiko and Al Nobel

Markham Pottery: h. 7″, #2963, Ann Arbor period

30 The surface treatment falls into two general categories. *Reseau* has a fine texture and delicate, web-like veinings which are slightly raised, almost appearing to be applied. *Arabesque* is coarser in texture, rough to the touch, and the design is a maze of raised, irregular fine lines. This piece is an example of *Reseau* ware.

Private collection

Markham Pottery: h. 5″, #6939 National City period

31 An example of Markham's other ware, *Arabesque*, this piece again has the typical coloring of the pottery's output. Sometimes examples are found with hints of red, green or other subtle colorings, and often a particular metallic appearance is noted. Pieces of Markham Pottery of both the Ann Arbor (1905-13) and National City (1913-21) periods are in the collection of the Fine Arts Gallery, San Diego.

G. Breitweiser

Markham Pottery: h. 6⅞″, #6312, National City period

32 While the Robertson Pottery was not established in name until 1934, it was established in fact as early as 1906 when Fred H. Robertson joined the Los Angeles Pressed Brick Company. As a clay expert with that firm he produced numerous experimental pieces using new mixtures of clay. About 1913 he began producing artware bearing his initials, marked *F.H.R./Los Angeles*.

Private collection

F. H. R./Los Angeles: h. 4¾″, dated 1913

32

Robertson Pottery

33

34

37

35

34 Luster artware such as this was part of the collections which earned Gold Medals at both the 1915 San Diego and San Francisco expositions.

The Robertson family

F. H. R./Los Angeles: h. 7⅞″

35 Undoubtedly work of this nature was carried on in the pre-1920 period while Robertson remained at Pressed Brick, but never to any great degree. Flowing glazes as exemplified by this piece are of a quality surpassing many of the volcanic-type pieces produced by Fred's uncle, Hugh C. Robertson, at the Dedham [Massachusetts] Pottery.

The Robertson family

F. H. R./Los Angeles: h. 5¼″

36

36 In 1914, F. H. Robertson extensively pursued the development of successful luster and crystalline glazes. This piece is one of his most notable luster achievements.

The Robertson family

F. H. R./Los Angeles: h. 7½″

37 Other decorative techniques were also employed. Here the leaf design is formed by a flowing green glaze on a tan ground.

The Robertson family

F. H. R./Los Angeles: h. 5⅞″

33 This is a particularly successful crystalline piece. Work of this type was largely experimental and little was marketed.

The Robertson family

F. H. R./Los Angeles: h. 6½″

38

38 Among the accessories produced in the Arts and Crafts period were ceramic lamps with glass insets. Vase-Kraft (Fulper Pottery) was one of the first to introduce such lamps with base, stem and shade of pottery. By 1914 Fred Robertson was making similar lamps. This example is glazed with one of the Robertson crystalline glazes; glass insets were by the Judson Studios.

The Robertson family

F. H. R./Los Angeles: h. 15″

40

Rhead Pottery

39 Frederick H. Rhead began his pottery in Santa Barbara in 1913. He brought with him from Arequipa many of his familiar decorating techniques, including this use of the squeeze-bag outline into which a contrasting slip or glaze is filled.

Michiko and Al Nobel

Rhead Pottery: h. 3¼"

39

40 Another decorative technique was Rhead's inlaid process. This was used extensively at the Roseville Pottery, Zanesville, Ohio, in their *Della Robbia* line introduced by Rhead while he was art director (1904-08). This technique was effected by painting the decoration in outline, then applying the background slip and finally filling in the decoration with slips of various colors. After the piece was dried the slip was cut back using a sharp tool either to the outline color or to the body itself. One of the most successful examples of the inlaid process is this low bowl.

Private collection

Rhead Pottery: 8¾" diameter

41

41 Rhead experimented with over 11,000 formulas for a mirror-black glaze before achieving what he considered a success. He observed: "Columns could be written on this subject. The writer has spent some years in developing blacks of temperatures varying from cones 1-3 to 8-10, and finds astonishing possibilities of variation with a slight change of formula and manipulation." This is an example of Rhead's prized mirror black.

Private collection

Rhead Pottery: h. 12¼"

42 Another example of the inlaid process, showing some of Rhead's design concepts. These were often illustrated in the pages of *Keramic Studio* beginning as early as 1903.

Private collection

Rhead Pottery: h. 7¾"

42

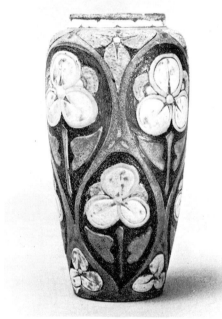

43

43 At Santa Barbara many practical items were also produced, such as this cream and sugar set, elaborately decorated using the inlaid process. Three- or five-piece garniture sets, consisting of two or four vases and a covered jardiniere, were also offered for sale. In 1917 Rhead returned to the east, where he put his great technical expertise to work at the American Encaustic Tiling Company.

G. Breitweiser

Rhead Pottery: h. 3"

California Faience

45 Some of the more typical glazes of California Faience are used in this tea tile with a hammered copper border **by Dirk van Erp.**

Private collection

California Faience: 5½″ diameter

44 The pottery which was to become California Faience was begun in 1916 by William V. Bragdon and Chauncey R. Thomas, at Berkeley. It was known as *The Tile Shop*, a somewhat misleading name since both art tile and pottery were produced. The artware, however, always bore the designation *California Faience*.

Michiko and Al Nobel

California Faience: h. 9½″

46 California Faience ware was mostly cast. Bragdon was responsible for the technical aspects of the pottery including mold-making. Thomas was responsible for most of the glaze development; these were predominantly of the matt variety, although some high-gloss glazes were used.

James and Janeen Marrin

California Faience: h. 1⅝″

Walrich Pottery

47 Artware, for the most part, had the simplicity Stickley deemed so essential to the Arts and Crafts ethos. Monochrome glazes were applied to simple forms so that the one complemented the other.

The Oakland Museum

California Faience: h. 6″

48 Work such as this came to an end by 1930. The production of art pottery was not resumed thereafter, although some tile work was done about 1932 for the Chicago World's Fair. A large collection of tiles from the earlier period is to be found at The Newark [New Jersey] Museum. About a dozen vases illustrative of the firm's earliest work are in the collection of the National Museum of History and Technology (Smithsonian Institution).

The Oakland Museum

California Faience: h. 5⅛″

49 James and Gertrude Rupel Wall were the principals of the Walrich Pottery, a name coined from their son's name, Richard Wall. While considerably later than the normal dating of the Arts and Crafts period, this is one of the exceptions which prove the rule that no hard and fast dates can be applied to any movement. In spirit the work done at Walrich is akin to that of their Berkeley neighbor, California Faience, and the Marblehead Pottery of Marblehead, Massachusetts.

The Oakland Museum

Walrich Pottery: h. 11⅛″

50 Again the simple forms and monochrome glazes predominate, with the bodies extensively cast. Many of the glazes were developed by J. Wall; a traveling case of glaze samples which depict the variety of glazes achieved is in the collection of The Oakland Museum. As at California Faience, art pottery production at Walrich ceased at the onset of the Depression, not to be resumed.

The Oakland Museum

Walrich Pottery: h. 4¾″

The Ceramists:

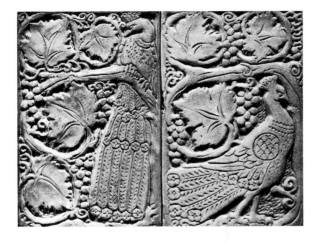

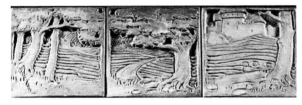

Ernest Batchelder
Cast ceramic tiles
ca. 1909-1920, assorted sizes
Elva Meline

Ernest Allen Batchelder
1875-1957

Ernest Batchelder was born in Nashua, New Hampshire. He was educated at the Massachusetts Normal Art School (grad. 1899). He was influenced by the design theory of the Harvard Professor Denman W. Ross, whose ideas form the basis for Batchelder's two books, *The Principles of Design* (1904) and *Design in Theory and Practice* (1910).

From 1902 to 1909, Batchelder was Director of Art at the Throop Polytechnic Institute. His summers were spent teaching at the Handicraft Guild Summer Schools in Minneapolis. He taught design theory and manual arts training in both places. In 1905 he travelled in England visiting centers of the Arts and Crafts Movement. In 1909 he set up a kiln in the studio at the rear of his property at 626 Arroyo Drive in Pasadena. Success, and complaints of too much smoke forced him to move to larger quarters "down

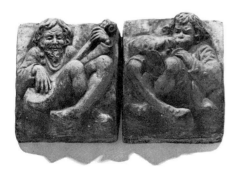

Ernest Batchelder
Cast ceramic corbels
ca. 1912, 6″ x 6″

Dr. Robert Winter

Ernest Batchelder
Ceramic garden fountain
The Oakland Museum

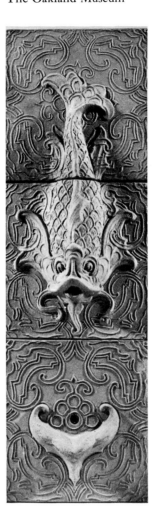

among the gas tanks" on what is now Arroyo Parkway. More success prompted a further move to a factory on Artesian Street in Los Angeles in 1916. His firm failed during the Great Depression. Eventually, Batchelder rented a small shop on Kinneloa Street in Pasadena and turned out extremely fragile slip cast wares, very different from his earlier work.

In the early years Batchelder designed most of his tiles himself. They were hand molded and fired in a kiln which "permitted us to fire nearly forty six-inch tiles at one fell swoop." Under expanded production the hand-crafting of tiles continued. They were "sun dried in a yard at the rear of the shed where cats and chickens frequently walked over them offering a 'pleasing variation of texture.'" Even when he moved to the Los Angeles factory, where conveyor belts took the sand pressed tiles into the vast kilns, Batchelder's motto was "no two tiles the same." At first he worked almost entirely in brown, with blue glaze rubbed into the indentations in vines, flowers, viking ships, peacocks and other animals which Batchelder loved to draw. One critic also noted Batchelder's delight in the California live oak and said, "Perhaps the most noticeable effect of locality is seen in the landscape tiles which speak so charmingly of California."

Robert Winter

William Victor Bragdon
CALIFORNIA FAIENCE

Bragdon, whose name is most often associated with
the California Faience works of Berkeley, was a
ceramic engineer trained at Alfred, New York. After
graduation in 1908 he taught at the University of
Chicago and the University City Porcelain Works
under Taxile Doat. He came to Berkeley in 1915 to
join the faculty of the California School of Arts and
Crafts. The following year, in association with
Chauncey R. Thomas, the operation that evolved into
California Faience was established. The principal
output of the firm was art tile and pottery, which it
manufactured until the Depression; thereafter the
California Faience facilities were used by local artists
and amateur decorators. In the early 1950s Bragdon
sold the pottery to new owners, but its subsequent
operation was of short duration. Bragdon died in 1959.

William V. Bragdon
4½″ diameter

James and Janeen Marrin

Cornelius Brauckman
GRAND FEU ART POTTERY

A native of Missouri, Brauckman came to Los
Angeles about 1909. He established the Grand Feu
pottery sometime late in 1912; the works being
located on the south side of West 96th, second West
of South Main, according to the 1913 city directory.
His work was awarded a Gold Medal at the San
Diego exposition in 1915 and was exhibited the
following year at the First Annual Arts and Crafts
Salon in Los Angeles. It is doubtful that he produced
artware on a commercial basis much after this time.
Little is known of the history of the Grand Feu works
or about Brauckman, who was responsible for the
outstanding ware produced. He died a
quarter-century ago at the age of 88.

Herman C. Markham
MARKHAM POTTERY

Markham was a traveling salesman living in Ann
Arbor, Michigan, and the story is told that he was an
ardent grower of roses. Unable to find containers
which he felt were satisfactory for displaying the
flowers without detracting from them, he began
potting in a most primitive fashion, using clays from

his own yard. From continuous experimentation and
discovery, the two surface decorations pursued by
Markham were evolved. He was joined by his son
Kenneth in 1905, at which time commercial
production of the ware was begun. Eight years later
the Markhams relocated the pottery in National City,
California, where the required clays were easily
obtainable. Output continued until the plant closed in
1921; the following year Markham died, and all
attempts to resume operation ceased.

Frederick Hurren Rhead
AREQUIPA POTTERY
RHEAD POTTERY

A native of England, Rhead followed in the ceramic
tradition of his father, Frederick Alfred Rhead,
becoming art director of the Wardle Art Pottery. He
came to the United States in 1902. After working for
various Ohio artware producers, in 1909 he joined
the University City works where he was associated
with Doat and Robineau. Two years later he came to
California and became ceramist and instructor at
the newly organized pottery at Arequipa Sanatorium
in Marin County. In 1913 he left to begin the Rhead
Pottery at Santa Barbara, where his work continued
for about three and a half years. He then joined the
American Encaustic Tiling Company of Zanesville,
Ohio. Remaining there until 1927, he became art
director of the Homer Laughlin China Company, a
position held until his death in 1942.

F. H. Rhead
Panel, ceramic tiles mounted in concrete
19″ x 35″, ca. 1913-1916

G. Breitweiser

This tile panel designed for garden use,
with lustre glaze, was made by Rhead
during the three year period when he had
his own pottery in Santa Barbara.

Alexander W. Robertson
ROBLIN ART POTTERY
HALCYON POTTERY
ALBERHILL POTTERY

Alexander Robertson was born in England in 1840
and came to the United States in 1853. Thirteen years
later he established the Chelsea Keramic Art Works
at Chelsea, Massachusetts. In 1884 he permanently

relocated in California, where he experimented with local clays. During the 1890s he tried several times to establish an art pottery in San Francisco until in 1898, in association with Linna Irelan, he organized the Roblin Art Pottery. Following the 1906 holocaust Robertson relocated in Los Angeles, remaining until 1910, when he began the operation of an art pottery at Halcyon, one of the state's utopian colonies. In 1912 Robertson was engaged by the Alberhill Coal and Clay Company to experiment with local clays at Alberhill, California. Plans for production of art pottery were not carried through, and he left in 1914. After brief appearances at the Mission Inn and the San Diego exposition, he retired from active work about ten years prior to his death in 1925.

Fred H. Robertson
ROBERTSON POTTERY

Fred Robertson, born in 1869 in Massachusetts, joined his father in work at the Roblin Art Pottery, San Francisco. Following their relocation in 1906 in Los Angeles he was employed at the Los Angeles Pressed Bricks works, where about 1913 he began experiments with artware, especially with crystalline and luster glazes. Output—marked *F.H.R./Los Angeles*—was limited and experimental in nature, although it captured Gold Medals at the San Diego and San Francisco expositions. In the early 1920s he became associated with the Claycraft Potteries, manufacturers of architectural tiles, and was joined there by his son, George B., about 1925. Ten years later they organized the Robertson Pottery, which continued in operation until 1952, the year of Fred H. Robertson's death.

Albert L. Solon
AREQUIPA POTTERY

Albert Solon was the second art director of Arequipa, following Rhead in 1913. Born in England in 1887, he was a member of a famed family of ceramists. Louis M. Solon, his father, was associated with the Sevres and Minton works. His grandfather, Leon Arnoux, was art director at Minton, a position to which Solon's brother, Leon V., succeeded prior to coming to the United States in 1900. Albert Solon remained at Arequipa for three years, introducing numerous new glazes including some Persian faience ones. During his tenure Arequipa received a Gold Medal at the San Francisco exposition. He left Arequipa and, after teaching for a short time at what has since become California State University, San Jose, he organized Solon & Schemmel at San Jose, manufacturers of decorative wall and floor tile. A decade later, after he was joined by Paul G. Larkin, the designation was changed to Solon & Larkin. Solon died in 1949.

Albert and Anna Valentien
VALENTIEN POTTERY

Both Valentiens were born in Cincinnati, Ohio, and both studied at the Cincinnati Art Academy.

Valentien and Anna Bookprinter were married in 1887 while they were decorators at the Rookwood Pottery. They left Rookwood in 1905 and Cincinnati two years later, when they relocated in San Diego. The move was evidently prompted by Albert's commission, received that year from Miss Ellen Scripps, to paint all the California wildflowers (this collection of drawings is now at the library of the San Diego Natural History Museum, Balboa Park). With the backing of a local banker, J. W. Sefton, Jr., who had a pottery designed by Irving Gill in 1911, artware was produced. Whether the Gill redwood board and batt structure was ever erected is unclear, but a tentative dating for the production of artware would be somewhere between 1910 and 1914. Albert Valentien died in 1925, Anna a quarter-century later.

James and Gertrude Wall
WALRICH POTTERY

Gertrude Rupel Wall was born in 1881, her husband James four years earlier. A native of England, James was employed at the Royal Doulton works before coming to the United States. The Walrich Pottery was begun in 1922 in competition with California Faience, the work of each being fairly similar. Production ended with the onset of the Depression, never to be resumed. Gertrude taught thereafter in various arts and crafts programs until ill health forced her retirement; she died in 1971. Richard worked for Westinghouse's Emeryville plant, which manufactured high-voltage porcelain insulators, and later for the San Francisco schools, firing for their art students; he died in 1952.

James and Gertrude Wall
5⅝" square

Private Collection, Riverside

Walrich Pottery produced high gloss tiles such as this as well as the vase forms shown elsewhere in this book. This particular tile is glazed in blue and yellow.

Fred H. Wilde
AREQUIPA POTTERY

F. H. Wilde, a native of England who came to the United States in 1885, succeeded Rhead and Solon at Arequipa, becoming its third and last director in 1916. Previously Wilde had been associated with several tile operations, including the Robertson Art Tile Company of Morrisville, Pennsylvania, and the Pacific Art Tile Company of Tropico, which later became the Western Art Tile Company. The pottery operation of Arequipa closed in 1918. Wilde joined the Pomona Tile Manufacturing Company of Los Angeles at the time of its formation in 1923 and remained there as ceramic engineer until his retirement in 1940.

One of the aspects that excited the founders of the Arts & Crafts Movement was the individuality of expression in medieval decorative art. As aesthetes and artists, Ruskin and Morris abhorred tedious repetition of design, regardless of whether it was executed by hand or by machine. They considered spontaneity and integrity of workmanship to be the necessary components of a vital art form.

In 1901, Gustav Stickley began to publish *The Craftsman*, a magazine devoted to the propagation of the Arts & Crafts Movement in this country. The first issue, a monograph on William Morris, quoted him on the ideal workman: "The true workman must put his own individual intelligence and enthusiasm into the goods which he fashions. He must have a natural aptitude for his work so strong that no education can force him away from his special bent. He must be allowed to think of what he is doing, and to vary his work as the circumstances of it vary, and his own moods. He must be forever stirring to make the piece at which he is at work better than the last. He must refuse at anybody's bidding to turn out,—I won't say a bad,—but even an indifferent piece of work, whatever the public wants, or thinks it wants. He must have a voice worth listening to, in the whole affair."

Stickley's own experiment with the guild system lasted only two years and then his organization reverted to more traditional methods of production while still maintaining excellence of workmanship and materials. In 1906 he said "The hope of reform would seem to be in the direction of a return to the spirit which animated the workers of a more primitive age, and not merely to an imitation of their method of working."

Dirk van Erp was an inheritor, not an imitator of pre-industrial craftsmanship. As such, he proved to be the embodiment of the Morris ideal. As the son and apprentice of a commercial coppersmith, van Erp was a product of the vernacular tradition that Morris admired.

Lacking formal training in design, van Erp's early shell vases have a naive quality but exhibit sensitivity to form and proportion. Little is known about the transition from this early stage to the refinement of his mature works. Although he subscribed to *The Craftsman* for some unspecified period of time, he was not in the habit of using books on design. When he became established, he occasionally collaborated with artists and other craftsmen in his shop.

Once a design became part of the working vocabulary of the shop, it was almost irrelevant who the originator was. Each craftsman was free to modify a design according to his mood. The resulting work had a validity of its own, analogous to that of a folk painting which owes its inspiration to some established work of art.

These fluctuations in designs were a natural outcome of the working procedures. William van Erp recalls that his father would cut a sheet of copper into as many as twenty shapes and hammer them spontaneously into finished forms. According to William, his father "had it in his head and in his hands. There was no lost motion whatsoever when he started to make a piece. [Either] it came out a very nice piece, [or] it never got finished."

At some point, more rigorous procedures were implemented to manufacture lamps. There was division of labor to the extent that bases were made by journeymen and shades by apprentices. Patterns were used for both the bases and shades. Even so, subtle variations of proportion and planishing distinguish each example of a given design.

Although spontaneity of execution was a goal of the Arts & Crafts Movement, it was rarely practiced. Roycroft is an example of a professed guild organization which permitted its craftsmen little in the way of spontaneity. Granting that Roycroft objects were made by hand, certain expediencies were employed which resulted in a uniformity of expression characteristic of mass production. These included the use of lathes and wooden templates to form the objects and the use of specially constructed tools to stamp the repoussé ornamentation. As an amusing commentary on the Roycroft claim that all objects passed under the hand of the craftsman, van Erp said that Hubbard probably stood on a bridge over the railroad tracks and extended his hands over the passing trains laden with Roycroft merchandise.

To van Erp, a hand-wrought object had to be made without the use of any power tools. An anecdote told by his son illustrates his attitudes toward the machine. The incident occurred after the responsibility for the shop had been transferred to William, and Dirk only worked there occasionally. "I was making a fire screen one day, and I went over to the hardware store and . . . saw an electric drill, . . . I had been sitting there with a hand drill, . . . and I thought if I buy that drill I can make a fire screen in half the time, so I . . . bought the drill. That day he [Dirk] walked out and went home. And he said, 'When you make a thing by hand, you make it by hand.' "

Metalwork
Bonnie Mattison

At the other end of the spectrum, Gustav Stickley said of the machine, "Given the real need for production and the fundamental desire for honest self-expression, the machine can be put to all its legitimate uses as an aid to, and a preparation for, the work of the hand, and the result be quite as vital and satisfying as the best work of the hand alone."

Because van Erp was not an empire builder, his impact on the Arts & Crafts Movement was limited predominately to the Bay Area. His works, rooted in a utilitarian tradition, complied with the aesthetic canons of the emerging American style. Simple, abstract forms were enhanced by planishing which followed the form of an object and lent interest to the surface texture analogous to artists' brush-strokes. Structural elements, such as rivets, were used ornamentally. Other ornamentation was confined to a restrained use of brazed, appliqué monograms and cut-out designs. These two-dimensional motifs were usually contributed by consulting artists. Van Erp introduced the use of rutile, titanium dioxide, to achieve reddish-brown color effects. It had been used in his father's hardware shop as an agent which permitted the workmen to see their hammer marks while planishing an object. Some of van Erp's works were left unplanished, revealing the actual hammer marks that shaped the form. These objects have a warty appearance and are usually accompanied by *fire-color*, a brilliant red achieved by heating the copper during the annealing process. Because van Erp never indulged in the more exuberant and romantic extensions of the Arts & Crafts style, his works have a timeless quality which characterizes the vernacular art of past ages.

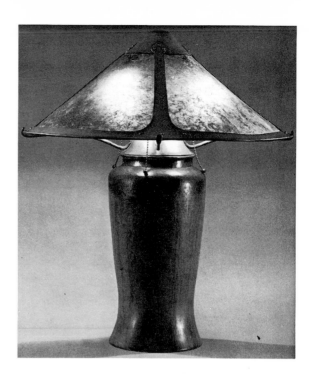

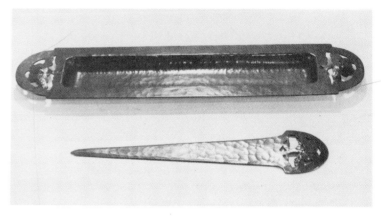

This vase was left unplanished, revealing the original hammer marks that formed the shape, leaving a "warty" surface texture. Mark: *DIRK VAN ERP* in a broken box below windmill motif with *SAN FRANCISCO.* h. 5"

Private collection

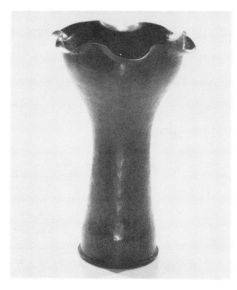

This is one of the very early vases made from brass shell casings. The bottom bears the munition manufacturer's initials (U.M.C. Co.) and a number (6-98) which probably represents the date of manufacture. Unmarked. h. 13" ca. 1900.

Mr. and Mrs. William van Erp

The oak tree motif on the letter opener and pen tray was designed in 1915 by Thomas A. McGlynn for Dirk van Erp. McGlynn studied at the San Francisco School of Design (ca. 1903) before working for Lucia and Arthur Mathews at The Furniture Shop. Later in his career, he became known in the Bay Area as a landscape painter. Mark: *DIRK VAN ERP* in a broken box below windmill motif with *SAN FRANCISCO.* L. Letter opener 7½", pen tray 11"

Private collection

The occurrence of a broken hallmark on this lamp establishes that the break occurred before the shade was modified. h. 26". Mark: *DIRK VAN ERP* in broken box below windmill motif.

James and Janeen Marrin

This umbrella stand is marked *DIRK VAN ERP* in a broken box below windmill motif with *SAN FRANCISCO*. It is not known when the '*SAN FRANCISCO*' mark was introduced. It is a separate stamp which often occurs in the blank area vacated by the removal of Miss Gaw's name. It can also occur outside the original windmill hallmark. h. 22"

Private collection

Between 1911 and 1915, the rim of the shade on the table lamps was changed from a continuous slope to the bent shape shown here. Mark: *DIRK VAN ERP* in broken box below windmill motif with *SAN FRANCISCO*. h. 22½"

James and Janeen Marrin

The proportions of this early rivet lamp are more severe than those of the later versions. The diameter of the neck is 1¼" sloping to 7" at the widest part of the base The evolution of this shape represents two different points of view with respect to form. In the early version, designed by Miss Gaw, an artistic effect has been achieved by extending the proportions to their extremes. The later version illustrates van Erp's restrained interpretation of this design. The mica paneled shade is by William Van Erp, 1974. Mark: *D'ARCY GAW & DIRK VAN ERP* in a box below a windmill motif. h. 17", 1910

Private collection

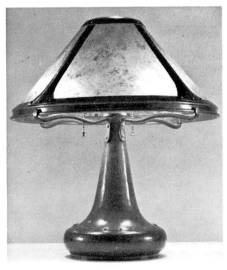

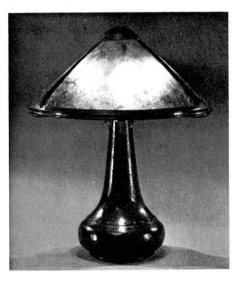

Inkwell with riveted applique on lid. Mark: *DIRK VAN ERP* in box below windmill motif. h. 2¼"

Ethel and Terence Leichti

The sensitive treatment of the radial hammer marks on the handle and body of the desk blotter lend interest to an otherwise simple and functional object. Mark: *DIRK VAN ERP* in broken box below windmill motif with *SAN FRANCISCO*. l. 5⅝" w. 3⅛"

James and Janeen Marrin

The radial hammer marks carry out the shape of the tea tray. Marked *D'ARCY GAW & DIRK VAN ERP* in box below a windmill motif. Diameter: 22" 1910

Private collection

This lamp illustrates that the essential elements of van Erp's lamp designs were established before his partnership with D'Arcy Gaw. The four straps on the shade extend to the top of the shallow cap where they meet at the center. The fine workmanship includes hand planishing of the structural rivets. Hammered copper with mica panels in shades are characteristic. Unmarked. h. 22"

Private collection

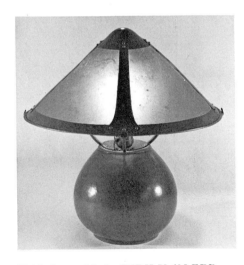

Camelia bowl. Mark: *DIRK VAN ERP* in box below windmill motif. h. 3″ ca. 1912

Private collection

Vase. Mark: *DIRK VAN ERP* in broken box below windmill motif with *SAN FRANCISCO*. h. 7″

James and Janeen Marrin

Table lamp. Mark: *DIRK VAN ERP* in a box below windmill motif. h. 17½″ ca. 1912

Private collection

Vase. Mark: *DIRK VAN ERP* in a box below windmill motif. h. 15″

Private collection

Table lamp. Oriental designs were a source of inspiration for van Erp. Mark: *DIRK VAN ERP* in a box below windmill motif. h. 25½″ ca. 1912

Private collection

Vase. Brass with copper bottom. Mark: *D'ARCY GAW & DIRK VAN ERP* in box below windmill motif. h. 8½″ 1910

Ethel and Terence Leichti

Bookends with cut-out design. Mark: *DIRK VAN ERP* in broken box below windmill motif. h. 7″

Ethel and Terence Leichti

In this candlestick the repetition of hexagonal shapes and the starkly angular handle suggest that this design was contributed by a consulting artist. Mark: *DIRK VAN ERP* in box below windmill motif. h. 3¼″ ca. 1912

James and Janeen Marrin

Ernest Batchelder, designer
Douglas Donaldson, craftsman
Chandelier
21″ diameter, 1913

Mr. and Mrs. Thomas H. Ott

This chandelier was fabricated from
copper and glass by Donaldson to
Batchelder's design for his own dining
room. The bird motif is used in other
areas of the Batchelder house.

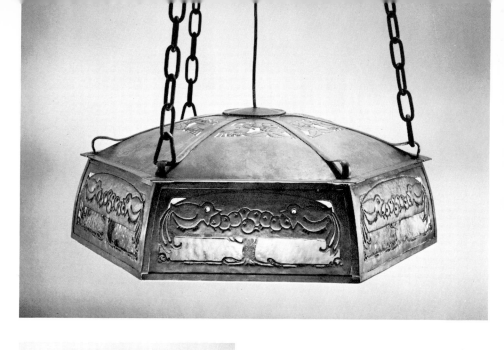

Harry S. Dixon
Wall hung fixture

Mrs. Harry Dixon

This copper and glass wall hung external
fixture indicates the honest design
approach with which Dixon emerged
from his apprenticeship to van Erp.

Harry S. Dixon
Umbrella stand, brass
17″

James & Janeen Marrin

Harry S. Dixon
Covered jar, copper
4¾″

James & Janeen Marrin

Harry S. Dixon
Shop sign
29″

Collection of the Oakland Museum

This sign of inked woodcarving marked
the San Francisco shop of Harry Dixon,
metalsmith.

This lamp with four bulbs and pierced
shade was not listed in the Burton catalog,
and was possibly a custom piece. Mrs.
Burton worked in bronze and brass as well
as copper, and the names she gave the
lamps in her line, Prometheus, Diana,
Athene, Aphrodite, etc. gave strong hint
of classical leanings.

Elizabeth Eaton Burton
Table lamp, copper repoussé
20″

Mary Q. Zaffuto

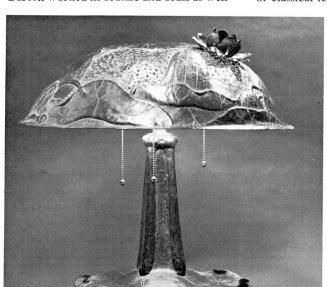

Old Mission Kopper Kraft
Bookends, copper with embossed decoration

Private Collector, Riverside

Little is known about the San Francisco based firm whose products are shown below.

Clemens Friedell
Trophy placque
20½″

Dr. Francis Ballard

Handsome trophies were very much a part of the times. This particular piece was remembered by Friedell's son as having been made for Anita Baldwin. The copper work is raised and chased, with orange blossoms and the ubiquitous California poppy placing it firmly in time and place.

Old Mission Kopper Kraft
Desk set, copper and brass

Mr. and Mrs. Charles R. Crozier

Anonymous
Table lamp, copper and abalone shell
12″

G. Breitweiser

This lamp is not marked, though obviously, in the use of materials at least, it is influenced by Elizabeth Burton.

Elizabeth Eaton Burton
Table lamp, copper and abalone shell
10″

G. Breitweiser

This lamp was listed in Elizabeth Burton's catalog at $15. It could be ordered with a shade of melon, nautilus or abalone shell.

Elizabeth Eaton Burton
Table lamp, rose tarpon and copper
14″

G. Breitweiser

Endless variations of the copper tube and shells were available in lamps from one to five lights. Mrs. Burton worked in Santa Barbara.

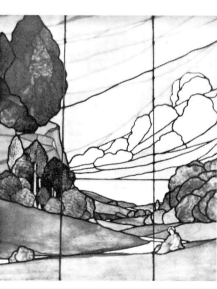

Bruce Porter
Window, stained glass, leaded
San Diego Children's Home 39″, ca. 1900

Catherine Porter Short

John O. Bellis
Spoons and fork, hand wrought silver
ca 1900-1915

Dr. Elliot Evans

Left and right: Salad fork resembling Shreve & Co.'s *Antique Hammered* line, and cross topped spoon recalling their final "XIV Century" pattern. Both pieces appear to be Bellis' reworking of blanks made elsewhere. The spoon still carries the stamp of the Newburyport Silver Co. to which Bellis' name and STERLING have been added. The initials were individually designed and are recollective of Bellis' early training at the Shreve & Co. factory.

Center: Tea and dessert spoons of 19th century inspiration with especially designed-engraved initials.

Marked: *JOHN O. BELLIS STERLING*

Shreve & Co.
Spoons and porringer

Dr. Elliot Evans

Left to right:
Spoon of the later *XIV Century* pattern, 1912, in which all pieces were alike, cross topped, studded.

Handmade spoon, forerunner of Shreve's *XIV Century*, it carries the engraved date, *1905.*

Spoon of the *XIV Century* pattern of 1908, in which "12 different styles of tops in each dozen" were featured.

Norman Hammered spoons appeared early in 1909.

Marked: *SHREVE & CO. STERLING*

Clemens Friedell
Silver rose pin
4¾"

Dr. Francis Ballard

The rose was the symbol of Pasadena and this was therefore a popular piece in Friedell's shop.

Rudolph Schaeffer
Coffee pot
8½", 1913

Rudolph Schaeffer

Schaeffer taught manual training at Throop before establishing his own design school. This refined little coffee pot, silver plated over copper with walnut handle makes one regret that he did not do more metalwork.

Expertly hammered child's porringer is enhanced with a very early version of the notable *Shreve Strap*, heavier and more sinuous than the later types. This piece bears the engraved date, December 24, 1900.

Marked: *SHREVE & CO. SAN FRANCISCO STERLING*

Clemens Friedell
Silver bowl
3"

Dr. Francis Ballard

The California poppy is here seen in yet another form. Sunday excursions to the poppy fields at the end of the Pacific Electric's red car runs brought tourists back with armloads of these delicate flowers, which may explain their relative rarity today!

Clemens Friedell
Silver pitcher
9″

Dr. Francis Ballard

Fine craftsmanship, solid weight, were the constants with florid baroque repoussé as often employed as hammered finishes.

Water pitcher, ca 1912, a distinctive *Shreve Strap*, hammered, studded and with spaced crosses, combined with gracefully curved outline and handle is typical of much of their work, 1900-1920.

Marked: Three part bell mark *SHREVE & CO. STERLING SAN FRANCISCO*
3½ pints
#1868

Dr. Elliot Evans

Anonymous
leaded glass window
18″, ca. 1910

Tim Andersen

Frederick L. Roehrig
Table lamp
16″, from the 1905 Eddy house

Tim Andersen

Made of wrought iron and with a mica shade, this lamp was part of the furnishings of the recently demolished Eddy house.

Anonymous
Newel post lamp
9¼″

James & Janeen Marrin

Made of copper and stained glass, this functionally designed external light seems of timeless design.

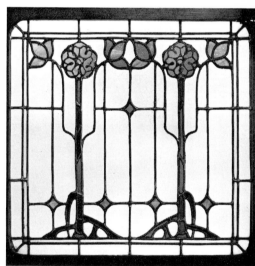

Attr. Alfred Heineman
Window, leaded glass
W. E. O'Brien house, 18½″, 1912

Robert Winter

Louis B. Easton
Light fixture
18½″, from the Volney Craig house, 1908

Katherine B. Trower

The wall mounted fixture is made of brass, opalescent glass shades.

Arthur & Alfred Heineman
Exterior light fixture
10⅜″, for Winslow Ross house, 1910

Mr. & Mrs. Malcolm Stinson

The oak tree was a favorite natural subject, and here, in this wall mounted copper light fixture with mica shade it assumes graceful and integrated form.

Greene & Greene, designers
Craftsman unknown
Mail box copper
10″, 1911

The Gamble House

The Metalsmiths:

Harry St. John Dixon
1890-1967

Harry Dixon's sixty year career was punctuated by two world wars and a depression. The period prior to the First World War was devoted to acquiring the skills of his profession. Two important figures in his development were his brother Maynard and Dirk van Erp. From the latter, he received a foundation in the materials and processes of metalwork. The utilitarian aspects of Harry's training were reinforced by five years in Lillian Palmer's shop followed by an interlude in the shipyards. Harry's artistic development was influenced by Maynard and his circle of friends. He also received formal training in design at the California School of Arts and Crafts in Oakland. The result of this background was a balance between artistry and craftsmanship.

Although Harry Dixon's studio work began after the First World War, and thus falls outside the Arts and Crafts period, many of his most vital works throughout his career were extensions of the Arts and Crafts idiom. His major commissioned work of the 20s was the elevator doors for the San Francisco Stock Exchange Club.

In spite of failing health, Harry continued to work until his death in 1967. His last major work (1960) was the 48 inch copper sundial in the shape of a lotus blossom at the Burbank Memorial Garden in Santa Rosa.

Bonnie Mattison

Douglas Donaldson
1882-1972

Coming to Los Angeles from his birthplace, Detroit, Michigan, Douglas Donaldson taught design, metalwork and jewelry at many Los Angeles area schools, and was associated at various times with Ernest Batchelder, James Winn, Rudolph Schaeffer, and Ralph Johonnot. His first position was at Throop Polytechnic as Director of Manual Arts, which he left to teach at the new Chouinard School of Art. (His position at Throop was filled by Rudolph Schaeffer.) He was subsequently head of the Art Department of the Los Angeles Manual Arts High School. There, as elsewhere, he emphasized to his students that "the conception of beautiful ideas must lead the way—the technical processes simply being the words which compose the language of art." Later Donaldson taught at the Otis Art Institute, and formed his own School of Decorative Design at his Hollywood home in the 20's. With his wife, he established a Decorative Arts Guild which displayed outstanding crafts from around the country. In 1925 Donaldson was elected first vice-president of the newly-formed Arts and Crafts Society of Southern California.

Clemens Friedell
1872-1963

Clemens Friedell was known for his fine craftsmanship in silver, and especially for his repoussé work. Born in New Orleans, he grew up in his parents' native Vienna. When he was fourteen he earned money giving lessons on the zither and other stringed instruments. He worked seven years as an unpaid apprentice to a Viennese silversmith, and in 1892 returned to the United States. He worked for a

silversmith in San Antonio, Texas, and from 1901 to 1907 worked for the Gorham Co. in Providence, Rhode Island. In 1908 Friedell came to Los Angeles and first supported himself by making silver ash trays for the Broadway Department Store. In 1909 he moved to Pasadena and set up a back-porch workshop. Friedell later had shops on North Lake Avenue and Colorado Boulevard, and in the Huntington and Maryland Hotels. The single commission of which Friedell was most proud was a 107-piece handwrought and chased sterling silver dining set which he spent over six-thousand hours making, and which was ornamented with more than ten-thousand orange blossoms. For many years Friedell designed and made the silver cups awarded for prizewinning floats in Pasadena's Tournament of Roses.

Bruce Porter

1865-1953

Bruce Porter was designer, painter, poet, and critic, perhaps best known for his San Francisco monument to Robert Louis Stevenson in Portsmouth Square. Porter was born in San Francisco and was largely self-educated, having left school at the age of fourteen. He painted murals, designed gardens, and created numerous church windows for clients in San Francisco, San Mateo, Stockton, and Pacific Grove. In Southern California, he designed windows for the Children's Home in San Diego and the Christ Episcopal Church in Coronado. Many of the details at Lummis' "El Alisal" were by his hand, and also a garden in nearby Pasadena. With Gelett Burgess, Porter edited the lively little journal, *The Lark*, and contributed to its essays, poetry, cover designs and illustrations. He also wrote the prefatory essay for *Art in California* published in 1909. Porter was a member of *les Jeunes*, the young Bay Area Bohemians, and was secretary of the San Francisco Guild of Arts and Crafts.

Rudolph Schaeffer

1886—

Rudolph Schaeffer is one of the pioneers in the field of color study related to environmental design. Born in Clare, Michigan, 1886, he taught school in Michigan and Ohio after graduating from the Thomas Normal Training School in Detroit. In 1909 he studied in summer design classes conducted by Ernest Batchelder in Minneapolis. At Batchelder's urging he came to Pasadena to teach manual arts at Throop Polytechnic School. This position had been previously held by Douglas Donaldson, who had gone to Chouinard School as one of the founding members. In 1914 he was appointed by the United States Commissioner of Education to make a study in Munich of the role of color in the curriculum of vocational schools. Just before the turn of the century Germany had perfected dyes which encompassed the entire range of the light spectrum including turquoise, chartreuse and magenta. Schaeffer was quick to introduce these new colors along with other prismatic colors into crafts, interior and stage design.

His concern with color led him to introduce especially dyed warp in his weaving classes—a departure from the traditional white warp. The late Dorothy Liebes credited Schaeffer for certain color ideas which changed the face of American industrial textile design.

Believing in the great therapeutic value of color in the home Schaeffer was early to organize courses in colorful flower arrangement, and in 1935 his book on flower arrangement was published.

Schaeffer established his own school of *Rhythmo-Chromatic* Design in San Francisco in 1926 which continues under his direction to train students in color, textile and environmental design, and over its long career has made a lasting impact upon the appreciation of aesthetic values in daily living.

Dirk van Erp

1860-1933

Dirk van Erp was born in Leeuwarden, Holland in 1860. His father was the proprietor of a hardware shop which produced handwrought milk cans and cooking utensils. As the eldest of seven children, Dirk was first in line to inherit the family business, but he chose instead to come to this country in 1886.

In 1900, while working as a marine coppersmith at the Navy shipyard in Mare Island, he began to bring home brass shell casings which he made into vases. This soon developed into a profitable side line and by 1906 a fashionable San Francisco gallery, (Vickery, Atkins & Torrey) was carrying his work on consignment.

In 1908, when he was forty-eight years old, he opened his own shop in Oakland and began to devote his full energies to art metalwork. Two apprentices to van Erp during this time were his daughter Agatha and Harry S. Dixon.

In 1910 he moved the business to Sutter St. in San Francisco, and went into partnership with D'Arcy Gaw, a weaver associated with the New York firm, Herter Looms. Since she collaborated on the metalwork designs, her name was included on the windmill hallmark introduced that year. When the partnership was terminated in 1911, Miss Gaw's name was removed from the hallmark. In the process, the lower right edge was weakened and later chipped off.

The studio reached its zenith in 1915. The following year the United States went to war, van Erp went to work in the shipyards, and the studio was maintained primarily by Agatha with some assistance from his son William. After the war, some of the old designs were modified as a concession to changing styles, but the emphasis was still on form and good craftsmanship. van Erp retired in 1929, but continued to work occasionally until his death in 1933.

Bonnie Mattison

The year 1910 appears midway in a period when a remarkably versatile couple occupied the forefront of San Francisco's flourishing arts community. Indeed, the term *California Decorative Style* has come to be applied almost exclusively to the wide range of artistic creations produced by Arthur and Lucia Mathews from the late 1890's to the early 1920's.

For the Mathewses the word *decorative* held none of the superficial connotations that are implied by its pejorative use in today's art criticism. Arthur and Lucia Mathews subscribed to the then popular notion that *decoration* was the artist's highest calling. They harkened to a time when great artists were engaged by a wealthy patronage to supply the visual enrichment to civilized living.

By 1890 San Francisco had established itself as the solitary outpost of genteel civilization in the West, a reputation hard won from a period of exuberant development that had occurred since the Gold Rush. San Francisco, in its perfect setting of rolling hills surrounded on three sides by an ocean and a natural bay, with its nearly ideal climate, became the obvious point of convergence for a wide variety of enterprises that followed close behind the rich discoveries in the nearby gold fields. A healthy economy ensued from the influx of shipping, merchants, builders, banking and railroads that in turn produced the wealthy class, a patronage for the artists, during what may be referred to as the first golden age of the arts in California.

Although not in the same league with Paris and New York, *cosmopolitan* San Francisco nevertheless provided California citizens and visitors virtually their only access to culture for several decades, and thus earned for itself the sobriquet *Paris of the West*. During that period, this identification with Paris, especially in the arts, became even closer than the term implies. In the 1890's many of the faculty who taught at the School of Design in the Mark Hopkins Institute, San Francisco's *art academy*, received their training in Paris rather than Munich and Düsseldorf as had their predecessors. This contact with the French Beaux Arts was especially meaningful for its effect on Bay area artists after the turn of the century; and it was Arthur Mathews, Dean of the Mark Hopkins Institute from 1890 to 1906, who was largely responsible for that influence.

After coming to California from Wisconsin at an early age, Mathews received his art training in Paris under Boulanger and LeFebvre at Académie Julian. As a student he easily demonstrated his competence as a figure painter worthy of the French academic style, but he also absorbed many of the new art attitudes that flourished in Paris during the late 1880s. Consistent with his classical orientation, Mathews chose subjects from mythology in which figures metaphorically expressed his affinity for a philosophy that equated art and nature. It is not surprising that his major influences outside the Académie were the paintings he had seen by Puvis de Chavannes and Whistler rather than those of the Impressionists, although certain decorative aspects of the Post Impressionists and the Nabis left their marks on his mature style. It was the figurative murals of Puvis de Chavannes and the aesthetic values, especially color tonality, of Whistler's paintings which had the greatest effect upon Arthur Mathews as an artist-decorator-teacher. Mathews, like Whistler and other artists in Paris at the end of the nineteenth century, became fascinated by Oriental art—particularly Japanese woodblock prints. What they suggested by way of insights to the decorative application of figurative imagery in line, color and composition is apparent among the designs and paintings in the California Decorative Style.

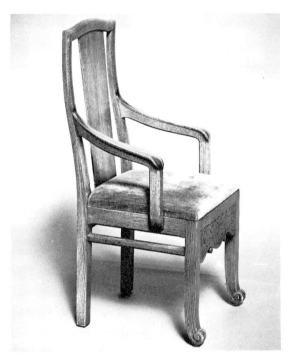

Arthur F. Mathews (Furniture Shop construction)
Dining chair, carved, stained, incised wood, velvet upholstery.
41½" x 23" x 20"

Collection of the Oakland Museum

Arthur and Lucia Mathews
Harvey L. Jones

Some of those same influences from Asian art served as inspiration to many artists working in the then popular international style called *Art Nouveau*. It is interesting to consider possible connections between it and the California Decorative Style, but there is really very little beyond the common spirit of origin to compare. Arthur Mathews considered Art Nouveau to be merely a fad and not a style at all. A few recognizable symbols such as swans, peacocks or other exotic nature forms favored by Art Nouveau occasionally appear in Mathews' paintings and designs, but the characteristic whiplash curves and arabesques are seldom used. A rare but notable exception is found in Mathews' painting titled *The Wave*, which evokes a certain rhythmic sense of Art Nouveau. It is unlikely that he ever consciously worked in the style despite his identification with the broader themes of the movement which were compatible with his own *art and nature* ideas.

Following Mathews' return to San Francisco, the French artistic impressions were tempered or somewhat modified by certain aspects of California itself. Climate, color, light, topography, vegetation and prevalent ideals of the social scene were coming to bear on Mathews' *French* figurative style.

In retrospect, his greatest contribution to California painting was to establish a figurative tradition which was uniquely California—Mathews' characteristic combination of classic figure groups in the distinctive regional landscape. Nature was truly his most direct source of inspiration and his best teacher. Few painters before Mathews had captured the unique essential qualities of the California landscape which are distinguishable from any other locale: the specific contours of the hills, the true colors and that most elusive aspect, the bright hazy atmosphere. Mathews revealed that he never worked outside until four o'clock in the afternoon because he felt that the most extraordinary color effects here in the West come only in the diffused afternoon light. Artists coming to California from Europe or eastern America at an earlier time were predominantly landscapists who preferred the awe-inspiring scenes of Yosemite Valley, the redwood forests or the rugged coastline to the exclusion

of figure-dominated subjects. In Mathews' paintings we are given a somewhat generalized yet more personal viewpoint that reveals subtleties of California scenery that are somehow more typical than the *postcard* views dramatized by other artists.

San Francisco born Lucia Kleinhans began her long association with Arthur Mathews first, as his prize student at the Mark Hopkins Institute and later, as his wife and sometimes collaborator in decoration projects. That Lucia's work fits within the definition of the California Decorative Style is evident, and that it shows the influence of her husband is perhaps obvious, but there remains a special accent within the Style that is uniquely hers. Possibly the better artist of the Mathews couple, her best efforts, although fewer in number and smaller in scale, attest to the notion that she was at least his equal in most respects. Scale is a significant factor in distinguishing between Arthur's and Lucia's individual painting styles. Unlike her husband, Lucia did not approach painting from an architect's or muralist's orientation. Hers was a somewhat more *painterly* technique. It was confined to a small format and projected an immediacy of expression that was

The Furniture Shop and Lucia K. Mathews
Four Panel Screen, plywood, oil paint
and gold leaf
Each panel 72″ x 20″

Collection of the Oakland Museum

somehow lacking in Arthur's creations on the grand scale. Among her most appealing works are the watercolors and pastels of children, flowers and landscapes. As a decorative artist, Lucia often took a dominant role in the collaborative projects with Arthur.

An American sensibility formed by the Puritan ethic and a background of pioneer experiences readily accepted the aesthetic principles which extended from the English Arts and Crafts Movement of the 1880's. Under that influence from William Morris, and later from his American disciple Elbert Hubbard, there was a similar interest in this country for the custom designed, aesthetically pleasing, hand-crafted objects which emphasized practical function and truth to material in their production.

The Furniture Shop; Arthur and Lucia K. Mathews
Storage cabinet, stained, incised and painted pine
49¼″ x 37½″ x 19½″
Collection of the Oakland Museum

The Furniture Shop and Lucia K. Mathews
Jar with lid, wood carved and painted
11½″ x 11½″ diameter
Collection of the Oakland Museum

In San Francisco the precepts at the heart of the movement were embraced by three of its most influential artist-craftsmen-teachers, Arthur Mathews, Bernard Maybeck and Frederick Meyer. They each worked in separate disciplines—Mathews was a painter, Maybeck was an architect and Meyer was a designer-craftsman—but they shared comparable academic backgrounds, an affinity for traditional styles along with an appreciation of the ideals expressed in the Arts and Crafts Movement. There is no evidence of Mathews, Maybeck and Meyer having collaborated on projects, but the compatibility of concepts among many of their individual works suggests the appropriateness of a regional classification.

At the turn of the century a California emphasis upon informality and an inclination toward an indoor-outdoor mode of living fostered a new west coast style of domestic architecture and furnishings that featured hand-crafted use of native materials. The inherent boldness of works in the Craftsman tradition was here tempered by the incorporation of graceful hand-carved details from the artist's adaptations of Gothic tracery, classical motifs or Oriental decorative devices. This new and distinctive Bay area style, particularly as associated with Maybeck, was achieved without sacrifice of unified design or historical continuity.

Within that broad context there also developed what we now refer to as the California Decorative Style, of Arthur and Lucia Mathews. The Mathewses would have doubtlessly agreed with the William Morris dictum, "Have nothing in your houses which you do not know to be beautiful"; for during their lives they championed a doctrine of environmental harmony to produce great numbers of works that exemplified the highest aesthetic ideals of their time.

Arthur Mathews, trained primarily to be a fine painter, was proud to consider himself a decorative artist in the sense that Puvis de Chavannes and Whistler were decorative artists. Mathews was inclined to regard all aspects of decoration in a position subordinate to mural painting. Even in his easel paintings he attempted to spread his sense of harmony beyond the canvas to include the frame so as to better integrate the work with its architectural surroundings. For Mathews the obvious extension beyond the mural was to undertake the complete harmonious decoration of interiors: paintings, frames, furniture, fixtures and accessories, just as Whistler had conceived his famous Peacock Room. It came within the basic concept of the Arts and Crafts Movement to recognize the role of the artist in creating a total environment, but Mathews maintained his independence from affiliation

The Furniture Shop and Arthur F. Mathews
Dining chairs and side table, stained oak, rattan seats
39″ x 19″ x 19″ chair, 36″ x 54″ x 18¾″ table

Collection of the Oakland Museum

The chairs are decorated with signet "S" crest for the Sloss family. The crests are painted blue, green and red on one chair and green, yellow and red on the other.

with any organized group or movement. Arthur Mathews was by definition a painter-decorator rather that an artist-craftsman if we are to make the distinction between his direct involvement as a designer in a decoration project and that of the artisans who hand-crafted the various components. It was to accommodate this collaborative mode of production that the Furniture Shop in San Francisco was conceived and under which it continued to operate successfully from 1906 to 1920.

During the period of intense rebuilding activity that occurred in San Francisco following the great fire of 1906 the Furniture Shop was kept busy trying to meet a demand for quality custom designed interiors and

furnishings. John Zeile, a good friend of the Mathewses and a devoted patron of the arts, was instrumental in forming the highly fortunate partnership in which he served as financial backer and business manager. As the Furniture Shop's master designer, Arthur Mathews originated each creation aided by his chief assistant and former student Thomas McGlynn, who saw to the faithful interpretation and execution of Mathews' sketches. Lucia often collaborated on the design of interiors and furniture in matters of color schemes and applied decoration. It has been estimated that as many as thirty to fifty craftsmen may have been employed for the completion of some large architectural interior projects, but the carpenters, cabinet makers, wood carvers and finishers employed on a regular basis were fewer in number.

Products of the Furniture Shop can be separated into two categories: those pieces commissioned for complete domestic or public interiors to include large suites of matching furniture and fixtures designed to be in harmony with the custom murals, wall panels and rugs; or those even more highly individualized creations that were generally reserved for the Mathewses' personal use.

The limited production or contract furnishings of the first category are the more conservatively designed of the two types, although certainly no less well crafted. Furniture of solid wood construction in oak, mahogany, walnut or beech, utilized some machinery as well as much handwork in its production. Mathews combined the inspiration from historical models with contemporary influences to produce pieces of a highly individualized style that are comfortably functional and easily integrated with traditional interiors. It is in the aspects of embellishment and ornamentation that the Mathews' designs reveal the widest departure from the comparatively austere, undecorated Craftsman style furniture identified with the Gustav Stickley, or some of the works of the Greene brothers.

The unique, elaborately decorative pieces of the second category are far more distinctive in appearance and make the strongest statement of originality for the California Decorative Style. Among the beautifully carved, incised, inlaid, gilded and painted pieces are picture frames, cabinets, chests, desks, tables, piano cases and various tabletop items. Of these Lucia took particular pride in the exquisite decoration she applied to the boxes, jars, candlesticks and mirror or picture frames that served as accessories and keepsakes.

The Furniture Shop frames are in a class apart—truly works of art in themselves. Conceived as the complementary transitional element between a painting and its surroundings, the frame sometimes inadvertently calls more attention to itself. During the intervening years since their completion, many Mathews paintings and frames have been interchanged and re-combined so as to leave some question regarding the success of their original effect.

In his designs for frames and furniture, Arthur draws upon a vocabulary of Beaux-Arts architectural ornament which he adapts and transforms with numerous personal touches. Lucia's emphasis within the style lay in her use of floral motifs. The flat patterns of figures, foliage and flowers she uses are reminiscent of Chinese and Japanese prototypes, but a recognizable California theme is represented by a profusion of the region's trees, fruits and blossoms—especially the California poppy, a virtual trademark, rendered in the characteristic muted tones of the style.

The Furniture Shop; Arthur F. and
Lucia K. Mathews
Covered box, painted wood
3″ x 12⅝″ x 7¾″

Collection of the Oakland Museum

Further regional aspects of the California Decorative Style derive from Mathews' followers. There was never intended an actual movement or school of art connected with the style, but there is evidence of its considerable influence upon the students and contemporaries of Arthur Mathews. Work of such noted California artists as Gottardo Piazzoni, Xavier Martinez and Francis McComas exhibit the decorative tonalist characteristics of Mathews' landscape paintings, but show little interest in the continuation of his figurative allegories of *art and nature.*

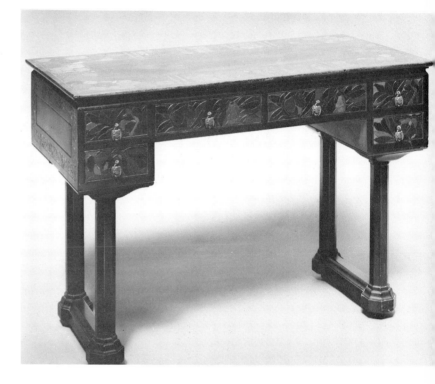

The Furniture Shop; Arthur F. and
Lucia K. Mathews
Writing table, mahogany and brass
30″ x 44¾″ x 22″

Collection of the Oakland Museum

With *Philopolis* magazine Mathews established, along with his associates, a vehicle through which he did hope to be influential. This was a small, monthly publication devoted to art and city planning that came out of the Furniture Shop operation. Typically, the Mathews decorative style was evident in the layout and illustrations designed by both Arthur and Lucia. The intent of *Philopolis* was to consider the ethical and artistic aspects of the rebuilding of San Francisco after the fire. In it Arthur Mathews, the most prolific contributor, found a voice by which he could influence public opinion on city planning and other matters pertinent to the arts.

The affection the Mathewses held for San Francisco and the loyalty to their aesthetic ideal and civic-mindedness prevented them from achieving much recognition outside the Bay area. They rejected numerous opportunities which might have established a national reputation.

Most of the rather large number of Mathews works extant are concentrated in only a few California collections, so until recently the lack of public exposure had caused the memory of their remarkable achievements to fade. Despite this relative obscurity the enormous diversity of creative outlets and the excellence of artistic production pursued by the Mathews couple during a period of more than fifty years remains praiseworthy. That there is renewed interest in their California Decorative Style speaks well for its enduring qualities.

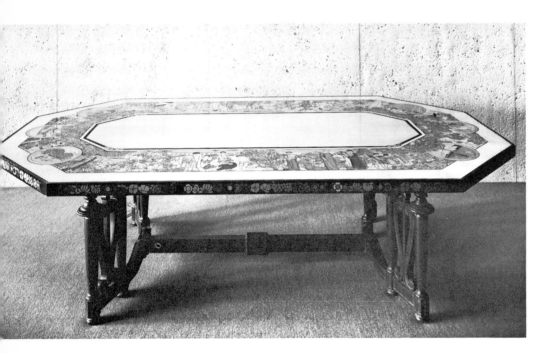

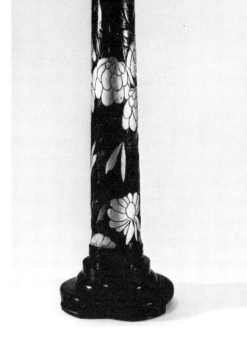

Lucia K. Mathews
The Furniture Shop
Dining table, top oak, painted; base, oak, stain
1918, 30″ x 61″ x 109¼″

Collection of the Oakland Museum

The table top, decorated by Lucia with oil paint and gold leaf depicts romantic, classically based scenes placed within abstractions of California floral proliferation. The trestle base, by the Furniture Shop is stained oak.

The Furniture Shop and Lucia K. Mathews
Hexagonal box with cover—wood, oil paint, gold leaf

Collection of the Oakland Museum

The Furniture Shop; Arthur and Lucia Mathews
Taper holder, turned wood, paint, gold leaf
26¾″

Collection of the Oakland Museum

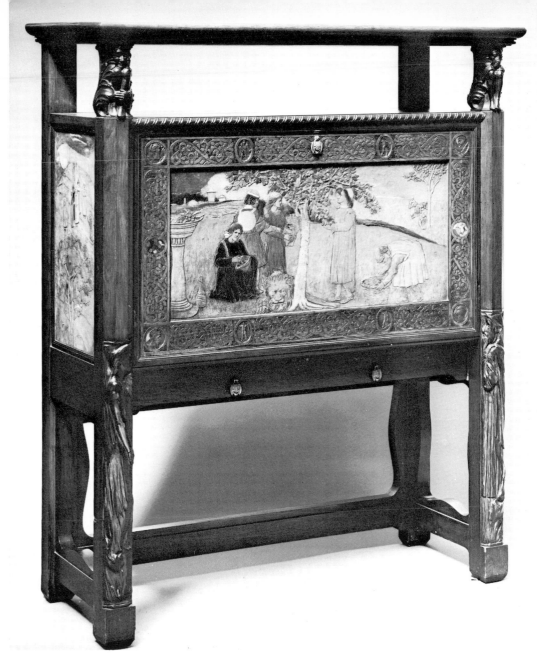

The Furniture Shop; Arthur and Lucia
K. Mathews
Desk, carved painted wood, brass
hardware
59″ x 48″ x 20″

Collection of the Oakland Museum

The Furniture Shop; Arthur and Lucia
Mathews
Hourglass, wood, glass, sand
9″ diameter 5″

Collection of the Oakland Museum

The freedom of life style among Californians has encouraged the great variety of its architecture— the articulate serenity of a Gamble house, the outrageous black and gold tiled late Richfield building, the enchanting beauty of *La Miniatura*, the ridiculous Brown Derby restaurant, the technological sophistication of the Lovell *health house* and the humorous little orange-shaped juice stands along the highway to San Bernardino. Each of these structures in its own way has been an expression of California.

In 1905 Charles Sumner Greene summed up the architectural character of California as ". . . the union of a Franciscan Mission and a Mississippi steamboat. . . . Happily, for the most part, those days are over and California's architecture finds its own reason for being." But he does not suggest that creative variety be cast aside, for he continued: "It is not beyond probability that where the sands of the desert now idly drift and only the call of the coyote breaks the stillness, there may be a Villa **Lante or a Fukagawa** garden."

In Pasadena, the work of Charles and Henry Greene, architects, is identified with the best in the period before World War I. While some of their later work can be found in other areas, including northern California, their legacy is most evident in Pasadena. Here among other followers of the Arts and Crafts Movement, Greene and Greene played a leading role in establishing one of the centers for the development of significant new directions in American architecture.

Their creative development falls into three distinct periods. The first decade (1893-1903) represented years of search and experimentation; years of frustration during which they nurtured the convictions which would slowly turn them away from the past and open the doors to their own creative genius. Their second and most well known period (1903-1909) saw their entry into the Arts and Crafts Movement and the development and refinement of their own personal style. Finally, in the third stage of their career (1910-1923) there was a dwindling of their personal practice, and again a search for new directions to counter the waning popularity of the Craftsmen's Movement. This was coupled with the fact that the Greenes' own aesthetic and structural demands priced their work out of the reach of most clients.

That the Greenes were captivated by turn of the century orientalism, by the loveliness of an Italian garden, by an English country home, or by the

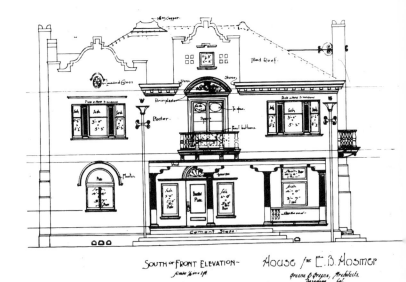

South or Front Elevation. House for E.B. Hosmer. Greene & Greene, Architects, Pasadena, Cal.

Edward B. Hosmer house, 1896

The Greenes' brief encounter with academic architecture evident in their early work demonstrates their frustration with the tired traditional styles as they sought forms which seemed appropriate to the California life and landscape. Consequently, the rapid evolution and refinement of their own highly original style following the turn of the century attests to their own individual convictions and artistic genius.

architecture of the Swiss Alps is quite clear in the articulated structure of their Arts and Crafts period. What is not so well known was their respect and admiration for the work of the Franciscan Fathers so beautifully expressed in the silhouettes of the California missions. This influence is evident in the Greenes' work before and after the years in which they worked primarily with wood. In their early work the Mission style appeared boldly in their designs, and was again expressed in their gunite and stone houses almost two decades later. Charles put it this way in 1905: "The old art of California—that of the mission fathers—is old enough to be romantic and mysterious enough too. Study it and you will find a deeper meaning than books tell of, or sun-dried bricks and plaster show. Then too, those old monks came from a climate not unlike this. They built after their own fashion, and their knowledge of climate and habits of life were bred in the bone. Therefore, giving heed to these necessary and effective qualities there is good and just reason why we should study their works. . . . Simple as it is, and rude, it has something that money cannot buy or skill conciliate. It runs in every line, turns in every arch, and hangs like an incense in the dim cathedral light."

Charles and Henry Greene

Randell L. Makinson

The purist may very well regard this influence as eclectic, and perhaps it is. However, the Greenes were not concerned with academic analysis of the derivation of their work. They simply sought the forms and materials which they deemed appropriate to each particular task, and if necessary, they were not self-conscious about adapting principles found in other cultures. But in doing so, they interpreted these principles in a way that is only California. The simplicity of their philosophy was best expressed by Henry Greene in *The Craftsman* magazine (August, 1912): "The whole construction (was) carefully thought out and there is a reason for every detail. The idea was to eliminate everything unnecessary, to make the whole as direct and simple as possible, but always with the beautiful in mind as the final goal."

A discussion of the changing character of the Greenes' individual work does not permit the historian to fit them conveniently into particular periods or styles which make for tidy chapters in an analysis. Greene and Greene were two unique individuals who responded to contemporary events and associations, and reacted to them by producing their own special kind of architectural statement.

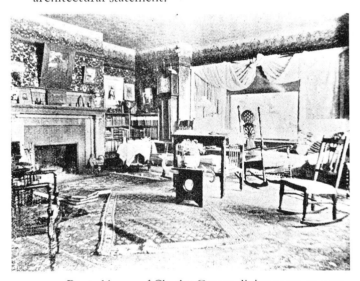

Rented home of Charles Greene, living room ca. 1901

This photograph shows a similar interior to the homes of Henry Greene and Frank Lloyd Wright prior to 1900. It suggests that they were all very much a part of the Aesthetic Movement before becoming disciplined by the Arts and Crafts Movement.

Although the Greenes were best known for their very important role in the Arts and Crafts Movement, this role was not adopted overnight. It took them almost ten years to escape the prevailing Aesthetic Movement of the late Victorian era. Early photographs showing the interiors of their own homes exhibit the typical melange of Victorian clutter. Great swags of drapery crisscross windows or part doorways; oriental rugs and Victorian furniture are scattered in no particular order; books, paintings and photographs are everywhere; and undoubtedly there is somewhere displayed the popular peacock feather.

In the *Journal of the Society of Architectural Historians* (December, 1971) H. Allen Brooks illustrates this same point with an interesting photograph of the interior of Frank Lloyd Wright's home, and writes: "If you assumed (this was) illustrating a typical, cluttered Victorian interior you were of course correct, because what this pre-1895 photograph indicates is Wright's taste in furniture and design before he came in contact with the Arts and Crafts Movement."

If we agree with Mr. Brooks' thesis that the Arts and Crafts Movement caused even the most creative architects to clean up and bring a more disciplined order to their designs and furnishings, then that same thesis can as well apply to Charles and Henry Greene.

The major influences which most clearly affected them were the turn of the century orientalism, the early publications expounding the Arts and Crafts philosophies, and their own manual training background.

The Greenes' introduction to Japanese architecture at the World's Columbian Exposition of 1893 in Chicago, is well documented by those who interviewed the Greenes in their later life. Like Frank Lloyd Wright and others, the Greenes were enamoured by the simplicity and integrity of the *Ho-o-den* in contrast to the surrounding eclecticism at the Exposition. However, a closer study of the Greenes' early work shows clearly that this experience had far less influence upon them than we have been led to believe. It was not until they had further and deeper encounters with oriental culture that the articulated structural integrity of Japanese architecture affected the development of their own vocabulary.

In 1897 the Greenes became acquainted with John Bentz, an importer of Chinese and Japanese antiques. Throughout their most creative years they maintained a close association with Mr. Bentz and his two brothers, and with their shops in Pasadena, Santa Barbara and San Francisco. As Mrs. Louise Bentz related in a letter to this writer: "They (Greene and Greene) were very fond of the stock of Japanese goods which my husband imported and often dropped in to chat and

enjoy the various articles and reference books, nearly all of which concerned the temples. He (Charles) liked the heavy timber work in their construction."

While essentially correct, a careful study of the Greenes' later work suggests, by the direct similarities of detail, that their interests were even more focused upon Japanese Imperial Palace architecture than upon the temples. Mrs. Bentz further related: "When I made my first trip to Japan in 1901, I brought back numerous little old books—mostly second-hand ones—and a number of prints; all of which he (Charles) loved, so I gave him many of them."

The Greenes' growing interest in the Orient was further stimulated a short time later—about 1903—when an itinerant bookseller happened by the home and studio of Charles Greene. L. Morgan Yost relates the event, as told to him in an interview with Mr. Greene in Carmel, 1946: "Idly, Charles Greene leafed through the pages until his attention was arrested by pictures of Japanese homes and gardens. This was what he had been seeking. Here was the expression of post and beam construction; of articulated structure. Here too were the house and garden as one, an informal yet carefully conceived whole."

Such experiences prompted the Greenes to collect Oriental books, imported furniture and prints of historic Japanese buildings. Once when we visited Charles Greene in his studio in Carmel in 1954, our evening was spent by the fireside as he eagerly brought out the books and prints of Japanese structures he so enjoyed. Of a similar experience, Clay Lancaster writes: "Many of the office prints were of historic Japanese buildings . . . and these made interesting comparisons with photographs of Greene and Greene work. Alice (Mrs. Greene) later told me privately that Mr. Greene used to contemplate his Eastern objets-d'art for hours by way of gaining inspiration for creating himself."

Charles Greene himself alludes to such sources of inspiration in his own unpublished novel, entitled *Thais Thayer*, in which he wrote: "My eye fell upon the bronze urn. Presently I had a revelation. . . . I laid out my scheme and began to build upon paper the essence of inspired thought. . . . But strange as it may seem to the layman, the spirit of that old bronze urn was the guiding motive of the design. I didn't draw a line or form a contour but my mentor stood before me, bathed in the still morning light where it always met my gaze."

Unlike Frank Lloyd Wright who visited Japan in 1905, neither Charles nor Henry Greene—much to their regret—ever traveled to any part of the Orient. This may, however, have been most fortunate. By assimilating all that they could from art objects and books, the Oriental influence was for them filtered through the various cultures of California and consequently made their own work delightfully fresh.

On two occasions Charles Greene traveled to England and Europe; first on his honeymoon in mid-1901, just prior to the Greenes' whole-hearted involvement with the Arts and Crafts Movement, and again in 1909 while at the peak of their most refined work. In England, Charles' interest was caught by the simple half-timber dwellings and the masonry ruins of Tintagel, and in Italy by the villas and gardens. Nevertheless, it was the indirect exposure to Japanese design that played the major role in molding the Greenes' future.

The second and most significant influence on the Greenes between 1901 and 1903 was a number of articles published in Gustav Stickley's *The Craftsman*, and the series of Will Bradley articles in *The Ladies Home Journal* throughout 1901; clippings of which were found in the Greene and Greene scrapbook. The integration of Bradley's furniture designs and his interiors seems to have been of more interest to the Greenes than the Art Nouveau line of his designs. The concept of the architect designing and building furniture for his own buildings opened up new opportunities for the Greenes who had not yet ventured into furniture design, with the exception of one table Charles had made for his bride.

At the time of Charles Greene's first visit, England was *the* center of Arts and Crafts activity. Although we do not know the extent of his contact with the English craftsmen, Charles' fascination with the English country house was clearly translated into the Greenes' design for the James Culbertson house several months later.

The initial issue of *The Craftsman* magazine arrived in October of 1901, coinciding with Charles' return from England. Its contents were to give real encouragement to the Greenes at a particularly searching period in their own work. This first issue dealt with the philosophy of William Morris, which was now—through Gustav Stickley—actually being implemented in the United States. They must have been exalted to find a man not only writing of the new Craftsman philosophy, but also designing and producing furnishings of the highest quality and workmanship. Stickley, who had established

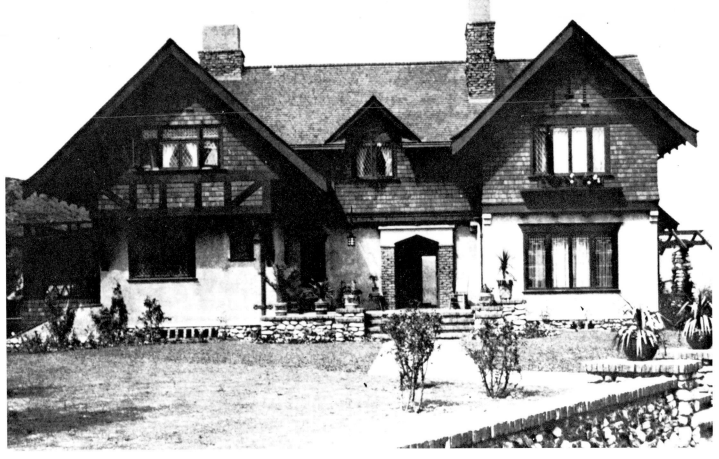

James A. Culbertson house, 1902

Influenced by the half-timber country houses Charles Greene experienced on his trip to England in 1901, the Culbertson house represents a bridge between the Greenes' eclectic background and their direction toward the Arts and Crafts Movement.

James A. Culbertson house, living room

In remarkable and successful fashion, the Greenes have masterfully combined here: the orientalism of the ceiling trim with the linear abstraction of the clear leaded windows, the four-square directness of Stickley's oak furniture, carpets of American Indian design and accessories out of the Tiffany and Rookwood Studios. In spite of all this it is simple, it is direct, and it all seems to hang together.

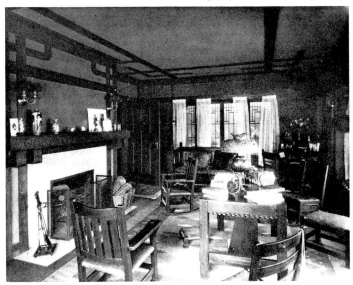

his workshops as the *United Crafts of Eastwood, New York*, wrote in the foreword of this first issue of *The Craftsman:* ". . . the new association is a guild of cabinetworkers, metal and leather workers, which has been recently formed for the production of household furnishings. . . . The United Crafts endeavor to promote and to extend the principles established by (William) Morris, in both the artistic and socialistic sense."

There also appeared in the same issue an article entitled "An Argument for Simplicity in Household Furnishings" in which Stickley declared: ". . . present tendencies are toward a simplicity unknown in the past . . . The form of any object is made to express the structural idea directly, frankly, often almost with baldness." Not since their days at Woodwards Manual Training High School had the Greenes found these principles so openly expressed.

There is no doubt that Charles and Henry Greene actually saw and read these first issues of *The Craftsman* for within a few months they completely furnished the James Culbertson house with Stickley furniture; selecting the pieces which had appeared in the October and November, 1901 issues. But the influence of the magazine on the Greenes went further than the selection of furniture. The article on *total* design of the house— the structure, the interiors and the furniture— expressed their own emerging interests.

Of particular note are the July and August issues of 1903 in which the work of Harvey Ellis first appeared. His illustrations have a real feeling for the work of the Mackintoshes and Voysey. And although there is a kind of two-dimensional graphic design quality to some of the decorative details there is a strong sense of *oneness* in the overall design and furnishings. In the August issue, the square-peg motif of the music room for "An Urban House" is especially interesting. While there is no way of proving that there was a direct relation between Harvey Ellis and the Greenes' extensive use of the square peg in their structures and furniture, the timing of this issue of *The Craftsman* suggests the possibility. In any case, the Greenes' first-hand knowledge of manual training, of materials, of construction and woodworking techniques, gives their handling of the square peg detail a powerful three dimensional quality combined with the sense of structural integrity found in Japanese joinery.

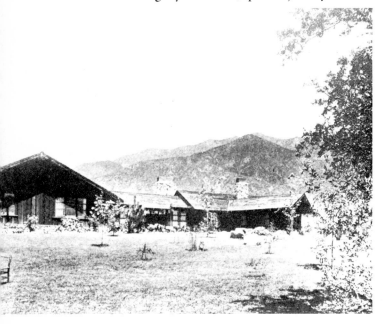

Edgar W. Camp house, 1904

The Camp bungalow in Sierra Madre elaborated upon the earlier Bandini plan and method of construction, creating its own handsome and beautifully sited living environment from the most basic of materials native to the area.

While the interior details of the James Culbertson house of 1902 reflected the influence of the Oriental, it was a year later, at the same time as the appearance of Ellis' articles, that the Greenes' artistic sense seemed to burst forth in new directions. Wood was the primary language. It was readily available, easily adapted to their ideas, very much a part of their vocabulary, and with their craftsmen the Greenes exploited its qualities with unsurpassed finesse. Their designs had distinct style. They were bold and expressed a relaxed freedom from the past. They hinted at the Orient, at the Swiss Alps, at the missions of California—yet there was a freshness to their houses which was particularly appropriate to the California landscape.

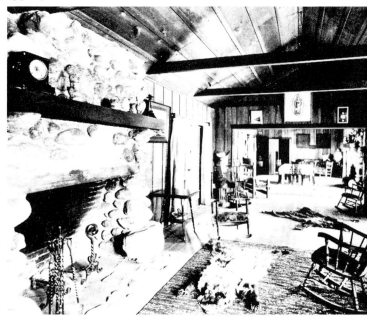

Arturo Bandini house, 1903

The rustic redwood board and batt construction of the Bandini bungalow with its *U* form plan was one turning point in the Greenes' career that ushered them into the Arts and Crafts Movement.

From the early Californians the Greenes took the patio floor plan built in a *U* shape to create an interior courtyard. In the nearby arroyos they found the cobblestones which were used for foundation walls, fireplaces, and garden steps. These boulders were later mixed with klinker brick to give added color. The Arturo Bandini bungalow of late 1903 was designed in this manner, inspired by the houses of early California. But it was the Jennie A. Reeve house, built in Long Beach, where the Greenes' new architectural vocabulary was fully expressed for the first time. Here they incorporated broad-sweeping, gabled roofs to keep the hot, drying rays of the sun from the walls of the building. In later designs the ridge of the roof would

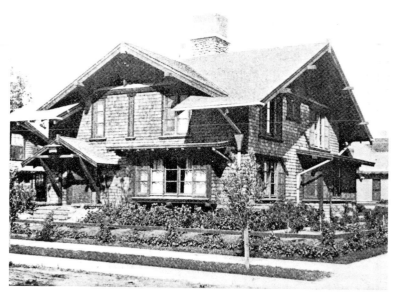

Jennie A. Reeve house, 1904

It was here that Greene and Greene for the first time brought together most of the architectural elements that would become readily identified as their own unique vocabulary. It is singularly the pivotal structure in their embrace of the concepts of the Arts and Crafts Movement. This small, two story shingle clad bungalow contained the Greenes' characteristic articulated timber structure, multiple gabled, deeply overhanging roofs (with the projecting support beams now shaped on the ends), open sleeping porches, a vertical slit window, horizontal bands of casement windows, a sensitive combination of boulder and cobblestone with brick masonry, their special touch of a front door with Tiffany glass in the windows, doors, and outside lanterns, and the coordination of landscape, walks, fencing and garden gates.

lift gently as in Oriental designs, and the timber work would become more bold. Joints were openly expressed, often fastened together with wooden pegs or metal straps with oak wedges. These elements were integrated into the overall scheme and contributed a rich texture throughout. Beam supports and wooden bracketing revealed a hint of the Japanese as did much of the open detail of railings, fences and porch structure. Posts often rested upon stones or brick in typical Greek fashion to keep the water on the hand-made tile terraces from rotting the wood. Chimney stacks reflected the character of the stone lanterns admired by the Greenes. Outside spaces became as important as interiors, and great attention was paid to the incorporation of pergola and trellis structures which spanned the spaces between house and garden and were sometimes built to resemble "torii" structures. On the exterior, broad-capped metal lanterns hung from beams

Jennie A. Reeve house, dining room

No part of the Reeve's house escaped the imaginative attention of the Greenes who coordinated every aspect of the beautifully crafted interior. Their unmistakable imprint is easily recognized in the carefully detailed paneling and built in cabinetwork where the expressed pegs are softly rounded and the finish of the wood has a waxed patina. Leaded glass designs coordinate for the doors on china cabinets and interior storage units where the craftsmanship and design quality, here in 1904, is equal to their masterpieces of 1907-1909. Special attention was given to the then new electric lighting, and for the first time the Greenes designed hanging and wall sconce lanterns of Tiffany glass with vine-patterned lead overlay, capped by broad canopys—not unlike the oriental. The Greenes' furniture for the house was styled after the designs of Gustav Stickley, although with a bit more tenderness. The pegs in the oak and cedar were left to protrude and the edges and corners were eased to soften straight lines. A faint stain was used and again the finish was rubbed to a glass-like touch.

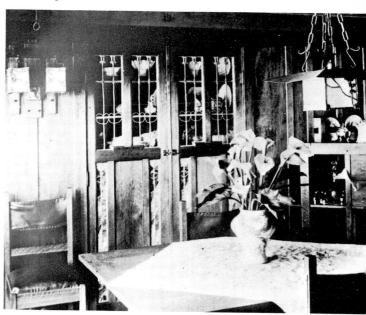

or eaves, lighting the terraces softly in the evening and reflecting in the quiet pools filled with golden carp and water lilies. Numerous lanterns of wood and Tiffany stained glass, suspended by leather straps, provided lighting for the interiors and blended harmoniously with the soft velvet finish of the panelled walls and timbered ceilings.

The interior furnishings designed and built for their houses were remarkable for the times. Furniture, built-in cabinetry and seating, picture frames, lighting, hardware, and occasionally even carpeting and curtains were designed as an integral part of the total scheme.

Throughout the Greenes' work at this time was a continuity of spirit and a fresh, overpowering oneness which was often regarded as an American domestic style all its own. The remarks of Ralph Adams Cram in 1913 are as relevant today as when they were written. Referring to the Greenes, Maybeck and their California contemporaries, he says:

"Where it (California architecture) comes from, heaven alone knows, but we are glad it arrived, for it gives a new zest to life, a new object for admiration. There are things in it Japanese; things that are Scandinavian; things that hint at Sikkim, Bhutan, and the fastness of Tibet, and yet it all hangs together, it is beautiful, it is contemporary, and for some reason or other it seems to fit California. Structurally it is a blessing; only too often the exigencies of our assumed precedents lead us into the wide and easy road of structural duplicity, but in this sort of thing there is only an honesty that is sometimes almost brazen. It is a wooden style built woodenly, and it has the force and the integrity of Japanese architecture."

The real substance of the Arts and Crafts Movement in America was craftsmanship. In pursuing this, American artists were no less vigorous than their counterparts in England or on the Continent. Among architects, few became as totally devoted to craftsmanship as Greene and Greene. Their work was an extraordinary combination of Charles Greene's vivid imagination and sculptural hand with his brother Henry's strong sense of order and system which brought a disciplined unity and simplicity to the many elements of their designs. If superb craftsmanship and design possessing a distinct style are the criteria for high quality, then surely the Greenes were unmatched.

In the specific area of furniture design Charles Greene was the master. High regard for his work was acknowledged early in the writings of Charles Robert Ashbee, recently brought to light by Robert W.

Winter. Ashbee was perhaps the most universal observer of the Arts and Crafts Movement, both in England and America, and his comments are therefore particularly significant. Following a visit to the Greenes' workshop in Pasadena in January, 1909, Ashbee wrote: "I think C. Sumner Greene's work beautiful; among the best there is in this country. Like (Frank) Lloyd Wright the spell of Japan is on him, he feels the beauty and makes magic out of the horizontal line, but there is in his work more tenderness, more subtlety, more self effacement than in Wright's work. It is more refined and has more repose. Perhaps it loses in strength, perhaps it is California that speaks rather than Illinois, any way, as work it is, so far as the interiors go, more sympathetic to me.... Here (in Pasadena) things were really alive—and the "Arts and Crafts" that all the others were screaming and hustling about, are here actually being produced by a young architect, this quiet, dreamy, nervous, tenacious little man, fighting single-handed—until recently—against tremendous odds."

From 1903 through 1909 the Greenes developed and refined the style for which they are now best known. Its principles adapted as well to the small single bedroom dwelling as to the more elaborate designs they did for their wealthy clientele. For the first time even the smallest of houses had a dignity and an architectural quality which in the past had often been available only to the wealthy.

Their ideas penetrated the bungalow style and spread rapidly through the periodicals and bungalow books of the day. They were copied, often by architects and builders whose own work, though interesting, exhibited little understanding of the Greenes' underlying principles. Needless to say, the copies usually lacked the integrity of the Greenes' original concepts and did little to promote their art.

As a result, prospective clients who earlier might have turned to Greene and Greene for progressive and fresh designs, began looking to traditional styles associated with supposedly more cultured tastes. Meanwhile the Greenes, having fully mastered their wooden vocabulary and prompted by their own inquiring genius, entered their third period (1910-1923). They explored other materials and concepts, but seldom with the same sense of sculpture, scale and sensitivity which had set their earlier work apart from that of other architects.

The Greenes, however, were so identified with the wooden bungalow—then as today—that in the early part

David B. Gamble house, detail of living room

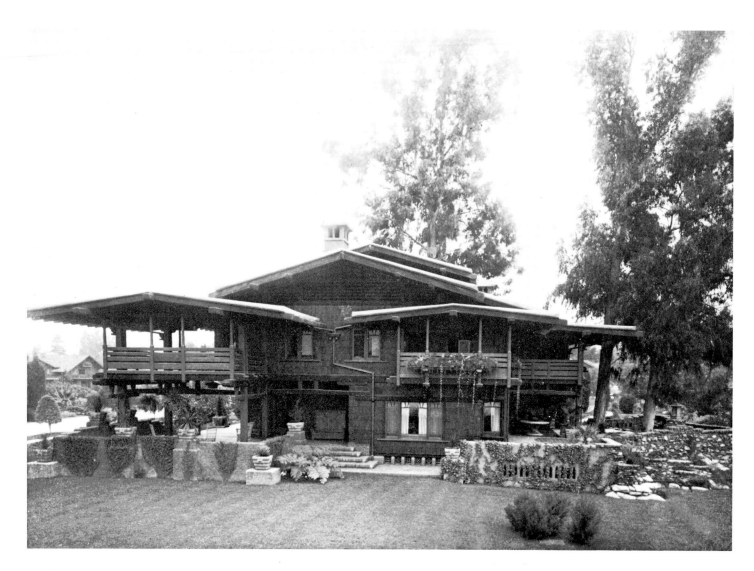

Gamble house, ca. 1910

of this third period their practice declined sharply. During this time several large projects came from their drawing boards that would never reach construction. Studies of these and the Greenes' experiences with some designs that were built, are exciting to the historian, but suggest that the demand for quality and artistic integrity which they placed upon their art may have priced them completely out of the market.

Greene and Greene have made a great contribution to American architecture, and nowhere is this contribution quite so evident as in Pasadena. Here, opportunities for the study of their work are available not only to scholars but also the general public. With this accessibility it is hoped that the Greenes' achievement and their inspiration will bring about a greater awareness of fine architecture, will encourage pride in this cultural heritage and stimulate a serious concern for its preservation.

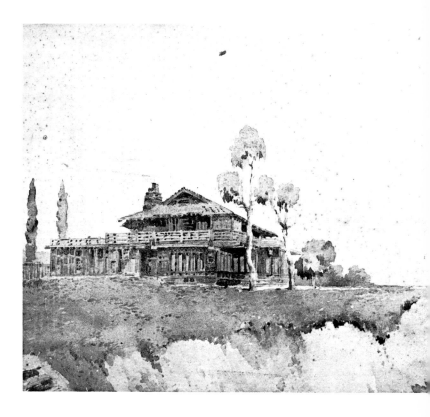

Charles Greene
Rendering of Tichenor house, watercolor
10½ x 5", 1904

The Gamble House

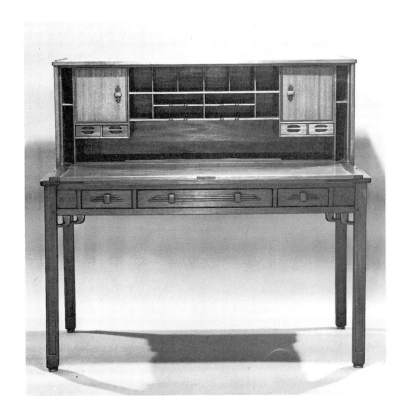

Charles Sumner Greene
Secretary cabinet and library table, teak, from Blacker house, 1909
47″ x 50½″ x 26½″

Mr. & Mrs. Richard Anderson

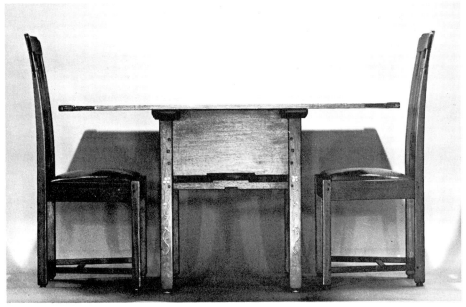

Charles Sumner Greene
Card table and chairs from Blacker house, 1909
Table h. 30¼″
Mahogany with silver and abalone shell inlay.

Mr. & Mrs. Richard Anderson

Charles Sumner Greene
Maple cabinet from the Gamble house, 1908
8″ x 20½″ x 10″

The Gamble house

This cabinet was made for the guest room desk of the Gamble house. The silver inlay ornament is most conspicious but literally every inch is superbly crafted. Two interior drawers.

Charles Sumner Greene
Storage bench from Blacker house, 1909
34″ x 53½″ x 19¾″, teak

Mr. & Mrs. Richard Anderson

Notice the seat which lifts to reveal a storage box.

Charles S. and Henry Greene
Set of three fireplace tools, from the Gamble house, 1908
Poker 29″, tongs 28½″, shovel 28¾″

The Gamble house

Wrought of steel and polished, these beautifully crafted objects blend styles of Occident and Orient.

Charles Sumner Greene
Chest, from the Blacker house, 1909
45″ x 54″ x 22″, teak

Mr. & Mrs. Richard Anderson

A masterpiece in teak. Charles is said to have carved the inset himself.

Charles Sumner Greene
Rocker, from Blacker house, 1909
24½″ x 37¼″, teak

Mr. & Mrs. Richard Anderson

The Oriental motif is here on top of
craftsman principles. The inlay is of
silver and abalone shell.

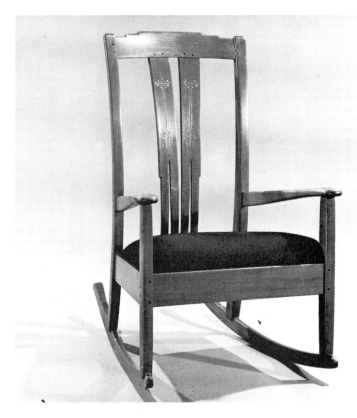

Charles Sumner Greene
Mirror from Blacker house, 1909
38″ x 16″

Mr. & Mrs. Richard Anderson

This detail is of a teak mirror which is
hung with leather straps.

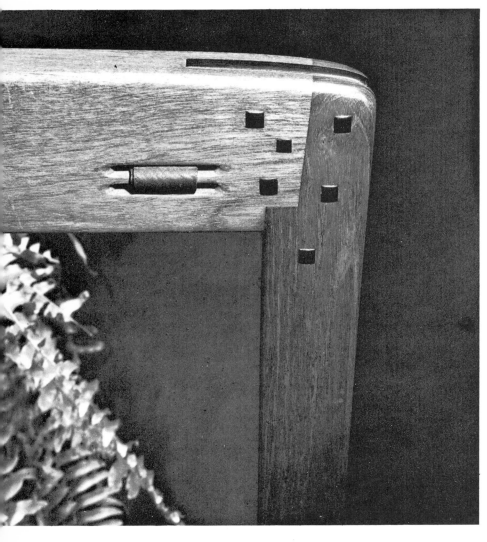

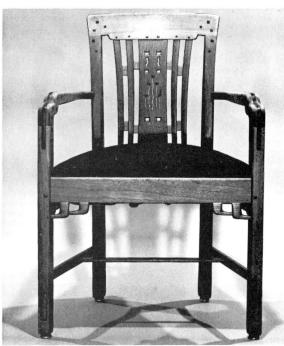

Charles Sumner Greene
Armchair from Blacker house
24″ x 34″

Mr. & Mrs. Richard Anderson

The squat monumentality of this piece is
in a totally different design idiom from
the more vertical and attenuated lines of
most of the Gamble house furniture
designs.

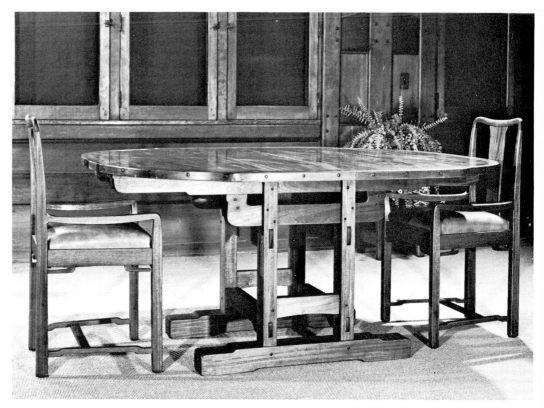

Charles Greene
Window, leaded glass, from the Ford
house, 1907
33½″ x 15½″

Mr. & Mrs. Alexander Whittle

These windows are of translucent light
amber glass with spots of bright yellow.

Charles Sumner Greene
Table and two armchairs from Robinson
house, 1906
Table, 30″ x 65½″ x 60½″ Chairs h. 36¼″

The Gamble house

The leather seated chairs are of mahogany
rather than the more often used teak.

Charles Sumner Greene
Dining room buffet from Blacker house,
1909, mahogany
39″ high

Mr. & Mrs. Richard Anderson

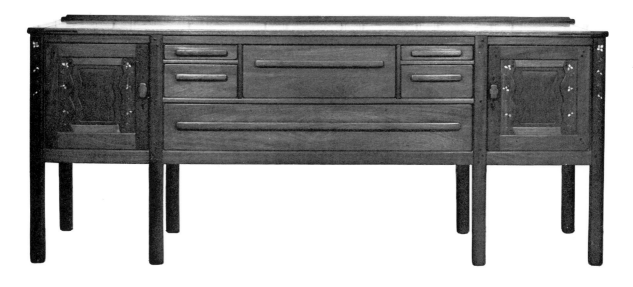

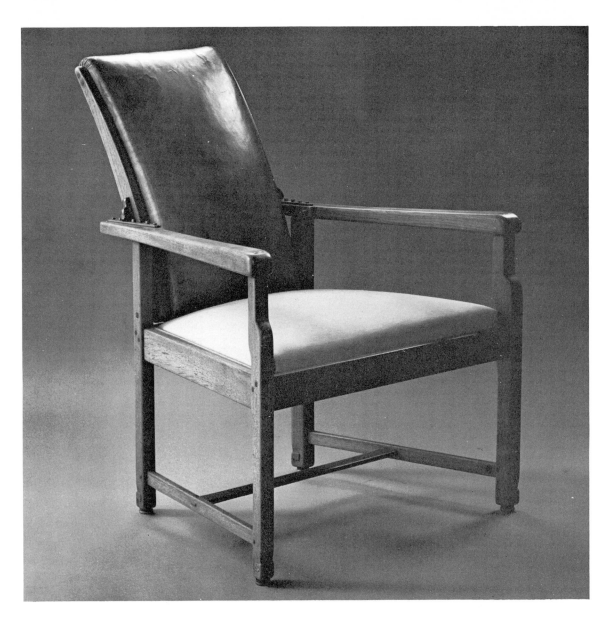

Charles Sumner Greene
Armchair from Blacker house, 1909

Stanley C. Anderson

The Greenes' version of the Morris chair, made in teak.

Charles S. and Henry Greene
Ceiling fixture, leaded art glass
Porter house, ca 1905
17¾″ x 15″ x 9″

James & Janeen Marrin

This small geometric lantern, a front porch fixture, was originally attached with the hood flush to the ceiling.

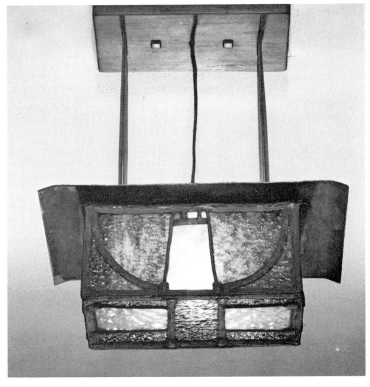

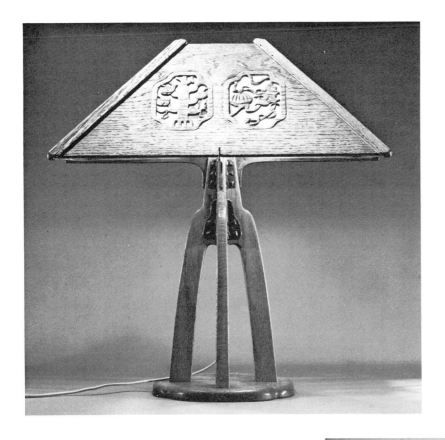

Charles Sumner Greene
Table lamp from the Robinson house, 1906
22¼″

The Gamble house

An oak lamp à la Stickley but given the Japanese treatment in its cutouts backed with silk.

Charles Sumner Greene
Breakfast table from Robinson house, 1906
30⅜″ x 72″ x 33⅜″, redwood

Ronald Chitwood

As close to the pure craftsman aesthetic as the Greenes ever came.

Charles S. and Henry Greene
Ceiling fixture, leaded art glass
Freeman Ford house, 1907
31″ x 45¼″ x 15¾″

James & Janeen Marrin

The design of this large glass box suggests moving cloud formations with small, stylized bird forms incorporated into the leading.

If there could be a prototype of the Arts and Crafts personality on the West Coast, it might be George Harris. When he left the farm in Caldwell, Ohio where he was born in 1867 he went to New York to work for a publishing house. There he fell under the spell of Elbert Hubbard, whose magazine, *The Philistine*, exhorted Americans to be "rational doers," to express their individuality, and to develop their latent talents through manual training.

It was a period in history when Americans were first looking for their cultural inspiration at home. Mark Twain was teaching us to laugh at Europe, Teddy Roosevelt incited the notion to seek adventure and enjoyment in outdoor life.

George Harris became an apostle of nature and common sense. He shaved off his Van Dyke beard, discarded his silk hat, and in 1906 came to California. For a while

he continued to represent the New York publishing house. But then in his own words, "About four years ago, after more than twenty years of business experience, I took a crosscut saw and an axe and a pick and shovel, walked down the road and demanded higher wages than any trained mechanic in the city of Los Angeles received at that time. Previous to this I had had no experience whatever in the handling of tools excepting what any farm boy might have from fixing fences, gates, etc. I made a few pieces of garden furniture such as chairs, seats and tables, which no one would buy—because the prices were too high. I kept on making garden furniture until I had an acre lot almost covered with it, and nobody would take it away. Not one single piece of this work sold for over a year,

and then it all went almost at once, and since I have had no time to make anything to sell for over three years."

"I have proven to my own perfect satisfaction that doing the work beats all the schemes on earth for raising wages and holding a job. I believe in organization, I believe that every worker should organize himself, and pass a resolution at each day-dawn to do more and better work. I also believe in reform and reformers. I believe that every man should constitute himself a reformer and resolve to reform one man—himself."

He built his first house in 1911, a neighborhood club house on Westchester Place. For the material he went to the city dump and salvaged broken-up concrete paving. The truss work of the open-ceilinged hall was of tree trunks. His talents were widely appreciated. Hundreds of gardens, estates and ranches have examples of his stone work in pergolas, fountains, waterfalls, bridges and fireplaces. These were all in a style he called *fashioned by nature*. "Natural architecture," he said, "is an intuitive, spontaneous impression suggested to our minds by the natural environment, heredity and the long, loving association with nature in its many phases —It is necessary to get away from the artificial and conventional, and requires much imagination."

Bolton Hall, his masterpiece, was built in Sunland in 1913 as the central hall of a utopian community whose members were buoyed by the idea of "a little land and a lot of living." They asked Harris to design for them a building "fashioned by nature." It was built of granite boulders from the stone pastures of Tujunga. It was imbued with his philosophy of life, independent from the traditions of the past, and a faith in the present.

Robert Marsh private club—pergola

George Harris
Esther McCoy

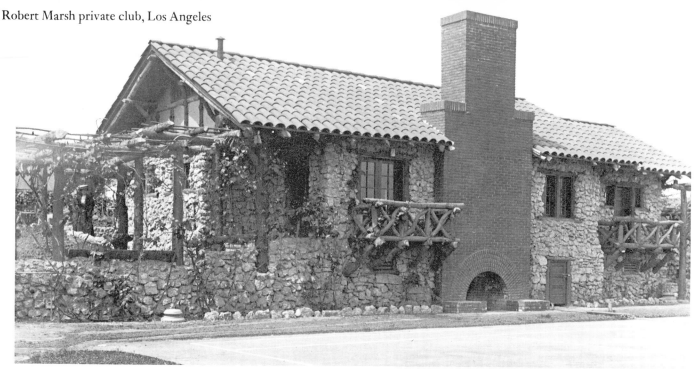

In Harris' words, "The stones were gathered from the hillside and selected and placed in natural positions such as they might assume when falling down from a cliff and settling in their own natural position. If a stone is rolled down the hill its shape and the ground on which it stops will determine the position. It is an understanding of this principle that enables one to do natural construction. Bolton Hall was built almost entirely without plans, it being a growth, an evolution directed by the materials and surroundings, and made to harmonize with them. This great fireplace is not *rustic* masonry but natural construction, and is made to resemble a natural precipice with an opening in which to build a fire. The great log which forms the mantelpiece might have been simply part of a tree chopped for firewood and used for the purpose because of its convenience."

At the dedication of the building he said, "This building may furnish an invaluable example to those who have become members of this community. Here is a perpetual lesson, ever before you, which will lead, if you will follow it, each and every one of you to a successful termination to whatever you undertake. The lesson it teaches is one which I have proven to my satisfaction, and that is that we may and can do what is within our mental and physical capacity, if we believe in ourselves and work with but one thought in view, a determination to succeed."

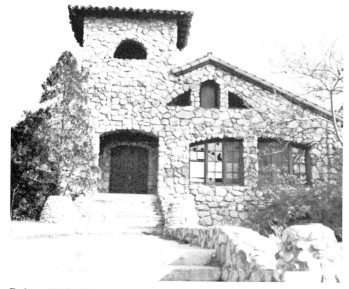

Bolton Hall, Tujunga

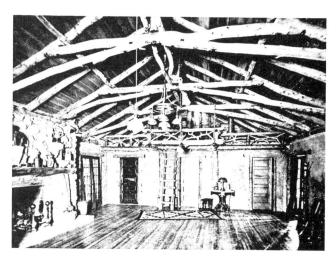

Bolton Hall—interior

When we conjure up an image of the turn-of-the-century Craftsman house, we tend to visualize a woodsy shingle or board and batten bunglow, closely attached to the ground by its foundations and low retaining walls of river boulders, perhaps interspersed with clinker bricks, and the whole covered by the spreading umbrella of a wide overhanging low pitched roof. But when we begin to thumb through the pages of the popular magazines of the time: *The Craftsman, House Beautiful, Sunset,* it becomes readily apparent that the architectural imagery of the Craftsman movement in the United States was remarkably varied, ranging from the woodsy California bunglow, to Stickley's version of the simple stucco box, to lightly handled adaptations of the then-popular Colonial Revival, to houses which reflected the Mission inspiration, and finally those which looked abroad to the English Arts and Crafts cottages of Voysey and Baillie Scott, and to the Secessionist work then emanating from Vienna.

To understand the Craftsman movement in the U.S. and particularly Irving Gill's participation in it, we must not only think in terms of imagery, of style, we must equally be aware of the specifics of method and of ideology which underlay the American movement. If we look into these last two ingredients of the Craftsman movement, we will increasingly become aware of Gill's personal preeminence in the movement. If for a moment we set aside our preconceived vision of the Craftsman house and look at the Craftsman product in terms of its essential components, we will find that all of these are to be found in Gill's buildings. What are these ingredients? One of the most important of these is scale. Even if the house happens to be fairly large, as in the Blacker or Gamble houses of the Greenes, or Gill's Timken or Dodge houses, they were designed to convey a feeling of smallness and modesty of size. Though the Craftsman-object often makes reference to past architectural styles, such references were purposely understated, so as to make it perfectly plain that historicism was not to be used to convey pretense. To avoid a sense of the pretentious, simple everyday materials—wood, brick, natural river boulders, and stucco—should be used, and these were to be assembled in an elemental *folksy* way. To be successfully unpretentious the ideal Craftsman house should exist within the world of low art, it should not emerge strongly as a high art object. As a low art object the ideal Craftsman product should reveal its nature by appearing to concentrate on utility; the building's basic form, spaces and details should be openly clumsy and at best ungainly and awkward.

Though the building may be composed of elemental boxes, its details should be as simple and direct as one could ask; at the same time, though, the building should be reasonably complex—to mirror the many down-to-earth demands that are in truth made of a utilitarian enclosure of space.

To one degree or another the elements which make up the imagery of the American product can be found in English and continental examples of the Arts and Crafts movement—though the total resulting European product was as different as one could imagine from that of the American. These differences were not only due to the peculiarity way the parts were assembled to form a *style;* they were equally the result of the American approach to method, and of the ideology which underlies the U.S. movement. By 1900 the English and continental proponents of the Arts and Crafts had worked out a modest, rather circumspect accommodation to the machine and mass production. Ashbee, Voysey and others were willing to use and express the machine to a limited degree in their designs. But their view of the machine was that of reticent accommodation, not open acceptance. Philosophically, the Europeans developed an approach which expressed the use of the machine in architecture and design, but at the same time their imagery carried on the Pugin and Morris tradition of hand craftsmanship.

The American experience was quite different. Though the U.S. was virtually flooded with magazines and books which espoused the cause of the Craftsman movement, all of this literature was, from an ideological point of view, mushy, confused and hardly inspired. As a group, the Americans who were exponents of the Craftsman movement had a strong and firm belief in the machine, mass production, technology, and science. They were committed to middle class free enterprise, and to the ability of American business to create a new environment. Suburbia was to be realized by the production processes of the building industry, ranging from pre-cut components and prefabricated buildings, to the mass production of suburbs themselves by large-scale developers. Technology and machine production would then be employed as tools to realize the *American Dream* of a rural, small-town life in low density suburbia.

Even the handcrafted element of the American Craftsman movement took a far different twist from that of England or the continent. While one might perhaps acquire a few choice handcrafted objects ranging from Tiffany glass to Rookwood pottery, the

Irving Gill

David Gebhard

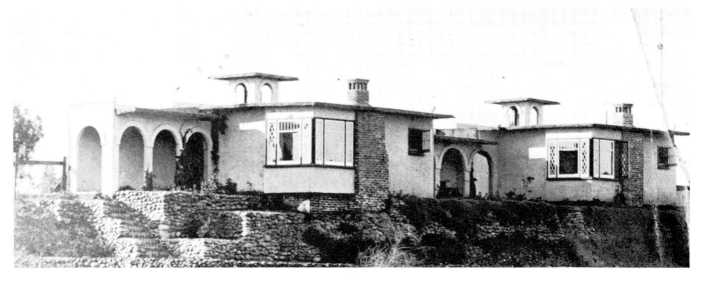

Gill double house, San Diego
1902-08

thrust of handicrafts in the U.S. was *do-it-yourself*. And the do-it-yourself product—a lamp, a chair, a plate rack—would at least in part end up being a product of the machine. Since the home do-it-yourselfer would under most circumstances not have an elaborately equipped machine shop, he would have to rely on standard size machine-cut lumber and metal. His personal act would be to modify these machine-made elements, with his own tools and to assemble them in a simple uncomplicated fashion. Thus fumed oak Mission furniture, whether produced by Stickley or in Grand Rapids, or produced by the home craftsman, turned out to be a machine product.

The U.S. Craftsman movement, and Irving Gill as one of its spokesmen, derived the basics of its philosophy from the English parent movement. But the philosophical foundation of the American group was distinct. Socialism, for example, never entered into the American movement. Instead, the cornerstone of the Craftsman movement was a strong belief in a universal middle class which would spread itself out horizontally on the landscape. Such a middle class would retain its sense of scale and values by relying on the small family unit which would keep itself in close touch with the virtue of the soil. The simple life, at least as a symbol, would be realized in the single, free-standing dwelling situated in a wooded suburbia. Here the stern, ethical and puritanical values of an earlier America could continue uninterrupted. The modern twentieth century world of machine production, new materials and products, of an increasingly complex and large business

and corporate establishment, were to be used as the means of creating this expanded middle class; of spreading out into the countryside, via the automobile, where one could live in the rural or small-town world of a single-family dwelling. Thus when Wright, Gill and others spoke and wrote about democracy, and architecture as an expression of it, they were expressing their belief in the ideal of a universal middle class, thinly spread over the landscape, and an America which continued to adhere to the rural ethical puritanism of a previous century.

If one thinks exclusively in terms of imagery, the architecture of Irving Gill would seem marginal to the Craftsman movement. Even his philosophy, at least on the surface, would appear to be at odds with what is normally encountered in the soupy, romantic ideology of the American movement. Yet, it can be convincingly argued that he is the perfect end product of the American version of the international Arts and Crafts movement, and in his own way he is as American as mom and apple pie. His writings and his buildings bubble over with stern and even painful puritanism. When he wrote he used such phrases as, "the remedial strength of the primitive," and, "monastic severity." He believed in the wholesome, out-of-doors life which builds and maintains character. He viewed nature, like Sullivan and Wright, through the romantic eyes of Whitman. He had a pure nineteenth century faith in science and technology. A building, he felt, should be a simple and bold machine object. Its severity of mass, of line, of plain undecorated surfaces, would sternly recall

man to his puritanical obligations and at the same time it would symbolize his belief in the virtues of health and the sanitary. An environment which expressed such a philosophy would create a neutral backdrop within which both man and nature could go their own way in their own rich fashions.

Intellectually, Gill sought to equate the return to the puritan, to the rural and the folk, with an aesthetic return to fundamentals. For him the fundamentals of architecture were entailed in what he felt was the basis of geometry—the straight line, the cube, the circle and the arch. These elements were not only aesthetically correct, they were also ethically correct. Since these elements should form the basis of architecture, they should as well directly serve two other purposes; to encourage man to return to the simple natural life of the puritan past; and at the same time, since they are functionally and symbolically expressive of the machine and mechanization, they should lead us on into and through our modern age.

As was the case with other turn-of-the-century progressives, Gill's first years of practice were a period of open groping for a correct set of images. Like the Greenes in their early work in Pasadena, Gill ran the full gamut of the then-popular styles. Between 1893 and 1908 Gill tried his hand at his version of the Renaissance Revival (San Diego Normal School, 1895), of the Colonial Revival (Frost house, San Diego, 1897), of the Shingle Style (Birckhead house, Portsmouth, Rhode Island, 1902), and of the English cottage (Waterman house, San Diego, 1900). These varying modes were followed by other explorations into the imagery of the Mid west *progressives*, (Burnham house, San Diego, 1906), and the Craftsman mode, (Klauber house, San Diego, 1907-10). Then, like many other California architects, Gill was drawn into the fold of the Mission Revival (perhaps most correctly expressed in his St.

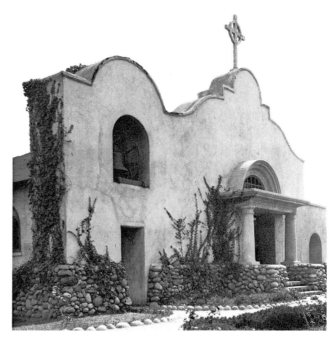

St. James Chapel, La Jolla
1908

James Chapel, La Jolla, 1908). For Gill, the Mission Revival provided the perfect answer. Its basic forms, surfaces and details were direct and primitive; it could easily use conventional, as well as more avant-garde, materials and methods of construction (and it could therefore be modern), and by stripping away the non-essentials he could get down to the basics of form—the straight line, the cube, the circle and the arch. By the time that Gill began to employ the Mission Style (1904), it was just emerging into its period of real popularity (which continued through 1914), so he could be assured of a reasonably large group of sympathetic clients.

As was true of other proponents of the Mission Revival, Gill combined many Craftsman elements with the new style. In the small cottages which he built for himself in San Diego (1902-08), the chimneys and fireplaces were of rough brick, river boulders were used for steps and retaining walls, and simplified Mission-esque furniture was designed for his own use. During the years 1904 through 1910 he often designed Craftsman interiors for his Mission-esque houses. The Cossitt house, (San Diego, 1906), has a finely detailed redwood board and batten interior, while the Douglas house, (San Diego, 1904-05), contained Mission and Southwestern baskets, Navajo rugs and Near Eastern Carpets, which were abstractly integrated into the interior in a Mondrian-esque fashion. Nor

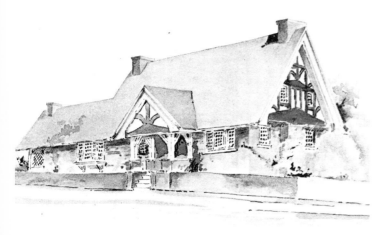

Hebbard & Gill
Drawing: Waterman house, San Diego
1900

Cossitt house, San Diego
1906
Entry hall

was Gill utterly opposed, as one often thinks, to the wood framed and wood sheathed house. Of redwood, he wrote in the May 1916 *Craftsman,* "Split into long, narrow shingles called shakes, or into long clapboards, it makes strikingly beautiful houses . . . Delightful little home-made cottages of redwood are found throughout California." Gill himself built several cottages of redwood, the most striking being a *Log House for Williams* built in 1908 at Etna Springs. In this cottage he used redwood logs in pure log cabin fashion, only of course he reduced the building to a single volume, and organized each facade, with the end result that the product was not a home-made object, but a designed object.

Esther McCoy (in her *Five California Architects,* 1960) has pointed out that the Laughlin house, (Los Angeles, 1907), marks Gill's first major step toward the puritanism of the straight line, the cube, and the arch in his domestic work. He developed this rigorous puritanism in a number of non-domestic commissions, (the Wilson Acton Hotel, La Jolla, 1908; the Bishop's Day School, San Diego, 1909). On the other hand, his residential work of these years was not as consistent. The theme was not appreciably carried much further until 1910 in his Fulford bungalow in San Diego, where the building was reduced to basic rectangular volumes, penetrated by a spatial arrangement of arched and rectangular openings. The full force

Douglas house, San Diego
1904-05
Upper part of living room, hall

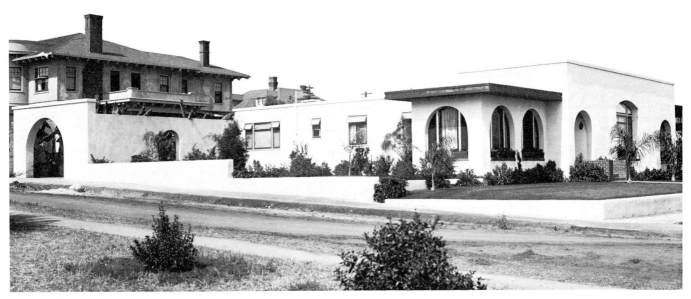

Fulford house, San Diego
1910

of this new aesthetic was reached the following year, in 1911, in the Timken house, (San Diego). Here, a much more complex pattern of rectangular volumes was openly composed as a piece of sculpture.

Like the Greenes, Gill's internal spaces and the relationship of his houses to the out-of-doors tended to be reserved and traditional. His general approach was to create a series of internal, separate, box-like cubicals. These spaces were arranged and related to one another

in a direct and orderly fashion. This internal world of cubicals was opened to the out-of-doors only in a limited fashion through separate rectangular or arched openings, which accentuated, rather than denied the existence of the wall surface. But once outside, Gill was quite innovative in making full use of courts, walled gardens, terraces and pergolas to create external usable living spaces which would take full advantage of the mild climate of Southern California. In the Timken house he organized the *U* shaped house around a screened courtyard, off which were situated three secluded loggias. In another house projected for San Diego, (c. 1911) he used the entrance courtyard and its *L* shaped porch as an exterior communication link between his internal cubicals. Finally, in the mid-1920s in a group of 3 town houses Gill pushed the traditional craftsman sleeping porch to its extreme, for in these houses the first floor cubicals were now open curtained loggias which faced out directly on an internal court.

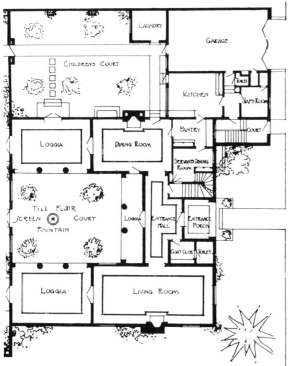

Timkin house, San Diego
1911
First floor plan

Though Gill extensively used such Craftsman (and Mission as well) external devices as porches, terraces, pergolas, courtyards and walled gardens, his approach to out-of-doors spaces was much more classical than his more typical Craftsman compatriots. His was an open, orderly world, which like his white stucco buildings, set the works of man distinctly and sharply off from nature. He spoke warmly of allowing the irregular pattern of vines, trees, shrubs and flowers, to be played off against his pristine white surfaces, but most of his gardens in fact were quite formal in

Project for house, San Diego
1912
Pergola

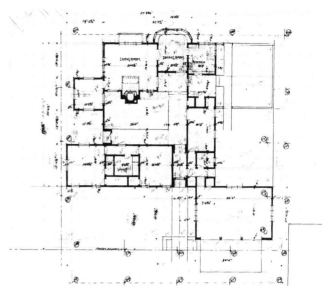

Project for concrete bungalow, San Diego
ca 1910
Floor plan

their layouts; hedges were planted in set rectangular forms and they were precisely clipped, while flowers and other low growing vegetation were tightly grouped in visually controlled beds.

With all of these points of difference can we really consider Gill as a Craftsman designer? It is obvious that Gill himself wished to set an appreciable distance between his own work and that of the typical Craftsman. With the example of Sullivan and Wright

before him, Gill openly cultivated the image of a way-out avant-gardist. As an artist-architect his work was often referred to as "cubist," while other articles associated him with the continental avant-garde (an "architect of secession"). But far more than Sullivan or Wright he wished to project an image of himself as the artist-engineer. Though in his own writings, he often waxed eloquent on the aesthetics of his building, he generally emphasized the hygenic, scientific, technological and practical aspects of his designs.

Project for three patio houses
1927
First floor plan

Darst house, San Diego
1908

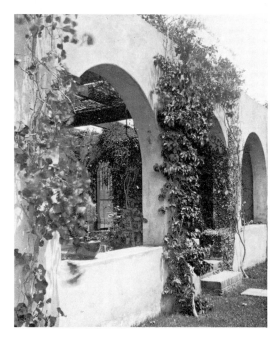

But the overall content of both his writings, and his products end up squarely in the Craftsman camp. Like them, he wished to produce buildings which had a, "made in America" look, and which visually would create, "a new architecture in a new land." His interest and involvement in low-cost housing, (as at Torrance, 1913), in the bungalow court, (as in the Lewis courts in Sierra Madre, 1910), in the use of hollow tile, concrete and the tilt-slab in many of his modest priced dwellings reflected his commitment not to a form of

socialism, but to the individual, the family and suburbia. As is true of the characteristic Craftsman product almost all of Gill's buildings emerge as low art objects, though often like other Craftsman objects they reveal high art passages. In Gill the impersonality of technology and of science at last becomes low art and homey—the century-old battle between the machine and the Arts and Crafts movement is at last resolved.

Cossitt house, San Diego
1906

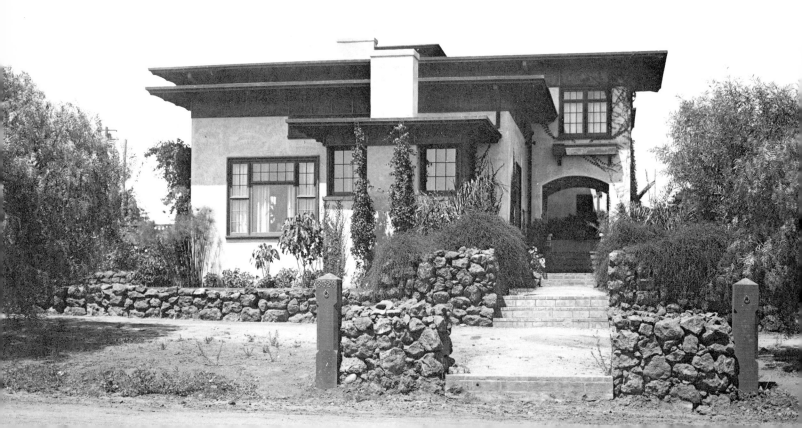

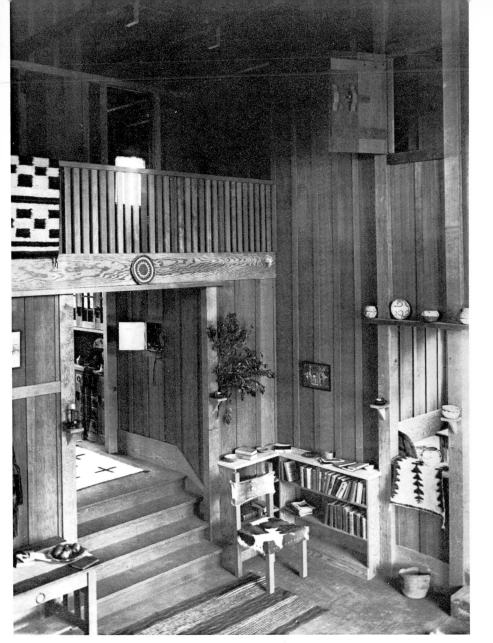

W. J. Bailey house, La Jolla
1907

Living room and bridge to bedrooms
as it appeared ca 1910

W. J. Bailey house—detail of closet door

Irving Gill
Desk and chair, redwood, horsehide, for
W. J. Bailey house, 1907
Desk h. 29″ chair h. 38″

Sim Bruce Richards

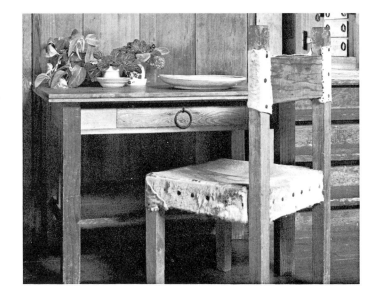

Harold Doolittle
Telephone table and stool
Table 26", stool 15"

James & Janeen Marrin

This furniture, made in pine has a simple directness of design which reflects the manual arts training Doolittle received at Throop Polytechnic, though the pieces were made at a later period in his life.

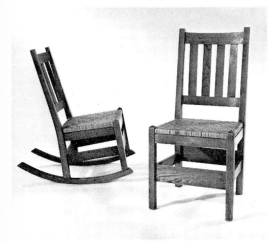

Harold Doolittle
Rocking chair and straight chair
33" and 37"

Mr. & Mrs. Edward Bunting

These very direct chairs in oak were made around the same time as the chest (1907).

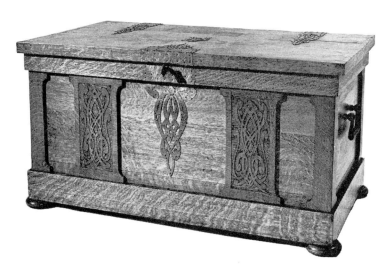

Harold Doolittle
Chest, brass fittings
22½", 1907

Mr. & Mrs. Edward Bunting

This chest was made by Doolittle for his bride. He made a similar chest for each of his two sisters as a hope chest. In spite of the massive quality of the solid oak, the inset carved panels and the handsome brass fittings lighten the design. Notice the handmade brass key on which his monogram is incised. Doolittle was a craftsman in all media. He had a fascination with letter patterns and designed many monograms. His niece remembers his collecting linen rags because he made handmade papers.

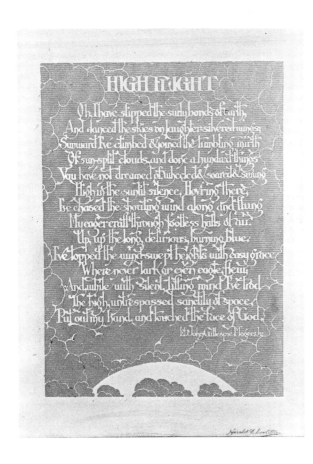

Harold Doolittle
Etched brass design
10″

Mrs. John Carrington

Harold Doolittle was a mechanical engineer by profession, but his lively enquiring mind probed and explored in many areas. He was experimenting with color photography on imported French plates in the early 20s. He made movies in the late teens and early 20s. In his later life he became interested in printing and experimented in almost every printing method. He made etchings, lithographs, mezzotints and aquatints among others. The challenge of this piece was to create the design so that every line touched another.

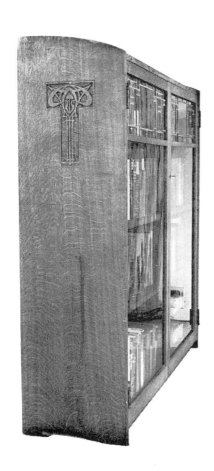

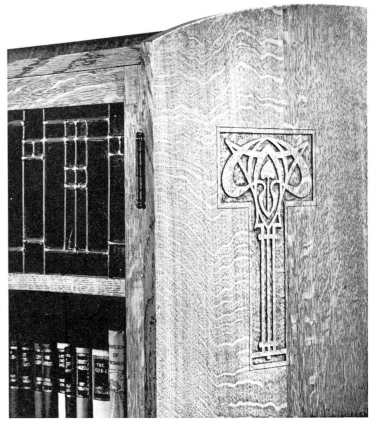

Harold Doolittle
Bookcase, leaded glass doors
51″

Dr. & Mrs. B. D. Sharma

Harold L. Doolittle

Louis B. Easton
Carl Curtis ranch, exterior

Following the initial construction in 1906
of a simple rectangular plan, redwood
board and batten structure, the Curtis
ranch was enlarged through small
increments. On the north elevation we
see that a bay window has been added
and another room with a fireplace
beyond. Easton believed that construction
materials should serve the dual purpose
of being the finish surface as well as the
structural support. His board and batten
walls could effectively withstand weather
if protected by deeply overhanging
eaves, serve as interior finish, and be
easily disassembled to accommodate
appendages without destroying previous
work.

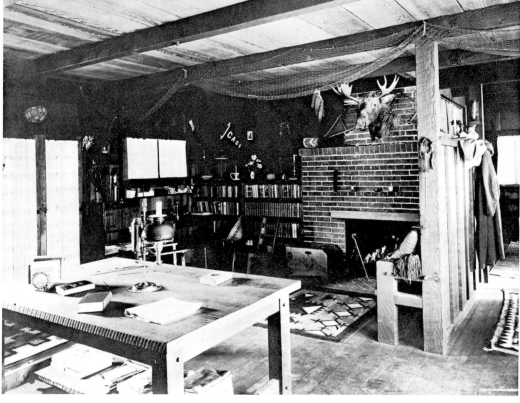

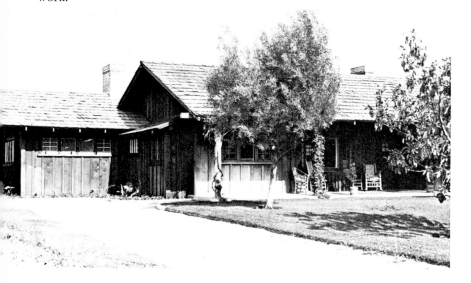

Louis B. Easton
Table, redwood
l. 73″, w. 46½″
Carl Curtis ranch
1906

Occidental College Library

From this early photograph we can see
how the furniture was intended to
become an integral part of the house.
When Carl Curtis met Easton and told
him that he planned to build a home,
Easton is said to have drawn an envelope
from his pocket, and on the back a floor
plan was prepared. They, with the help
of one additional man, soon began
construction. Easton's daughter recalls
that as the work progressed, her father
would occasionally stop, and sitting on
the floor with his drawing board perched
over his knees, work out the various
details.

Louis B. Easton
Music cabinet, redwood, with hammered
iron hardware
h. 47¾″
Carl Curtis ranch
1906

Barbara Curtis Horton

This was one of the pieces built by Easton
and the owner for the newly completed
ranch, presumably of left over lumber.
The redwood has the same wire brush
finish as the interior of the house. The
huge pegged keys top and bottom reveal
more an enthusiasm for joinery than any
need to be easily disassembled.

Carl Curtis
Child's desk and chair, redwood
Desk h. 35½″, chair h. 30¾″
ca 1919

Barbara Curtis Horton

By 1919, Carl Curtis had thoroughly absorbed Easton's structural vocabulary. In these pieces for his daughter there is a continuity visible which goes back to the initial house constructed thirteen years earlier.

Louis B. Easton
Screen, 3 panel; redwood and burlap with leather hinges
Carrie Whitworth house, h. 72″, 1912

Barbara Curtis Horton

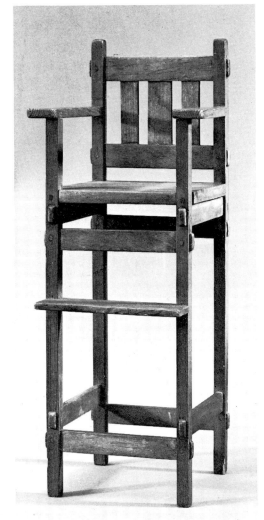

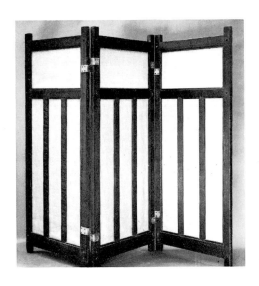

Carl Curtis
Toy crib and high chair, redwood
High chair h. 19¾″, crib h. 14½″
ca 1919

Barbara Curtis Horton

These toys reveal a commitment to craftsmanship and joy in the process of making things. There is an understanding mind behind their construction and a confident eye responsible for their proportions.

Louis B. Easton

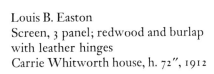

A. Page Brown, A. C. Schweinfurth
Swedenborgian Church, San Francisco 1894
Chapel, looking toward entrance

Joseph Worcester, the original pastor of the church, is thought to have strongly influenced its design. To emphasize the symbolic significance of nature in the Swedenborgian philosophy, one enters a garden before the chapel. Once inside, madrone logs buttressed the roof and boughs of pine hung from the rafters and decorated the pulpit. The furnishings were especially made individual chairs instead of pews. Four paintings depicting the seasons were contributed by William Keith, and Bruce Porter designed the leaded glass windows. Even now, there is generally a fire going and always candles lit for services.

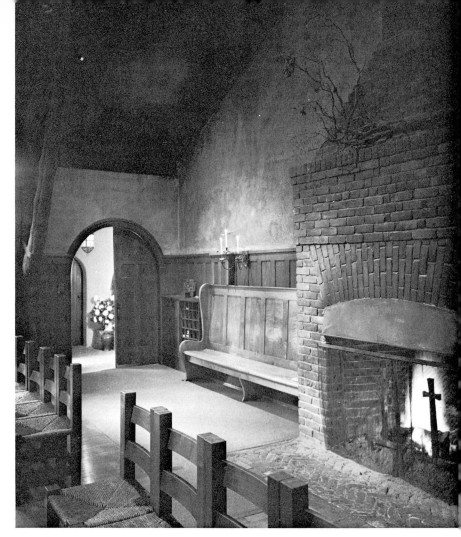

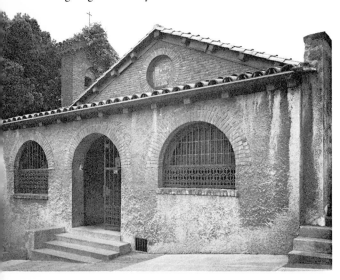

A. Page Brown, A. C. Schweinfurth
Swedenborgian Church, San Francisco 1894
Façade, entrance to loggia with garden beyond

The building of this innovative church involved the collaboration of many artists brought together by Reverend Joseph Worcester, perhaps a key figure in the formation of the Bay Region architectural style. After its completion, the informal atmosphere of the church provided a meeting place for many of those who took part. Fixtures especially designed include almost all metalwork and furniture.

Attr. A. Page Brown
chairs, maple with tule rush seat, h. 36″
Swedenborgian Church, 1894

San Francisco Church of the New Jerusalem

A contemporary account attributes the design of these chairs to Brown; although we would have suspected Bernard Maybeck, a young draughtsman in the office. Their heavy squared legs allow the chairs to be placed tightly together in neat rows. The tule rush is from the Sacramento River. Gustav Stickley reportedly saw one of the chairs exhibited in New York a few years before his *Craftsman* furniture appeared.

detail–Swedenborgian Church

Swedenborgian Church

Arthur B. Benton
Mission Inn, Riverside
begun 1901

tower and courtyard from northeast

Frank Miller's mecca for early tourists coming to
California was constructed and amended over a period
of many years. Shops were set up in the *catacombs*
of the first buildings to produce many of the fixtures,
such as balcony railings, light fixtures, and door
hardware. The hammered ironwork was laid in the
sun as it was finished and sprinkled with water to *age*.

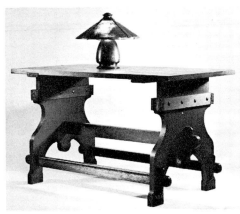

Old Mission Kopper Kraft
Table lamp, copper with
mica shade
h. 14½″

Private Collector, Riverside

Anonymous
Library table, fir with copper shields
30½″, ca. 1905

Mission Inn

This piece, made of California fir, was
found among the furnishings of the
Mission Inn and is presumed to have been
built there. With its oversized keys and
rakish curves, it is almost a caricature
of the sedate designs Gustav Stickley
produced in the east.

The entrance of the Inn as it appeared in 1910.

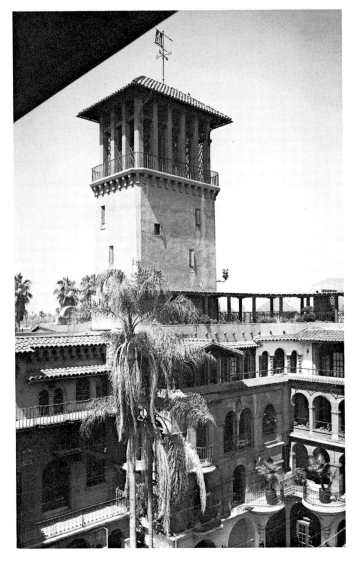

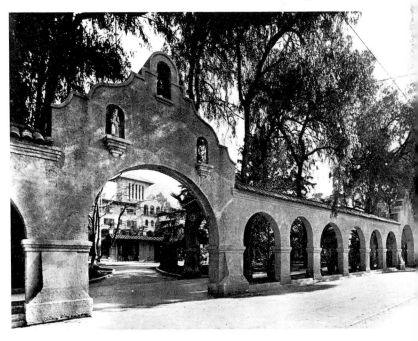

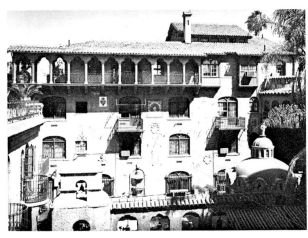

Mission Inn
view across courtyard looking east

Many guest rooms opened onto these balconies
overlooking the courtyard. The original furniture for
these rooms was supplied by Limberts, Gustav
Stickley, and other eastern firms. But as things got
moving, Miller brought in craftsmen to build some of
the furniture, and also resident potters such as
Cornelius Brauckman and Fred H. Robertson to
make well-crafted souvenirs.

Mission Inn

The fourteen architects included here all practiced in California between 1892-1914: by their designs, their work procedures, their ideas and ways of life, they all belonged to the Craftsman movement.

A Craftsman building strives to be a personal and sheltering background for human action, not a monument. The building types are all residential or places of the spirit—for churches, schools or recreation use—and most of these seek a domestic informality and scale. Significantly, there are no examples of Craftsman urban design, either civic or commercial. The connection with nature was fundamental.

To achieve a harmonious balance with their sites, the buildings did not actually merge with the landscape, but deferred to it and sought a connective link. Often their forms respond to contours or embrace a site feature—such as a courtyard surrounding an oak. At times, even a symbolic transition between nature and the building was sought—like the Greenes' use of undulating klinker brick retaining walls. Gently sloping roofs with wide overhangs, a blend of shingles and timbers, indigenous stone foundations rising into chimneys and earthy colors were all gestures to integrate these buildings into the California landscape.

The *experience* of a house was most important. Picturesque and evocative effects from a variety of architectural sources were freely used to enhance the emotive impact. Interiors of these middle class homes cultivated a sense of unity. Spaces flowed easily from one another and to the outdoors, with continuous mouldings and repeating motifs in doors and windows. Finishes were chosen to bring out the inherent qualities of materials, especially wood. From the architects' drawings, which were usually minimal, we may assume that design decisions were made throughout construction. Most of these houses contain subtle features often unnoticed at first, that reveal themselves over time. Perhaps there was a panel with a particularly lovely grain pattern saved for a special location, or some woodwork may have been mortised or scarved. The implicit message of fine craftsmanship was that those involved cared considerably about their work and the quality of the product. For workers and architects alike, their activity was of real personal consequence.

The Architects:

Ernest Coxhead
1863-1933

Ernest Coxhead is one of the least known of the San Francisco Bay Area architects of the turn of the century. He was, however, an original and resourceful designer, as well as a major influence on some of his better-known contemporaries (Willis Polk and Bernard Maybeck both spent brief periods in Coxhead's office). Like most of the designers who together evolved what is thought of as an indigenous *Bay Area* idiom, Coxhead came to California from somewhere else.

The son of an Anglican minister in Sussex, England, Coxhead was a registered British architect before he arrived in Los Angeles in 1886 at the age of 23. Much of his professional training had been received in the office of an architect specializing in ecclesiastical restoration, and Coxhead's Southern California work (Church of the Ascension, Sierra Madre, 1887 and Church of the Angels, Garvanza, 1889, are typical) shows traces of the influences to be expected given Coxhead's background: Morris, Butterfield, Pugin. In fact, throughout his career Coxhead's work was closer in feeling to the medievalizing tendencies of the English Arts and Crafts than to the studied rusticity of the American Craftsman Movement.

Apart from his solid European education at the Academy of Royal Institute of British Architects, Coxhead's tools as a designer included a great sensitivity to the building as a part of the landscape; a strong and lasting interest in vernacular and regional modes; a predilection for Mannerist manipulation; and a healthy lack of awe for the constraints of stylistic convention. Coxhead was motivated to produce art, maintaining that "if utility alone is needed, then an architect is not."

In 1890 Coxhead moved his office to San Francisco. He was by then well known as a church designer and his first San Francisco work was a series of remarkable (and sometimes bizarre) buildings for the California Episcopal Diocese. The finest (and strangest) of these, St. John the Evangelist, was

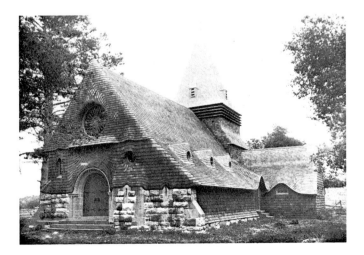

Ernest A. Coxhead
St. John's Episcopal Church, Del Monte
1891

That such delightful *toy* churches were the product of Ernest Coxhead is truly amazing. Certainly his academic British background and relationship with the Episcopal Diocese in California should have provided him a knowledge of all that is formal and proper. Nevertheless, these wonderful little buildings are from his hand. And they are little—from grade to eave is about five feet.

Architecture
Tim Andersen

destroyed in the San Francisco fire of 1906, but St. John's Del Monte (1891) and St. John's Petaluma (1890) are smaller buildings that have a similar feeling, and which remain in almost original condition. These buildings all involve extreme manipulations of scale and a collection of seemingly incompatible stylistic fragments.

As the '90s progressed Coxhead began to receive more and more residential commissions. He had a thorough understanding of the possibilities, as well as the limitations, of urban living, and his shingle town houses in the Pacific Heights area of San Francisco set a high standard both as living environments and as thoughtful components of the streetscape. Primarily of redwood shingles, these houses generally provide a severely plain, seemingly vernacular facade as a back drop for a few pieces of ornate decoration derived from or parodying historical precedents (Osborne residence, 1896; Porter/Waybur houses, 1902-4).

At the turn of the century Coxhead created two buildings whose interiors could have popped right out of the pages of *Craftsman* magazine (St. John's Presbyterian, Sausalito and an informal country house in Inverness). Starkly simple and of unfinished horizontal boarding with almost no ornament, these buildings are simultaneously rustic and elegant; careful, yet casual.

The 1906 fire and quake marked the end of an important period in Coxhead's career. The woodsy, regional idiom which he had helped to create was no longer fashionable: more durable materials and a more *correct* interpretation of historical sources were demanded. It was not an atmosphere in which Coxhead's particular talents flourished, and it was not until the 1920s when he (and public taste) embraced the Spanish Colonial Revival that his designs equaled the quality of those produced in the first period of his career. He died in Berkeley in 1933.

John Beach

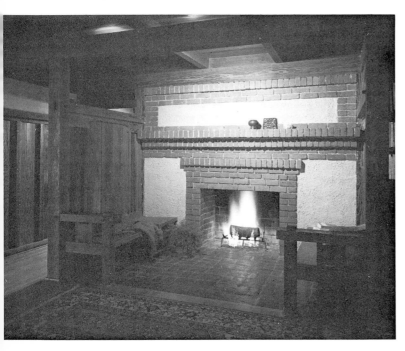

Louis B. Easton
1864-1921

Born in Half Day, Illinois north of Chicago, Easton was trained as a teacher graduating from the Bloomington (Illinois) Normal School in 1890. There He met his wife, Honor, sister of Elbert Hubbard. Easton taught manual arts training at Lemont High School, becoming vice-principal in 1893. Aided by "a few wealthy men, he organized classes of poor boys and taught them, with success, to make useful and beautiful things with their hands."

In the evening, Easton built furniture of his own design in oak and leather. Some of these pieces were exhibited in the 1903 Handicraft Exhibit of the Chicago Art Institute.

For reason of his failing health, the Eastons moved to Pasadena, California in the winter of 1902-03. After a year's recuperation, Easton adapted a design and built a house for his young family. When it was completed he hung a shingle in front—*Bungalows and Furniture*, and thereby became a contractor. Approximately twenty-five houses in the Pasadena area were personally designed, supervised and built by Easton with a few tradesmen.

Although Easton was never registered as an architect his designs were included in the 1913 Los Angeles Architectural Club exhibition. When the prominent architect, Myron Hunt decided to build a weekend beach house near Palos Verdes (1911), he chose Easton as the appropriate designer. The house was built in typical Easton fashion: redwood inside and out, an elaborate brick fireplace, custom furniture and fixtures integrating with the building.

In 1915, the Eastons left the changing Pasadena scene and moved to rural Anaheim. There, Easton remodeled an existing adobe and remained as a truck farmer until his death at fifty-seven.

Louis B. Easton
Volney Craig house, Pasadena
1908

This view of the inglenook reveals many characteristic features of Easton's buildings. Interiors usually had a redwood board and batten wainscoting, finished by brushing with a stiff-bristled wire brush. Above this would be undyed burlap or monk's cloth. He employed low partitions to give a sense of enclosure without breaking the flow of horizontal space; often as a transition between major spaces or the outdoors. Mortise and tenon joints and raised pegs had their appeal for Easton, and he generally found a few conspicuous places to incorporate them into his designs. Ceilings were almost always flat with redwood joists and decking exposed.

Redwood structural members were usually exposed on the exterior with untreated shingles or clapboards as infill panels between. As one of Easton's clients wrote in *Craftsman*: "There are no *fake* beams or posts in the house; every stick of timber is just what it appears to be, and does just what it seems to be doing."

Irving John Gill
1870-1936

Born in Syracuse, N. Y., Gill was the son of a contractor. After apprenticing to a local architect, he worked (1890-1893) in the Chicago office of Adler and Sullivan, then moved to San Diego where he established a successful practice. In 1914, he moved his office to Los Angeles, but by 1920 his success had waned; after an illness, he moved to Oceanside where he died.

His important buildings were the La Jolla group: Bishop's School (1906-1916), Women's Club, 1913, Community House, 1914; Klauber house, San Diego, 1907. Also the: Miltimore house, South Pasadena, 1911, Dodge house, Los Angeles, 1916 and Lewis Courts, Sierra Madre, 1910.

His mature style grew out of a process of simplification and elimination, and the development of a technology for concrete. Characteristics were cube forms, arcaded walls (from the California missions), the extension of buildings into gardens by use of pergolas, and trellised *green rooms*. His experimentations with concrete included lift-slab walls (Women's Club, Community House, etc.). His early interiors followed the simplification of the Craftsman Style, which revealed the integrity of materials: redwood in wide boards hand-polished to a sheen, four-piece doors, flush detailing. This same craftsman's approach was characteristic of the revealed concrete of his later interiors.

Esther McCoy

Irving Gill
F. B. Lewis Court, Sierra Madre
1910

Gill was oriented to the possibilities of the present. One can sense his feeling of expectation in his writings. He was romantic about California's unspoiled landscape and found inspiration in the mission architectural heritage. He optimistically believed that architects would take an important role in shaping the built environment of California, feeling a deep sense of responsibility to reflect his culture at its best. Lewis Court reveals his aspirations, perhaps best of all his completed works. Located above the small, relatively remote community of Sierra Madre, the site was a sloping, featureless terrain bordered on three sides by lightly-traveled streets. The mountains loomed over the site to the north with the vast alluvial plain stretching before it all the way to the Pacific. For Gill, these twelve units of one-bedroom apartments were to be a demonstration. He would show how available technologies could be employed to produce low-cost housing with a high standard of livability. He saw the advantages of concrete and plaster construction incorporating steel door and window casings as providing a more durable and cleanly structure than conventional wood framing. He saw the possibility of increasing density, organizing individual units into a cohesive, urban form to permit more usable open space. The opportunity of a mild climate enabled Gill to provide outdoor living spaces with a varied degree of enclosure. The intentions can be easily perceived, but the vision was to some extent compromised. Instead of cast concrete, less expensive plastered, hollow terra cotta tiles were used for walls and flat roofs. The units forming the south enclosure of the compound were built some years later, and, rather than defining, consumed much of the open space.

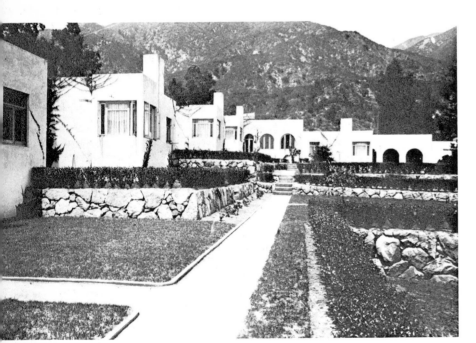

Charles Sumner Greene
1868-1957

More than any other turn of the century architect, Charles Sumner Greene was able to extrapolate from the Arts and Crafts movement and California scene an unique and creative vision. Charles was born the first son of a Cincinnati physician in 1868. In his early years, the family moved to St. Louis where he and his brother Henry attended public schools. After high school Charles enrolled (1882) in the newly formed St. Louis Manual Training School, the first of its kind in the United States. Graduating in 1886, Charles went on to study architecture with his brother at the Massachusetts Institute of Technology, receiving a special two-year certificate in 1890. After a brief period of working in Boston area architectural offices, Charles and Henry left in the autumn of 1892 to join their parents who had moved to Pasadena two years earlier.

Having tasted the potency of the natural setting and the excitement of possibilities, Charles and Henry decided to stay; opening their own office in January, 1893. Years of undistinguished buildings ensued, running the full gamut of styles. Then in the spring of 1901, one month after his marriage, Charles sailed with his bride to her native England. From there they traveled to France and Italy. The experience greatly enriched his outlook. Charles returned with a heightened sense of purpose. He began looking for the germinal influences of his own place and time, disavowing historicism in hope of finding indigenous expression for his own culture. The idea of creativity rooted in the landscape was, of course, a popular notion of the time. It had spurred other Californians such as Irving Gill, and the midwest *Prairie School* as well. Other concerns in the forefront of avant garde architectural thinking which Charles espoused were the examination of *the nature of materials*, and demanding utilitarian motives in design decisions. By 1906 the Greenes' architectural practice was flourishing. Most of the houses for which they are famous were produced within the next few years. Writing ca. 1905, Charles delineated his design intentions as follows: "To understand as many phases of human life as possible. To provide for its individual requirements in the most practical, useful way. To make these necessary and useful things pleasurable."

The commission to build the Fleishhacker estate ca. 1910 near Woodside marks the beginning of Charles's exit from Pasadena. Despite his professed desire to build "in the most practical, useful way," Charles was not really interested in merely expediting his clients' domestic requirements. Fleishhacker was willing, and able, to play *art patron*, and Charles liked the script. It would provide him the opportunity to concentrate on the minute detailing he so loved to do, but which many of his clients resented paying for. Also, concurrently, Charles's interest in orientalism was shifting from visual imagery to its philosophical essence. The effect was one of being pulled toward the Carmel community because of its reported empathy with **Eastern thought, and**

repelled from his more pragmatic Pasadena context. However, the break with Pasadena and his brother, Henry, was a slow process characterized by ambivalence. The year of demarcation is not clear-cut, because the partnership was not officially dissolved until 1922. The building of a small wooden studio on Lincoln Street in 1916 in Carmel is the best indication. Although still in his forties, Charles did not become influential in this community as he had in Pasadena. In the remaining years of his life he designed about a half dozen buildings choosing instead to devote his time to tinkering. **He died in Carmel in 1957.**

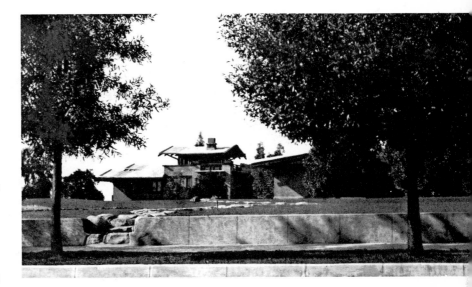

Charles and Henry Greene
Freeman Ford house, Pasadena
1908

This photograph, taken about 1910 by Louis B. Easton, reveals a quality characteristic of the Greenes' work which has become somewhat obscured with the passage of time. Within their clients' generous suburban lots, the Greenes designed every square inch to conform with their design vision. The houses from their most productive period (1906-09) are almost all sited as this one, in domestic gardens adjacent to streets. From the first step at the sidewalk to the key that unlocks the dining room buffet— *everything* was designed. But since then, the landscaping, alterations and subsequent neighboring development have changed most of their original schemes. Many owners have dutifully kept up with current tastes, altering their homes accordingly. This house has since been adorned with *mission* tile roofs, the eaves cut back to more modest proportions, and at some point a second story trunk room was lopped-off. The drawback in the *total design* approach is that the building must become frozen upon completion, and henceforth remain the same. Without the original architect's eye, there is almost no way to accommodate change and growth in an undestructive manner.

Alfred Heineman
1882-1974

The Heineman's came from the East, but Alfred and his older brother Arthur grew up in Pasadena. As young men, both were active in civic affairs and community planning, such as promoting the planting of street trees. Though the firm was under the name *Arthur S. Heineman*, Alfred was the designer of almost all buildings from 1909, when he joined the firm, until the early 1930's when it was broken up. Arthur was the inventor—perhaps of the bungalow court idea, almost certainly of the motel. Alfred carried out the ideas in architectural style, a fact very curious since he had almost no formal education.

He did a few buildings before he joined his brother in 1909. They are simple, straightforward and not very good examples of Craftsman houses. Then Batchelder touched him. Also, the Greenes, though as an old man he could not remember them. And Arthur, always a formidable influence on his life, must have done something to free Alfred's imagination.

The result is buildings (in our period at least) that are sometimes mistaken for works by Charles and Henry Greene and even Bernard Maybeck.

Alfred loved difficult sites and plotted his buildings accordingly, often playing with diagonals in his floor plans when orthogonal arrangements would not work. Like the Greenes, he loved exotic woods, though he used gums more often than teak. Almost always he paid a tribute to his teacher, Ernest Batchelder, by using Batchelder tiles, especially in fireplaces.

Unlike the Greenes, he and his brother went on into the '20s and '30s doing Spanish Colonial Revival, Tudor and even Streamline Moderne assignments. I once asked him how, since he had so thoroughly mastered the Craftsman style, he could so easily go off into other modes. "I guess I didn't know any better," was his reply—so characteristic of the man, who was a good architect and a great human being.

Robert Winter

Arthur and Alfred Heineman
Bowen Court, Pasadena
1910

The idea of the bungalow court was to provide in a confined area, amenities such as porches and gardens for people that would otherwise end up in apartment blocks. There are slight variations in the plans and details of these 35 units. Pedestrian access is through this wide promenade, while cars are corraled into a couple of small lots with access from adjacent streets. The sense of community is heightened by incorporating a eucalyptus—log *teahouse*, **literally as** large as one of the units, deep within the property. Houses were named instead of **numbered:** *Paloma, Toloso, Pepito*, etc. Over the years, personal adaptation has further differentiated the units. Many elderly people live here now and can be seen attending their flower gardens early in the morning. In ironic contrast, directly opposite this view has been constructed in recent years, a concrete tower with icecube tray balconies for *geriatrics*.

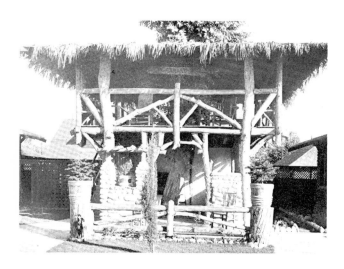

Bowen Court, playhouse

Notice that the eucalyptus—log house, *Farano*, has a eucalyptus tree growing through its center.

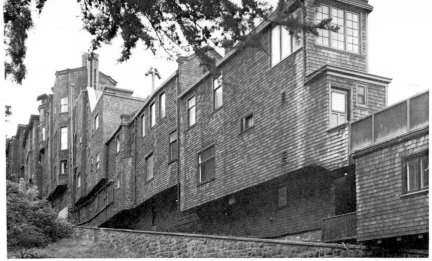

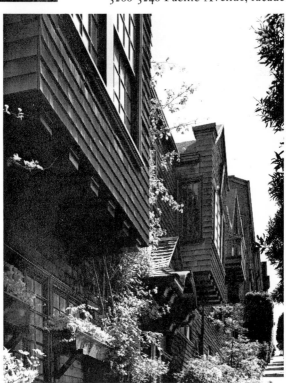

3200-3240 Pacific Avenue, facade

William F. Knowles
Ernest A. Coxhead
3200-3240 Pacific Avenue, San Francisco
1901-13

This extraordinary block of townhouses evolved over
a period of eleven years with at least three architects
involved. Each has responded to the topography and
respected his neighbor's right to the view. The
continuous skin of untreated redwood shingles provides
coherence to the otherwise delightfully *ad hoc*
assemblage.

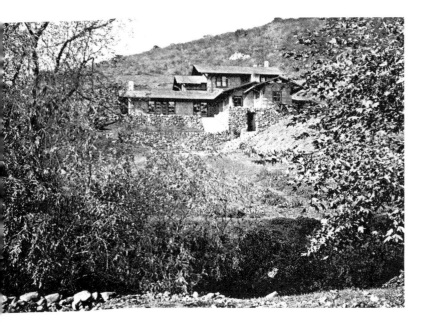

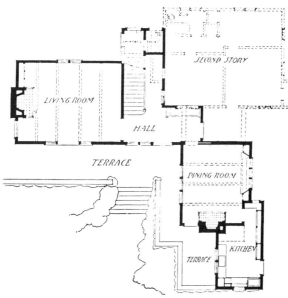

John T. Allen ranch, floor plan

Arthur Rolland Kelly
John T. Allen ranch, Hollywood
ca 1909

Arthur Kelly was educated in the east, coming to the
Los Angeles area in 1902. He formed a brief
partnership with Elmer Grey, but practiced
independently during most of his career. The
majority of his residential work during the Craftsman
period leans toward Colonial Revival and is of only
marginal interest. A rare exception was this house
from Kelly's office which encompassed a small
existing building in its construction. The house
nestles into the hillside using boulders from the site for
its retaining walls. The shingled gable roofs
descend in the direction of the slope, and the
coloring of materials blends with the tawny hills.
Compare this to Mullgardt's hillside solutions.

The plan of this house fits into an impression in the
hillside opening in two directions toward the view.
The rear of the building is at a higher elevation,
corresponding to the topography. Living room and
dining room open onto a generous terrace.

Bernard Maybeck

1862-1957

Bernard Maybeck can be more readily labelled an Arts and Crafts architect than most of his Northern California colleagues. His own life was characterized by unpretentiousness and simplicity, marked by a deep respect for nature and an overriding desire to return to what he considered the fundamentals of human existence. He regarded art as integral with life; work that does not so correspond could not be art. He felt that design was to be guided by the mood and character of those activities which it was to shelter; the design process was approached as a craft, not as an aloof fine art and certainly not as a business. While he was not adverse to the machine for many tasks, ornament and color were strictly a product of the hands, often his own.

Maybeck's family emigrated from Germany to New York where Bernard was born. His father was a woodcarver, so successful in that profession that he was able to give his son an excellent secondary education which Bernard was not too successful in mastering, an apprenticeship in woodcarving where Bernard's brilliant eccentricity made him a little out of place, and then a term of study at the École des Beaux Arts in Paris where Bernard was equally eccentric but which was an enormous influence in his life. The super-sophistication of l'École and the training in the sensitivity to materials gained from his woodworking were to be the polarities between which Maybeck was pulled back and forth throughout his long life of creativity.

The École des Beaux Arts background is obvious in Maybeck's frequent allegiance to Romantic Neo-classicism. The Palace of Fine Arts, done for the San Francisco Exposition in 1915 is in the Beaux Arts tradition of complete mastery of history. But it also exhibits an imagination which transcends simple Neo-classicism. We note it, because it is in a sense the absolute opposite of the Craftsman commonsense point of view. The First Church of Christ Scientist (1910) in Berkeley is another famous example of his Romanticism within historic styles. The lessons of Vezelay become decadent in the cast concrete of the exterior columns. And the tracery of the south window outdoes St. Severin in Paris in Gothic flamboyance.

Nevertheless, it is impossible to categorize this amazing genius. Maybeck, while never simple, could summon not just effects but solid craftsmanship. The ceiling of the Christian Science Church is a case in point—a celebration in wood of the cruciform truss, which Maybeck of course elaborated with decorative patterns from French Gothic. The result is Craftsman *woodsiness* of a very individualistic variety. Other rooms in the church are more clearly Craftsman, with rafters, paneling and even light fixtures fashioned of wood. The same Craftsman effects appear again at his Outdoor Art Clubhouse (1905) at Mill Valley, the Town and Gown Clubhouse (1899), the Faculty Club (1902) at Berkeley and in many other buildings, some very un-woodsy on the exterior.

He comes closest to the American Arts and Crafts movement—indeed becomes a part of it—in the shingled Swiss chalet houses and bungalows he built, mainly for the Berkeley intelligentsia, in the hills above the University. Maybeck even had a fan club, The Hillside Club, founded by Charles Keeler, his first client, especially to promote Maybeck architecture in Berkeley and its environs. Southern California Craftsman architects were never so fortunate.

It is fascinating to compare Maybeck with his counterparts to the south. Many of his buildings would fit beautifully into the Arroyo Seco, where Swiss chalets were plentiful. Yet to enter a Maybeck house is a very different experience from that which you have in crossing the threshold of most Southern California Craftsman houses. The point is Maybeck's conception of space. Where the Arroyo Craftsmen stressed intimacy and even sometimes the flowing space which Frank Lloyd Wright made famous in his work, Maybeck saw interiors as spatial explosions. He achieved this by playing with scale and axial changes —and also just plain surprises. It is illuminating to go from Maybeck's dramatic spatial arrangements— low ceilinged passages wandering toward baronial halls—into houses by Greene and Greene who only once in actual building showed an interest in vertical space (Pratt House, Ojai). The Greenes' rooms are boxes—beautiful boxes, immaculately conceived boxes. Maybeck spaces sometimes seem to go below the human scale but then stretch far beyond it. Maybeck's love for the grand as well as the simple, his roots in cabinet making and his Beaux Arts training, his almost simultaneous planning of Keeler's rustic Berkeley cottage and the formation of a visionary scheme for an enormous classical city to serve as the new campus of the University of California, mark the diversity and breadth of his genius.

Robert Winter

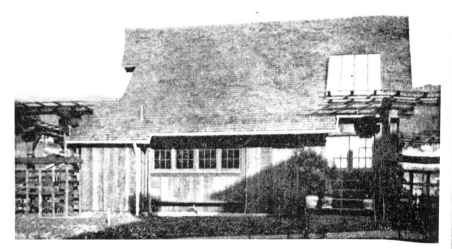

Bernard Maybeck
Frederick E. Farrington Studio, Berkeley
1905

To look to rural vernacular buildings as a source of imagery has been a recurring theme in California architecture continuing to the present. The sense of a timeless, simple form placed in a vast landscape has had its appeal for many architects, including Maybeck. This studio was destroyed in the 1923 fire which

Frank Mead

1865-1940

Mead was born in the shipbuilding city of Camden, New Jersey, his father a residential contractor. After receiving an architectural education he opened his own firm (ca 1900) in Philadelphia with Bart Keane. They are said to have been commissioned by an American periodical to photograph Bedouin villages on the Sahara Desert. With this impetus, Mead was able to see the vernacular architecture of North Africa which had long intrigued him, and also the Mediterranean and southern Italian. Upon his return, Mead independently relocated in San Diego. There he was employed (ca 1903) by Irving Gill, bringing to that office his recent experience with, and great enthusiasm for, primitive architectural form. Working with Gill, Emmor Brooke Weaver and Richard Requa, Mead took an active role in the design of commissions such as the Wheeler Bailey house (La Jolla, 1907).

His continuing fascination with Indian cultures led him to visit tribes then living in Arizona. On one such occasion in 1908, Mead was enraged by the condition of a particular Apache tribe whose land had been legally confiscated by squatters. An acquaintance and later client of Mead's lived on Oyster Bay next to the vacation home of Theodore Roosevelt. Mead asked her to arrange a meeting with the President in which he and a tribe spokesman would travel to Long Island and explain the situation. The meeting took place; Roosevelt was sympathetic, and appointed Mead his personal envoy to purchase the lands for the Indians—which he was able to do. Because of this success, Mead was offered a position as Superintendent of the Lame Deer Reservation in Wyoming (1909). After living there a year he relocated to the Pala Reservation in San Diego County.

Returning to San Diego ca 1912, Frank Mead joined Richard Requa who had since established his own practice. The firm of Mead and Requa designed several stark, plaster buildings in the San Diego and Los Angeles areas similar to Gill's, but with a much more exotic range of imagery; as in the Sweet house (San Diego, ca 1914). A draughtsman for the firm recalls Mead as the primary designer of these commissions with Requa's knowledge of structure as an essential contribution. Characteristic of the period was their five-story Palomar Apartments (San Diego, ca 1913) near Balboa Park with its *random* placement of window and door openings, and its apparent unwillingness to conform to a module. After the Krotona Court in Los Angeles (1914) there was little new work. Mead moved to Santa Barbara, and then to Ojai with the commission to redesign much of the business district leveled in a fire, and establish a cohesive aura for the community (1916-17). The partnership of Mead and Requa was formally dissolved in 1923. Mead was injured in an automobile accident and died in Santa Monica, 1940.

Frank Mead and Richard Requa
W. J. Bailey beach house, La Jolla
ca. 1915

This Pueblo Revival house tucked into the hillside flamboyantly expresses the designers' enthusiasms. Mead had absorbed the architecture of North Africa and the Mediterranean as well the American Southwest. Notice how the wall forms a staircase to the roof deck. Indeed, the building appears to be a man-made topography in itself.

swept the Berkeley hills. Surviving drawings are not known to exist, but one would imagine the interior space to be also barn-like in character—a single volume, pershaps with a loft. Notice the pergola structure, a device Maybeck often employed to blend his buildings into their sites. In many instances these vine-covered structures would be placed to block the summer sun, when they were dense with foliage, allowing it to penetrate during the winter months for the added warmth.

W. J. Bailey beach house, living room

Frank Mead is said to have taken an active part in the design of Irving Gill's 1907 house for this same client. Here, too, the architects have supplied the furniture of native woods. To further develop the scenario, Hopi Indians were commissioned to produce the light shades and rug.

Julia Morgan
1872-1957

Julia Morgan is perhaps the most important member of a slightly younger generation of San Francisco architects who were influenced by the catholic approach to design practiced by Polk and Coxhead in the early 1890s and soon afterwards by Maybeck. She came in contact with Maybeck during this period. While at the University of California, she was one of several engineering students to attend his informal class in architectural design. Then with the encouragement of both Maybeck and her family, she pursued her education at the École des Beaux Arts. In 1901 she became the first woman to receive its diploma. After some three years of apprenticeship, she opened her own office in San Francisco and for the next three and a half decades maintained a flourishing practice.

The large body of Julia Morgan's work falls outside the realm of Arts and Crafts design. Most of her buildings freely borrow from the Italian and Spanish Renaissance as well as late medieval and classical periods in England. Sometimes her use of precedent was loose, making only general reference to the past; sometimes it was scholarly, replicating elements of a readily identifiable monument. However, certain aspects of her attitude towards architecture as well as a relatively small number of buildings bear discussion within the present context.

In many respects, Julia Morgan wished to model herself after the then generally held conception of a medieval master mason as a semi-anonymous contributor to a communal undertaking. The architect's work could not mold society; it could only be a product of it. She had a deep admiration for the other arts and building crafts, but was inconsistent in the strict control she retained over them in her designs. Even at the enormous Hearst *ranch* near San Simeon where a small army of craftsmen set up camp during the course of construction, she dictated the execution of all work down to the last detail. However she did follow her ideal medieval builder in her rigid avoidance of publicity. She was not interested in writing or talking about her architecture and avoided the professional journals like the plague. While such an attitude brings to mind that of the Art Worker's Guild in England, it stands in direct contrast to methods of most leading advocates of the movement, especially in this country.

More in keeping with Arts and Crafts ideology was her appreciation for simplicity and respect for common things done with integrity. She was never known to have turned down a commission because it was too small or too inexpensive. Here can be seen the direct influence of Maybeck, and she was fond of quoting him to the effect that monetary restrictions imposed upon a design should be regarded as a challenge, not a detriment.

Unquestionably, the finest manifestation of this attitude is St. John's Presbyterian Church in Berkeley (1908, 1910). Responding to a program that permitted the expenditure of less than two dollars per square foot, she produced a design that was wholly structure, save for exterior sheathing and fixtures. Built almost entirely of redwood, it presents a magnificent balance between aesthetics and structure; the logic of French Rationalist theory is translated into warm materials and a celebration of the ordinary. Few designers would have attempted such a merger, fewer still would have been able to attain it with such subtlety and grace.

Richard Longstreth

Louis Christian Mullgardt
Henry W. Taylor house, Berkeley
1908-09

Mullgardt's most accomplished work was this huge residence built in the Berkeley hills. From this façade there was a magnificent view over the lowlands and across the San Francisco Bay. The building, with its light-colored roughcast stucco walls and roofs of a flat reddish tile, stands as an object in complete contrast to the landscape.

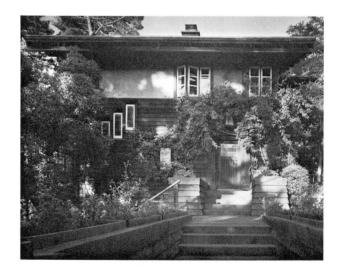

Louis Christian Mullgardt
Ernest A. Evans house, Mill Valley
1907

The effects of landscaping and aging redwood have softened the impact of this building on the landscape. In 1907 it stood as an isolated and self-contained form. A balcony cantilevered into the view, and this entry bridge, continuing the lines of the clapboard, reached out to connect with the pedestrian access. Notice the machined quality of its elements. This tight and orderly composition in redwood and plaster has none of the *woodsy* sentimentality preferred by many of Mullgardt's contemporaries.

Louis Christian Mullgardt

1866-1942

Mullgardt was born in Washington, Missouri—where his German parents had settled after the revolutions of 1848. He learned early a respect for craftsmanship (his father was a saddle maker) and an interest in architecture (two uncles were builders). At the age of fifteen he was apprenticed to an architectural firm in St. Louis. Six years later he was hired by Shepley, Rutan and Coolidge in Boston, where he worked on drawings for Stanford University. After a brief exposure to formal training at Harvard, Mullgardt went to Chicago in 1891, where he became the chief designer for Henry Ives Cobb. His most important task there was the detailing of the Fisheries Building at the World's Columbian Exposition of 1893.

Even before leaving Chicago, Mullgardt formed a partnership in St. Louis: Stewart, McClure and Mullgardt (1892-94). Following its dissolution, he made an extended study tour of Europe. Back in St. Louis, he resumed a modest practice under his own name (1895-1902), designing a variety of buildings which were of no special distinction—except for their fascinating details. Mullgardt was an active participant in preliminary discussions regarding the 1904 Louisiana Purchase International Exposition, although the official planners ignored his advice about its location and awarded him no commission for its buildings. He went to England in 1903, where he worked as an architectural consultant for two years.

In the late spring of 1905, Mullgardt arrived in San Francisco. He soon shared the office and letterhead of George Alexander Wright and Willis Polk; but this tenuous partnership ended by early 1906. During the next few years Mullgardt designed houses almost exclusively. They were unlike anything he had done before. Often planned for steep hillsides, they stood on canted foundations—his most consistent feature at the time—and could also be recognized by their rough-sawn clapboards, suggestions of half-timbering, and bands of casement windows. These houses proved to be among the most novel combinations of indigenous materials and simple planning to be found in California during the first decade of the new century. The Ernest A. Evans house in Mill Valley (1907), for example, illustrates Mullgardt's mastery of siting and his use of milled redwood. It makes reference to, among other things, the silhouette of the Alpine chalet and the timbering of the Japanese house.

The following year, 1908, Mullgardt began a series of larger residences whose exteriors were rendered with roughcast stucco—as seen in the Henry W. Taylor house at Berkeley (1908-09), now destroyed. Expanses of white, boldly fenestrated walls and prominent chimneys recalled the work of Charles F. A. Voysey which Mullgardt had seen during his British sojourn. Some critics noticed an affinity with Tibetan palaces in the way these structures rose from their sites. Others were struck by the Mediterranean contrast of white walls and red tile roofs. Mullgardt thus joined Maybeck, the Greenes and others in contributing to the California tradition startling combinations of diverse architectural images. The coastal land made these remarkable syntheses possible; for here Occidental and Oriental met in provocative confrontation, reacting with and molding each other as in few places elsewhere in the world.

After 1910, Mullgardt's career took another direction. His practice was no longer limited to residences, and there appeared a renewed interest in historicism. He was appointed in 1912 to the architectural commission of the Panama-Pacific International Exposition (1915). The festive nature of the fair and its impermanent materials encouraged his innate facility and boundless fantasy to prevail. *The Court of the Ages* was thus elaborately decorated and laden with complicated symbolism; yet there was a remarkable contrast of details and plain surfaces. Much of Mullgardt's subsequent work reflected a preoccupation with the festal courtyard, which had been a surprisingly popular success. After 1920, however, he—like so many architects of his generation—was almost jobless. Mullgardt died, quite forgotten, in 1942.

Robert Judson Clark

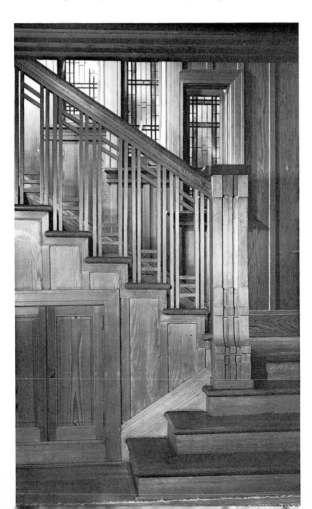

Ernest A. Evans house, detail of stair

This fragment of the living room reveals the overall quality of the interior. The redwood throughout is precisely milled, planed and fitted together. When compared to a redwood interior of an Easton house, one suspects that their design intentions were probably quite different. Easton's buildings seem primarily expressions of a life style—for both builder and client, while Mullgardt's appear as artifacts—complete unto themselves.

Frederick L. Roehrig

1857-1948

Born in Le Roy, New York, Frederick Roehrig received a Bachelor of Architecture degree from Cornell University in 1883. Following the pattern of so many of his contemporaries he continued his studies abroad in England and France. Thus equipped, he came to California in 1886 and opened his own architectural office in Pasadena, relocating to Los Angeles in 1890. Having been trained as an architect in the Classical manner and having come from an eastern family with a strong academic background, Roehrig's buildings reflected these conservative influences. His early residences (now mostly destroyed) reflected H. H. Richardson and early Stanford White buildings. In 1889 he designed (Roehrig and Locke) the two portions of Pasadena's Green Hotel which still exist, in a mixture of Mission Revival and Islamic architecture. But as the Arts and Crafts movement gained momentum many of his designs began to take their place within the less dramatic craftsman mode. Most of them were built in Pasadena, such as his own house on South Oakland Avenue, a good example; others being the Scoville, Watkins and Eddy houses. As if to epitomize the mood of the time and place, Roehrig designed in 1910, a Swiss chalet-like garage for Arthur H. Fleming, complete with stones on the roof!

Lawrence Test

Albert C. Schweinfurth

1864-1900

Albert Schweinfurth died only four years after beginning his own practice and of the six projects known to have seen realization, only one has escaped destruction or extensive change. However, Schweinfurth remains of no small importance to the history of West Coast architecture. Of all his Bay area colleagues, he appears to have been the most concerned with developing an approach to design that was characteristic of, even unique to, California.

A native of upstate New York, his early training was received in the offices of several prominent eastern firms, most notably Peabody and Stearns of Boston. For reasons of health, he moved to Denver in 1889, and by 1891 was in San Francisco. The next five years were spent in the office of A. Page Brown, himself a recent arrival from the east. During this time, Schweinfurth was primarily responsible for the design of Brown's commissions. Among the most notable was the Atkinson Building in San Francisco (1892), one of the earliest known Mission Revival structures in the state. Even more important was his contribution to the design of the Garden Church of San Francisco (1894) built for the Swedenborgian minister, Joseph Worcester. It remains a significant early manifestation of Arts and Crafts ideals in this country not only in its simple expression of local materials and its close relationship with nature, but as an extremely successful cooperative effort involving a number of the arts. William Keith produced a series of paintings incorporated into the sanctuary,

Bruce Porter designed the stained glass and it was probably Bernard Maybeck who was responsible for the chairs with tule rush seats.

An overriding simplicity combined with a strong regional expression also distinguishes Schweinfurth's independent work. His enormous country house for Phoebe Hearst in Pleasanton (1896) was arranged around an open court with every ground floor room opening onto at least one colonnaded porch, inviting a mode of living much less formal than dwellings of comparable size elsewhere. The vernacular architecture of Spain during the 17th and 18th centuries provided the major historical precedent, and was in Schweinfurth's mind, the best foundation from which a California architecture could emerge. Other sources were tapped as well, yet even the shingled First Unitarian Church in Berkeley (1898) or the Bradford house in San Francisco (1897) have the same low profile and massive elements, such as redwood trunk columns, that render them apart from the work of his contemporaries and important precursors to Craftsman design after the turn of the century.

Richard Longstreth

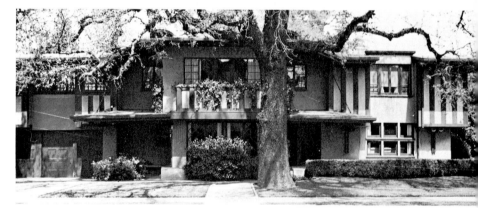

John Hudson Thomas
Stevens house, Woodland
1916

John Hudson Thomas

1875-1945

The Berkeley architect John Hudson Thomas was born in 1875. After graduating from Yale he began studying architecture as a graduate student at the University of California in 1901. At Berkeley, his principal teachers were John Galen Howard and William C. Hays.

In 1908 Thomas became a partner in the small Berkeley firm of Plowman and Thomas. For several years the firm produced designs which fit comfortably and rather quietly into the Craftsman tradition. Some of these had complex, articulated roof-support systems, such as the Kelly house (Santa Barbara, 1916). Others revealed—actually or symbolically—their structural wooden frame as an exterior skeleton; a notable example being the Hunt house (Berkeley, 1912). In many there is a strong affinity to Swiss vernacular buildings. As compositions, these houses often seem to be assembled from individually designed elements, sometimes at odds with one another. In independent practice Thomas

later developed this quality to an extreme degree. Components which would normally be de-emphasized are emphatically articulated; elements which would normally be similar are made to be violently disimilar; pieces which would normally be subsidiary are drastically over-scaled. Thus, in houses such as the Wintermute (Berkeley, 1915), Thomas created a powerful and dramatic design with means that in other hands could have produced chaos.

As Thomas evolved and refined his idiosyncratic approach to composition, his design idiom absorbed influences from the American Indian and Pueblo motifs, the Mission Revival, the Viennese Secessionists, and the Prairie School of the Midwest. Good examples would be the Locke and Pratt houses. But as he entered the 1920s, Thomas began to drop the bizarre quality of his early work, preferring to design in a stripped-down English cottage mode until his death in the mid 1940s.

Thomas' practice was almost exclusively residential and almost totally limited to the Bay Area. His houses have an open spaciousness, often flooded with natural light. The interior spaces are interesting environments with many amenities for family life.

> Thomas Gordon Smith
> John Beach

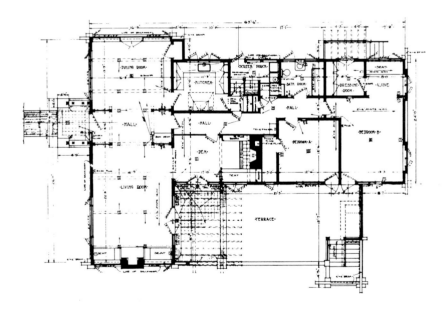

Frank C. Hill house, floor plan

John Terrell Vawter
1879-1919(?)

In 1904, Vawter graduated from the School of architecture at the University of Illinois, one year after his classmate Emmor Brooke Weaver. Traveling to Paris, he continued his studies at L'École des Beaux Arts, and was associated for a time with the Umbenstock Atelier. He recorded the architectural scene throughout Europe in drawings, etchings and watercolors. Returning to the United States, Vawter formed a brief partnership with Emmor Brooke Weaver in San Diego. Their first office was the basement of Weaver's newly constructed house on 26th Street. Together they worked on the design and construction of a board and batten house on the Mt. Woodson farm (Amy Strong house) deep into San Diego County, pitching a tent on the site for their own accommodations.

By 1910, Vawter had relocated in Los Angeles, joining the architect Albert R. Walker. The firm of Walker and Vawter produced designs of marked polarity; on the one hand stodgy and on the other, refreshing and personal. Since A. R. Walker's buildings prior to and after his association with Vawter are not of special distinction, one would suspect that it was Vawter's involvement in Los Angeles houses such as the W. W. Morgan, Frank C. Hill and A. R. Walker, that gave them their remarkable quality. These small wooden buildings, all on sloping sites, are responsive to their context, either composing themselves around existing trees or stepping down the contours in masonry forms. There is certainly an awareness of the Greenes' work apparent in their imagery, yet generally the Walker and Vawter plans are less contained, and the spaces more flowing. Their scale and interpenetration with the outdoors are a prelude to houses Harwell Harris and other Los Angeles architects would design twenty-five years later.

There are certain similarities between these houses and Weaver's, built in the San Diego area between 1905-1909. Indeed, Walker and Vawter's gable roofs are only more flamboyantly detailed versions of his; longer at the ridge than the eave, forming a *prow* with gutters concealed behind fascia boards, lap jointed where they meet.

With the advent of World War I, Vawter left the partnership in 1916. He was commissioned an officer in the U.S. Army, and by 1918 had advanced to Major in the Engineer Reserve Corps. Although we have found no mention of his death in architectural periodicals of the time, Vawter did not return after the war.

Frank C. Hill house, side elevation

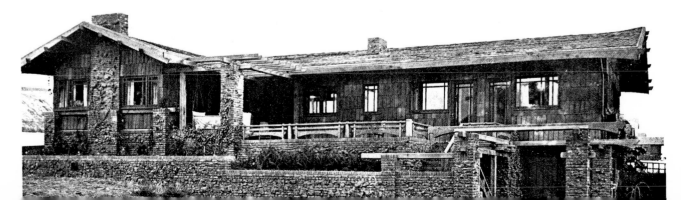

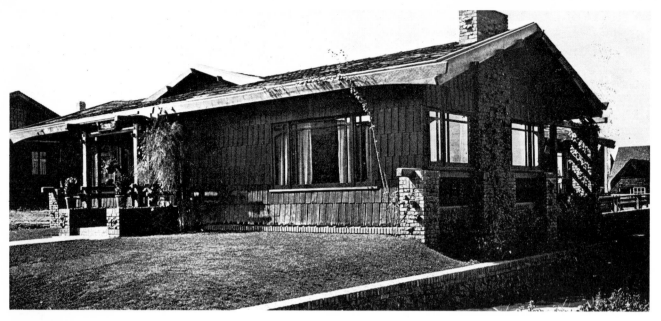

John Vawter and Albert Walker
Frank C. Hill house, Los Angeles
ca 1911

Emmor Brooke Weaver
1876-1968

Weaver was born in Iowa, raised in West Liberty.
He received a Bachelor of Architecture degree from
the University of Illinois in 1903. Advised by his
doctor to seek a warmer climate, Weaver left his
home in Michigan, arriving in San Diego May, 1903.
Immediately, he was employed in the architectural
office of Hebbard and Gill. He remained several
years with Irving Gill and Frank Mead, recalling in
later life particularly his involvement with the
George Marston house (San Diego, 1904). Weaver
was also employed by Templeton Johnson, and at
one time collaborated with John T. Vawter, and
later with A. Kenneth Kelloge.

Although never registered as an architect, Weaver
built about a dozen extremely sophisticated redwood
houses between 1905-1914 in the San Diego area.
Not only were these buildings assembled with great
finesse but their scale and spacial qualities are
remarkable as well. Weaver would employ angles
other than orthogonal on his plans to provide rooms
a sense of enclosure without isolating them from
adjacent rooms. The lines of battens in his low flat
ceilings direct the eye and lead one into the expansive
horizontal spaces. There is usually a continuous
header at the tops of all doors, windows and built-in
cabinetry, making these fixtures within easy reach.
Withal, there are many similarities in spacial quality
and exterior form with the contemporaneous work
of Frank Lloyd Wright. However, unlike Wright,
Weaver did not seem interested in being among the
avant garde, expressing machine technology. To him,
the houses were timeless: "There's a sort of mind
that hankers for wooden houses—board and batten—
Redwood and Oregon pine. It used to be so, and I
guess it always will be."

Weaver retired in 1945. In his later years he often
returned to one of his favorite early houses (Jane
Easton, La Jolla, 1907) to visit with the owners and
quietly admire his accomplishment.

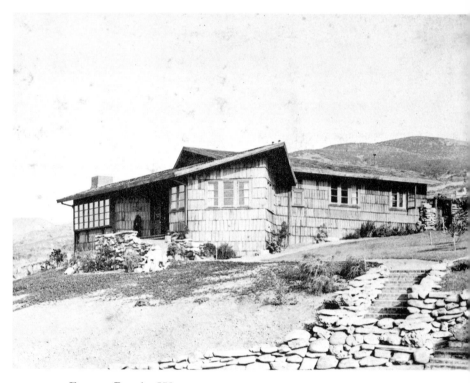

Emmor Brooke Weaver
Jane Easton House, La Jolla
1907

This house is as superbly crafted as any of the
Greenes', using many of the same devices. The
difference in appearance can be easily accounted for.
The Greenes often exaggerated joinery for its
decorative effect by oversizing components and
extending members beyond to make them more
conspicuous. Weaver's detailing is generally flush
with the adjacent surface, so one must look carefully
to appreciate what's going on. One would suspect
that Weaver viewed the process of constructing a
well-crafted house, not as an end in itself, but as
simply the responsible way to build.

Arthur B. Benton
Switzer's Chapel, San Gabriel Mountains
1924

There is a deeply seated notion in the American culture that contact with the wilderness and the primitive has survival value for the psyche. The importance of nature to provide oneself a sense of renewal and well being was popularized during the Craftsman period by John Burroughs, John Muir, and others. The 1913 episode of Joseph Knowles' supposed two month *return to the primitive* captivated Americans through nationwide newspaper coverage, culminating with a motorcade to Boston Common (see "The Wilderness Cult" in Roderick Nash's *Wilderness and the American Mind*). The Pikes Peak and Mt. Lowe incline railroads were constructed as a means to bring people into forested areas for a day's outing. The perils of Hetch-Hetchy's threatened natural state were creating a stir in the east, and Roosevelt, having tramped through Yosemite with Muir, was advocating the formation of National Parks. In Northern California, Bohemian Grove was the Russian River outpost of San Francisco's Bohemian Club. The redwood forests in the Santa Cruz Mountains were peppered with cabins, and along the nearby coast, the famed Carmel writers' colony was in full swing. Near Los Angeles, the San Gabriel Mountains were acquiring many tiny cabins securely snuggled into the slopes with boulder chimneys, and occasionally trees extending through notches in the eaves. Life in the Los Angeles area at the turn of the century was hardly overcrowded. Sojourns to the nearby mountains were not to escape an unbearable environment. One would have to conclude that their purpose was to experience the undisturbed natural scene—for recreation or communion.

The Switzer's Chapel, located at the headwaters of the Arroyo Seco, was accessible by a long burro trail which took riders to *Commodore* Switzer's resort. The structure was designed by the Los Angeles architect A. B. Benton as an extension of the cliffs using the same material. Benton was born and raised in Kansas, and like so many of his non-Californian contemporaries, was vitally interested in finding ideas of style which could be indigenous to the state. He propagandized the Mission Revival in architectural journals, and besides the Mission Inn, supplied some years later the plans for Santa Barbara's second Arlington Hotel in the same style.

Carl Curtis
Picture frame, redwood
8½", ca. 1908

Barbara Curtis Horton

As part of the early furnishings for his Easton-designed home, Curtis made and hung these signed portraits of Burroughs and Muir in the living room.

Ernest Batchelder
cast ceramic garden pot
ca. 1912, 12″ x 16″

F. L. Compton

Batchelder called this his Italian design.
It cost 65 dollars when new. Pots such as
this were as important a part of his
production as architectural tiles.

Illustration credits

All photographs by Morley Baer with the exception of the following:

Index

book design	Tim Andersen
	Tom Jamieson design office
	Clinton Wade

| type composition | *Janson* linotype body |
| | *Centaur* monotype headlines |

| initials | from Batchelder's *Principles of Design* |
| | and Arthur and Lucia Mathews' *Philopolis* |

| stock | 100# *Patina Matte* text |
| | 12 pt. *Carolina* cover |

| exhibit installation design | Tim Andersen |

| construction foreman | Mike Meredith |

| cover illustration | Elaine Hultgren |